THE
VIDEO GAME
CHEF

THE
VIDEO GAME
CHEF

76 ICONIC FOODS
FROM PAC-MAN TO ELDEN RING

CASSANDRA REEDER
THE GEEKY CHEF

EPIC INK

First published in 2023 by Epic Ink, an imprint of The Quarto Group,
142 West 36th Street, 4th Floor, New York, NY 10018, USA
T (212) 779-4972 F (212) 779-6058 www.Quarto.com

Epic Ink titles are also available at discount for retail, wholesale, promotional and bulk purchase.
For details, contact the Special Sales Manager by email at specialsales@quarto.com or by mail
at The Quarto Group, Attn: Special Sales Manager, 100 Cummings Center Suite, 265D,
Beverly, MA 01915, USA.

10 9 8 7 6 5 4 3 2 1

ISBN: 978-0-7603-8287-5

Library of Congress Control Number: 2023933580

Publisher: Rage Kindelsperger
Creative Director: Laura Drew
Editorial Director: Erin Canning
Managing Editor: Cara Donaldson
Editor: Leah Tracosas Jenness
Cover Design: Trey Conrad
Interior Design: Amelia LeBarron
Illustrations: Trey Conrad

Printed in China

For my babies.
I can't wait to cook food
and play video games
with you, my loves.

CONTENTS

TITLE SCREEN 8

CONSOLE TO KITCHEN
TUTORIAL 10

[THE '80s AND '90s]

POWER PELLETS
PAC-MAN 16

MUSHROOMS
SUPER
MARIO BROS.............. 17

RED POTION
THE LEGEND
OF ZELDA 20

WALL MEAT
CASTLEVANIA 21

GROG
THE SECRET OF
MONKEY ISLAND 22

SPICY FOOD
(AKA SUPERSPICY
CURRY)
KIRBY'S
DREAM LAND 24

YOSHI'S COOKIES
YOSHI'S COOKIE 26

GREEN CHEESE
ULTIMA VII:
THE BLACK GATE 30

TRASH CAN CHICKEN
STREETS OF RAGE 2 33

PEANUT
CHEESE BAR
EARTHBOUND 36

SWEET ROLL
THE ELDER SCROLLS:
ARENA 37

"LEVEL ATE" FLAMIN'
YAWN 'N' EGGS
EARTHWORM JIM 2 40

JURASSIC
PORK SOUP
CHRONO TRIGGER 43

JILL SANDWICH
RESIDENT EVIL 46

MANA POTION
DIABLO 48

PARAMITE PIES
ODDWORLD:
ABE'S ODDYSEE 50

TODAY'S SPECIAL
FINAL FANTASY VII 53

RATION
METAL GEAR SOLID 56

BATWING
CRUNCHIES
EVERQUEST 59

CORN PASTA
HARVEST
MOON 64 60

[THE EARLY 2000s]

COQ AU VIN
DEUS EX 64

BUTTER CAKE
SILENT HILL 2 66

ELIXIR SOUP
THE LEGEND OF ZELDA:
THE WIND WAKER 69

POKÉBLOCKS
POKÉMON RUBY
AND SAPPHIRE 70

STARKOS
BEYOND
GOOD AND EVIL 72

GRILLED CHEESE
THE SIMS 2 74

KOOPASTA
PAPER MARIO:
THE THOUSAND-YEAR
DOOR 76

SMOKED DESERT
DUMPLINGS
WORLD OF
WARCRAFT 79

PIZZA
DEVIL MAY CRY 3 82

THE FOWL WRAP
GRAND THEFT AUTO:
LIBERTY CITY
STORIES 84

SEA SALT
ICE CREAM
KINGDOM HEARTS II 87

SUPERB SOUP
THE LEGEND OF ZELDA:
TWILIGHT PRINCESS 90

SPAGHETTI
NEAPOLITAN
COOKING MAMA 92

SANDVICH
TEAM FORTRESS 2 95

THE CAKE
PORTAL 96

CREME-FILLED
CAKE
BIOSHOCK 99

BLANCMANGE
ODIN SPHERE 102

CHILI DOG
SONIC UNLEASHED ... 104

MABO CURRY
TALES OF
VESPERIA 106

GREASY
PROSPECTOR PORK
AND BEANS
FALLOUT 3 108

PORO-SNAX
LEAGUE
OF LEGENDS 111

[2010 TO 2015]

SINNER'S SANDWICH
DEADLY
PREMONITION 116

TUMMY-TINGLING
TUCHANKA SAUCE
MASS EFFECT 2 118

ELSWEYR FONDUE
THE ELDER SCROLLS V:
SKYRIM 119

SUSPICIOUS STEW
MINECRAFT 122

PIMENTACO
BORDERLANDS 2 125

CARROT SOUFFLÉ
GUILD WARS 2 128

APRICOT TARTLET
DISHONORED 129

PIEROGIES
DON'T STARVE 132

PRIESTLY
OMELETTE
FINAL FANTASY XIV ... 134

SPICY RAMEN
DESTINY 136

CRAB RANGOON
FAR CRY 4 139

BELGIAN WAFFLES
LIFE IS STRANGE 142

BUTTERSCOTCH-
CINNAMON PIE
UNDERTALE 143

WYVERN WINGS
DRAGON AGE:
INQUISITION 146

TAKOYAKI
YAKUZA 0 148

GINGERBREAD
THE WITCHER 3:
WILD HUNT 151

[2016 TO PRESENT]

KENNY'S
ORIGINAL RECIPE
FINAL FANTASY XV ... 156

ESTUS SOUP
DARK SOULS III 158

TACO TORNADO
OVERWATCH 159

PANCAKES
PERSONA 5 162

BLACKBERRY
COBBLER
STARDEW VALLEY 164

POUTINE
DIVINITY:
ORIGINAL SIN 2 167

CREAMY
HEART SOUP
THE LEGEND OF ZELDA:
BREATH OF
THE WILD 170

STUPENDOUS STEW
SUPER MARIO:
ODYSSEY 172

DURR BURGER
FORTNITE 174

PEARSON'S STEW
RED DEAD
REDEMPTION 2 177

CHEESE CURRY
POKÉMON SWORD
AND SHIELD 180

SAGHERT
AND CREAM
FIRE EMBLEM:
THREE HOUSES 183

MIXED-FRUITS
SANDWICH
ANIMAL CROSSING:
NEW HORIZONS 186

STICKY
HONEY ROAST
GENSHIN IMPACT ... 187

JAMBALAYA
CYBERPUNK 2077 190

CIORBĂ DE LEGUME
RESIDENT EVIL:
VILLAGE 192

BUNNY DANGO
MONSTER
HUNTER RISE 194

MILDUF'S TREAT
HORIZON:
FORBIDDEN WEST 197

BOLUSES
ELDEN RING 198

MEALS AT
A GLANCE 200

LEVELING UP 202

INDEX 204

ACKNOWLEDGMENTS ... 207

ABOUT
THE AUTHOR 208

TITLE SCREEN

The logic of video games doesn't always make sense. In the real world, it's not a good idea to eat a roast chicken that came out of a trash can, no matter how many pipe-related injuries you've sustained. But the idea of food as something that heals and fortifies, that enhances our experience and reflects our surroundings . . . that makes perfect sense!

Just as in the real world, the food in video games can serve many purposes. Often, it heals or enhances the players' stats. Cooking minigames can help with pacing, giving players a low-stakes break from combat. Gathering cooking ingredients can encourage players to explore the world in more detail and make new discoveries. Video game food also has important purposes outside of gameplay. Often, it enriches the lore and adds character to the environment. It can be humorous, like a strange taco in a glovebox. It can be deeply symbolic, like ice cream shared between friends, or a comforting soup made by a loved one. It can even break the fourth wall, like a giant anthropomorphic cheeseburger appearing in the middle of the California desert.

Video games are basically interactive stories; the purpose is to transport us to new worlds, placing the player behind the wheel—or the joystick, as it were. And food connects the player to the world and characters of the game. As the stories told in video games become more and more complex, we're seeing game developers not only incorporate food but really invest in the experience, approaching in-game cuisine with an incredible level of interaction and detail. It's a wild ride to look at where it started—quite literally just a few dots—to where it's heading. We've come a long way from the pixelated cherries of yesteryear!

As gamers, we know that crafting skills can sometimes be tedious to level up. The aim of this cookbook is to help gamers use their passion for video games to bring that sense of adventure to the kitchen. A favorite game can give us the motivation we need to try something new, whether that's a new dish or a new technique. In this book, you can learn things like how to make (olive-free) pizza from scratch, what the heck a "bouquet garni" is, or how to make delicious and moist chocolate cake that *isn't* a lie. Use this book to unlock new cooking achievements and level up your chef skills. Think of it as the ultimate strategy guide for making your favorite video game foods come to life. So put on some chiptunes and get cooking!

From silly and meme-y to otherworldly and innovative and detailed and realistic, these are some of the most iconic and influential foods in video game history—with instructions for how to make them!

PRESS START

CONSOLE TO KITCHEN TUTORIAL

This book will take you on a culinary journey through the history of food in video games. To aid you in your quest, you've been equipped with a magical talking spatula to act as your kitchen guide. Not really—but here's a quick walkthrough!

DIFFICULTY LEVELS

Though you're an expert gamer, your cooking skills might be on a different level. And even if you're an expert chef too, sometimes you're just in the mood for something simpler. Each recipe in this book is labeled with a difficulty level so you can get an idea at a glance of what it might entail.

BEGINNER

These recipes are simple, easy, and don't require a whole lot of EXP. They generally don't involve a lot of prep and can be made with 30 minutes (or less) of actual work. They also entail no special techniques outside of chopping, heating, and opening containers. They can be completed with relative ease by novice or apprentice cooks.

NORMAL

You're ready for these recipes if you've got a few cooking achievements under your belt and no one of questionable maturity could rightfully call you a "noob." Although not difficult, these recipes might require multiple techniques, need more prep work, or take more time than beginner recipes.

EXPERT

You're no stranger to the grind and you've invested quite a few points into the old culinary talent tree. These recipes have more steps, require more knowledge or skill, and often involve multiple techniques that are either highly RNG-based (like making a meringue) or time consuming (like assembling dumplings). If these recipes were mobs, they'd be the boss!

LEVELING UP

It's never a great idea to wander into a high-level zone when you're only level 1! The best way to get to the next level is to spend time slaying those beginner and/or normal recipes. Once you get comfortable, try out a more difficult recipe. Depending on how it works out, you'll know whether you need to complete some more beginner recipes or you're ready to unlock the next level.

HINTS, MODS, AND EASY MODE

In a rush? Don't know what "Frenched" means? Can't find catnip tea? Look for these useful quick tips, tricks, and cheats throughout this book.

HINTS
These helpful nuggets offer tips, suggestions, or supplementary information that may help you complete the recipe. Hints may tell you more about certain ingredients—what they are, what they taste like, and where they might be found—or explain a certain technique or method in more detail.

MODS
Here's where you can find suggestions for alternative ingredients or cooking methods. Mods might tell you how to make a recipe vegan, turn something a different color, or air fry a recipe instead of deep-frying.

EASY MODE
These cheats and exploits will make things significantly easier, allowing you to do speedruns or cheese your way through a recipe. This might be something like using boxed cake mix instead of making batter from scratch. Use these with caution! As in video games, some cheats or shortcuts might result in more instability and/or a less satisfying overall experience.

KITCHEN INVENTORY

"It's dangerous to go alone!" These items, tools, or specialty appliances will help you in your kitchen quest.

COMMON ITEMS

Most recipes in this book can be made using your stovetop, oven, and a few common kitchen tools, such as:

- Baking and/or casserole dishes
- Baking pan
- Baking sheets
- Blender
- Colander
- Cookie sheets
- Dutch oven

- Electric hand mixer
- Glass measuring cups
- Kitchen knives
- Ladle
- Large skillet
- Mixing bowls
- Rolling pin
- Rubber spatula

- Saucepan
- Saucepot
- Slotted spoon
- Spatula
- Tongs
- Wire whisk
- Wooden spoon

RARE ITEMS

Less common but not unheard of, you'll occasionally need these slightly more specialized tools, such as:

- Cake pan
- Cookie cutters
- Deep fryer (or air fryer)
- Food processor
- Glass bottles
- Grater

- Grill and/or smoker
- Ice cream scoop
- Meat thermometer
- Mini pie tins
- Oven-safe skillet
- Pitcher

- Ramekins
- Rice cooker
- Stainless steel mixing bowls
- Stand mixer (with attachments)

EPIC ITEMS

You'll only need these items for one or two recipes in this cookbook:

- Bamboo mat
- Candy thermometer
- Cheese knife
- Double boiler
- Food steamer
- Grill pan

- Loaf pan
- Offset spatula
- Pastry roller
- Piping bag
 (with attachments)

- Pizza pans
 or pizza stones
- Popsicle molds
- Slow cooker
- Springform pan
- Waffle maker

LEGENDARY ITEMS

Just a few recipes in this book require truly specialized equipment—but if you don't have these tools on hand, there are suggested alternatives for each:

- Broiler pan
- Cake stand
- Canoe pan
- Fondue pot

- Ice cream maker
- Melon baller
- Mini bundt pan
 (or dariole, canelé,
 or pudding mold)

- Ring molds
- Takoyaki pan
 (or ebelskiver)
- Wok

FARMING INGREDIENTS

From Japan to France, North America to Poland, video game foods have a range of cultural influences. While you can find most ingredients at your local supermarket, you might have to go on a side quest to find a few. For these ingredients, you may need to mount up and fly over to your local Asian market, baking supply store, health food store, Eastern European deli, or another specialty store. If you don't have these options nearby, you can always order any ingredients online!

THE
'80s AND '90s

POWER PELLETS

VIDEO GAME: **Pac-Man** · YEAR: **1980**

DIFFICULTY: ★ BEGINNER	YIELD: 25 POWER PELLETS

It all started with a tiny gobbet of pixels. *Pac-Man* can be credited with cementing the link between food and video games. Its meteoric rise to popularity acted as the catalyst for other food-centered arcade classics, such as *BurgerTime* (1982) and *Food Fight* (1983), as well as more nefarious retro titles created to sell specific food products, like *M.C. Kids* (1992), *Too Cool to Fool* (1992), and *Cool Spot* (1993). And then there's *Tapper* (1983), which exists somewhere in between. In *Pac-Man*, the player controls a ravenous little creature (the titular Pac-Man) as he devours pac-dots, power pellets, and fruit, all while avoiding malevolent murderous ghosts. When you think of *Pac-Man* food, you might first think of the cherry, but the Power Pellet is arguably more important. Once eaten, the Power Pellet turns the tables and Pac-Man can eat the ghosts, making it a very early example of a consumable power-up.

INGREDIENTS

2 cups (250 g) all-purpose flour

½ teaspoon kosher salt

1 teaspoon lemon zest

½ cup (50 g) confectioners' sugar, plus more for dusting

1 cup (2 sticks/225 g) unsalted butter, at room temperature

1 teaspoon vanilla paste or extract

¾ cup (100 g) macadamia nuts or pecans, finely chopped

¼ cup (40 g) mini white chocolate chips

1 tablespoon whole milk or light cream, if needed

Fresh fruit, to serve (optional)

DIRECTIONS

1 Preheat the oven to 375°F (190°C; gas mark 5). Line a baking sheet with parchment paper and set aside.

2 In a small bowl, mix the flour, salt, and lemon zest until well combined. Set aside.

3 Prepare a stand mixer fitted with the paddle attachment or a handheld electric mixer and a large bowl. Beat the confectioners' sugar, butter, and vanilla on medium speed. Then turn the mixer to low speed and add the flour mixture until combined. Add in the nuts and white chocolate chips, and continue to mix until evenly dispersed.

4 Form the dough into 1-inch (2.5 cm) balls and place on the prepared baking sheet about 1 inch (2.5 cm) apart. If the dough is too crumbly to roll, add a tablespoon of milk or cream and knead the dough with your hands to help it come together. (You want to avoid too much moisture, so only add a tiny bit at a time.) If your dough is too soft to hold its shape, add more flour, 1 tablespoon at a time, until you can form balls. Refrigerate for 10 to 20 minutes before baking.

5 Bake for 8 to 10 minutes, until the cookies are lightly browned on the bottom. Let the cookies cool until they're safe to handle.

6 Meanwhile, add the extra confectioners' sugar to a small bowl. Roll the slightly warm balls in the sugar and place them on a rack to cool completely. Once cooled, dust the balls in more of the sugar before serving, perhaps with an assortment of fresh fruit?

MUSHROOMS

VIDEO GAME: **Super Mario Bros.** ▪ YEAR: **1985**

DIFFICULTY: ★ ★ ★ EXPERT | YIELD: 8 MUSHROOMS

Like Mario's former rival Donkey Kong and bananas, Kirby and tomatoes, Sonic and chili dogs, Dante and pizza, or Bayonetta and lollipops, Mario and mushrooms belong together. Quite possibly the most iconic video game food, mushrooms made their first appearance in *Super Mario Bros.* in 1985. Initially, the mushrooms were orange-ish with brown spots, but they were later changed to the red-and-white toadstools we all know and love for the *Super Mario All Stars* compilation in 1993. In some games (and certain other Mario adaptations), it's been established that the bros, being Italian, have a taste for pizza and pasta. This recipe incorporates those Italian flavors in mushroom-shaped steamed buns filled with marinara sauce, cheese, and, of course, mushrooms.

INGREDIENTS

MUSHROOM TOPS

3 cups (375 g) all-purpose flour,
 plus more for dusting

¼ cup (50 g) granulated sugar

1 packet (¼ ounce/7 g) instant yeast

2 teaspoons baking powder

2 to 3 teaspoons red beet powder
 (optional)

2 tablespoons neutral oil (such as
 vegetable or grapeseed oil)

½ cup (120 ml) lukewarm water

½ cup (120 ml) lukewarm whole milk

1 teaspoon red gel food coloring
 (optional)

MUSHROOM STEMS

1 cup (125 g) all-purpose flour

2 tablespoons granulated sugar

¼ packet (¹⁄₁₆ ounce/1.75 g)
 instant yeast

1 teaspoon baking powder

2 teaspoons neutral oil (such as
 vegetable or grapeseed oil)

2 tablespoons lukewarm water

2 tablespoons lukewarm whole milk

FILLING

2 tablespoons unsalted butter

10 baby bella mushrooms, chopped

5 cloves garlic, minced

1 tablespoon dried Italian seasoning

½ cup (120 ml) marinara sauce

½ cup (55 g) grated
 mozzarella cheese

TOPPING

5 to 6 slices provolone cheese

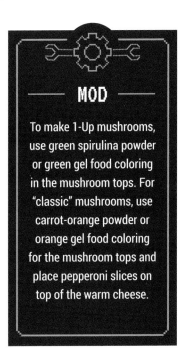

MOD

To make 1-Up mushrooms, use green spirulina powder or green gel food coloring in the mushroom tops. For "classic" mushrooms, use carrot-orange powder or orange gel food coloring for the mushroom tops and place pepperoni slices on top of the warm cheese.

CONTINUE PLAYING ▶

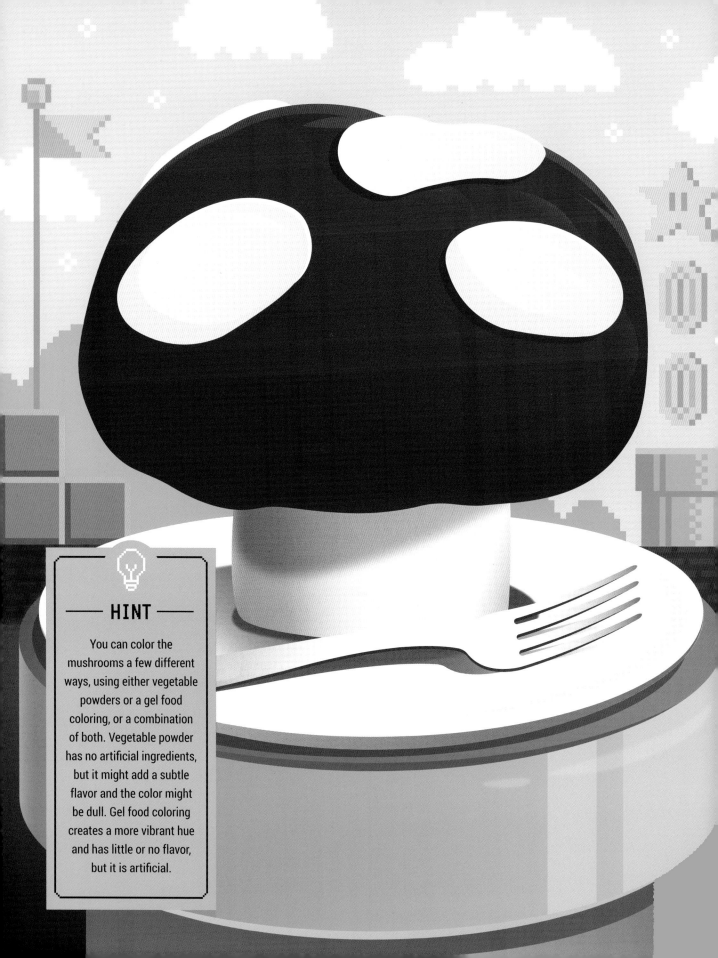

HINT

You can color the mushrooms a few different ways, using either vegetable powders or a gel food coloring, or a combination of both. Vegetable powder has no artificial ingredients, but it might add a subtle flavor and the color might be dull. Gel food coloring creates a more vibrant hue and has little or no flavor, but it is artificial.

DIRECTIONS

1 **To make the mushroom tops and stems:** In a medium bowl, sift together the flour, sugar, yeast, baking powder, and red beet powder (if using). In a separate bowl, whisk together the oil, water, milk, and red gel food coloring (if using). Add the wet ingredients to the dry and mix until well combined and a dough forms.

2 Lightly flour a clean work surface. Turn the dough out and knead until it is elastic and shiny. Form the dough into a ball and place it in a large well-oiled bowl. Cover with plastic wrap.

3 In a separate bowl, repeat this process for the stem dough (excluding the coloring agents). Let both the doughs rest in their bowls in a warm place until they have doubled in size, about 1 hour 30 minutes.

4 **Meanwhile, make the filling:** In a medium skillet over medium-low heat, melt the butter. Add the mushrooms, garlic, and Italian seasoning and cook, stirring, until the mushrooms have softened and the garlic is fragrant, 3 to 5 minutes. Remove from the heat and let cool.

5 Punch down the dough for the mushroom tops and roll it into a log on a lightly floured work surface. Portion the dough into 8 equal-size pieces and, using your hands, roll them into balls. Set them on a parchment-lined baking sheet. Cover with a damp kitchen towel and let rest for 15 minutes.

6 **To assemble:** Punch down the dough for the mushroom stems and roll it into a log on a lightly floured work surface. Portion the dough into 8 equal-size pieces and, using your hands, form each piece into a squat teardrop shape with a flat bottom. Set them on a parchment-lined baking sheet. Cover with a damp kitchen towel and let rest until it's time to steam them.

7 Line a baking sheet with parchment paper. On a work surface, flatten or roll one of the dough balls into a 5-inch (13 cm) disc. Add 2 teaspoons of marinara to the center of the disc, then top with 2 teaspoons of the mushroom mixture, followed by 2 teaspoons of the mozzarella. Bring the edges of the dough up around the filling, gathering the dough discs in the center and pinching them together to seal. Place the filled dough ball back onto the parchment-lined baking sheet, smooth side up. Repeat with the remaining dough balls, marinara sauce, mushroom mixture, and cheese. Cover the mushroom tops with a damp kitchen towel and let rest for another 10 minutes.

8 Fill the pot of a food steamer with water and bring to a boil. Place the dough stems into the basket of the steamer about 2 inches (5 cm) apart. Be careful not to overcrowd the basket because they will expand. Once the water in the pot is boiling, place the basket on top and cover with the lid. Steam the stems for 5 to 7 minutes, until they have expanded and are firm. Remove the stems from the basket and set aside. Add a few mushroom tops to the steamer basket, again being careful not to overcrowd. Steam the tops for at least 15 minutes. Repeat until all the buns have been steamed.

9 **While the buns are warm, prepare the topping:** Cut 32 to 40 circles (1 to 2 inches/2.5 to 5 cm) out of the provolone slices for the spots on the mushrooms. You can use a vegetable cutter, a shot glass, or even a bottle cap. Place 4 or 5 cheese circles on top of each mushroom top to decorate. Poke a small hole into the bottom of each mushroom top and stick the smaller end of a stem into it to assemble mushrooms.

RED POTION

DIFFICULTY: ★ BEGINNER	SERVES: 4 OR 5

A nearly universal rule of video games is that healing potions are red. *Diablo*, *Prince of Persia*, and *Ultima* are just a few notable examples of those that use it. Aptly called "Red Water of Life" in the original *Zelda*, the healing potion is one of the first video game inventory consumables. Using the rules established by the progenitor of the RPG, *Dungeons and Dragons*, healing potions can be traced all the way back to the text-based adventure games of the 1970s. However, *Legend of Zelda* was one of the first times it was shown on screen—and in the iconic bright red color. This recipe has a bunch of healthful ingredients brewed into a comforting, fragrant, crimson potion.

INGREDIENTS

¾ cup (30 g) hibiscus tea leaves

4 cinnamon sticks

2 whole star anise

2 whole cloves

2 whole allspice berries

3 pieces fresh orange peel,
 2 to 3 inches (3 to 8 cm)

2-inch (5 cm) piece fresh ginger

2 or 3 (¼ teaspoon) whole
 peppercorns (optional)

3 tablespoons grenadine or
 simple syrup, or to taste

¼ cup (60 ml) spiced rum,
 or to taste (optional)

½ cup (120 ml) cinnamon whiskey,
 or to taste (optional)

3 tablespoons blood orange juice
 (optional)

Edible luster dust (optional)

DIRECTIONS

1. In a large pot, combine 6 cups (1.4 L) water with the hibiscus tea leaves, cinnamon sticks, star anise, cloves, allspice berries, orange peel, ginger, and some peppercorns if you want a kick. Bring to a gentle simmer over medium-low heat and let cook for about 10 minutes. Remove the pot from the heat and allow the mixture to steep for 30 to 45 minutes.

2. Strain the mixture into a heatproof pitcher (glass is best, as the hibiscus can stain plastic). Place it in the fridge to chill for at least an hour, up to overnight.

3. When ready to serve, stir in the grenadine or simple syrup and the rum (if using), whiskey (if using), juice (if using), and luster dust (if using). Taste and add more grenadine, rum, or whiskey, if desired.

4. Serve over ice in glass bottles, with additional water, if desired.

WALL MEAT

VIDEO GAME: **Castlevania** · YEAR: **1986**

DIFFICULTY: ★ BEGINNER	SERVES: 2

There are a lot of unanswered questions about Wall Meat—like how long has the meat been in the wall and why is it in such great condition? The item known as Wall Meat was called "pork chop" in most of the early *Castlevania* game manuals, and it does resemble a large bone-in tomahawk-style pork chop. This wall-sourced protein is served with garlic butter, both because it's delicious and it helps ward off Dracula's minions. Best of all? Even inexperienced cooks can *whip* it up with ease . . . Get it? *Whip* it up.

INGREDIENTS

2 extra-thick bone-in pork chops, Frenched (see HINT)

½ teaspoon smoked paprika

½ teaspoon dried marjoram

½ teaspoon dried oregano

½ teaspoon onion powder

2 tablespoons extra-virgin olive oil

½ cup (1 stick/115 g) salted butter, melted

6 cloves garlic, minced

3 or 4 sprigs thyme

Salt and ground black pepper, to taste

DIRECTIONS

1. Pat the chops dry with paper towels. Season the pork with smoked paprika, marjoram, oregano, onion powder, and a generous sprinkle of salt and pepper. Let the chops absorb the seasoning for at least 30 minutes, up to 2 hours.

2. Preheat the oven to 375°F (190°C; gas mark 5). In an oven-safe skillet, heat the olive oil over medium-high heat. Sear the pork chops for about 3 minutes per side, until browned. Remove the skillet from the heat.

3. In a small bowl, combine the melted butter and minced garlic, then pour the garlic butter over the chops. Arrange the thyme springs alongside the pork in the skillet.

4. Place the skillet in the oven and cook for 5 to 7 minutes, then take the skillet out, flip the chops, and baste them with the garlic butter. Put the skillet back in the oven and cook for another 5 to 7 minutes, until the internal temperature at the thickest part of the biggest chop reaches 145°F (63°C) on a meat thermometer. (Cooking times might vary slightly depending on the size of your pork chops.)

5. Carefully remove the skillet from the oven. Let the chops rest for 10 minutes, then transfer them to serving plates. Serve the chops balanced on their edge, so that the bone sticks up and out. (You may need to cut the edge of the chops flat so they stay upright.) Spoon the garlic butter over the pork chops and serve.

— HINT —

Frenched means that meat is removed from the exposed bit of the bone. A butcher can do this for you or you can scrape the bone clean using a sharp knife.

GROG

VIDEO GAME: **The Secret of Monkey Island** ▪ YEAR: **1990**

DIFFICULTY: ★ BEGINNER	SERVES: 10 TO 15

The Secret of Monkey Island is a cult classic and an early and enthusiastic user of food as key items. Grog is a corrosive substance with a radioactive green color. It's used to bust Otis out of prison so he can join Guybrush's crew and help him sail to the titular Monkey Island. Unlike real grog, which is a mix of rum, water, and sometimes spices and fruit juice, the grog of MI is full of hazardous ingredients like battery acid, kerosene, axle grease, and "scumm," named after the Scumm engine, which powered this series and many other point-and-click classics like *Maniac Mansion* (1987). The scumm syrup in this recipe uses some ingredients that might be found in real-world grog, which takes the flavor of this lime punch to a more deep-in-the-Caribbean place. Grog! Grog! Grog!

INGREDIENTS

SCUMM SYRUP

Peel of ½ lime (optional)

2 cinnamon sticks

2 teaspoons ground nutmeg

1 whole clove

½ teaspoon sea salt

½ cup (100 g) sugar

GROG

3 cups (720 ml) cold pineapple juice

1 packet (3 ounces/75 g) lime-flavored gelatin dessert mix

½ can (6 ounces/180 ml) frozen limeade concentrate

2 cups (480 ml) cold water

1 cup (186 g) lime sherbet

1 cup (240 ml) white rum (optional)

½ cup (120 ml) coconut rum (optional)

2 cups (480 ml) cold lemon-lime soda

Ice (optional)

DIRECTIONS

1 **To make the scumm syrup:** In a small saucepan, add ½ cup (120 ml) water, the lime peel (if using), cinnamon sticks, nutmeg, clove, and salt. Bring the mixture to a boil over medium-high heat. Reduce the heat to low, cover, and simmer for 15 minutes. Uncover and, using a slotted spoon, carefully remove the lime peel and cinnamon sticks. Continue cooking and add the sugar, stirring until it's dissolved. Increase the heat to medium-high and bring the mixture back to a boil. Boil for 2 minutes and then remove from the heat. Allow the syrup to cool to room temperature before using or storing it in a sealable bottle or jar.

2 **To make the grog:** In a large punch bowl, stir together the pineapple juice, lime-flavored gelatin dessert mix, frozen limeade concentrate, water, and sherbet. Add some scumm syrup to taste.

3 When ready to serve, stir in the white rum (if using) and coconut rum (if using), or let folks add their desired amount directly to their cups. Top off with the soda and add ice, if desired. Ladle into tankards to serve. Or use it to break your friends out of jail.

```
❋ EASY MODE ❋

You can substitute falernum, a Caribbean liqueur,
for the scumm syrup.
```

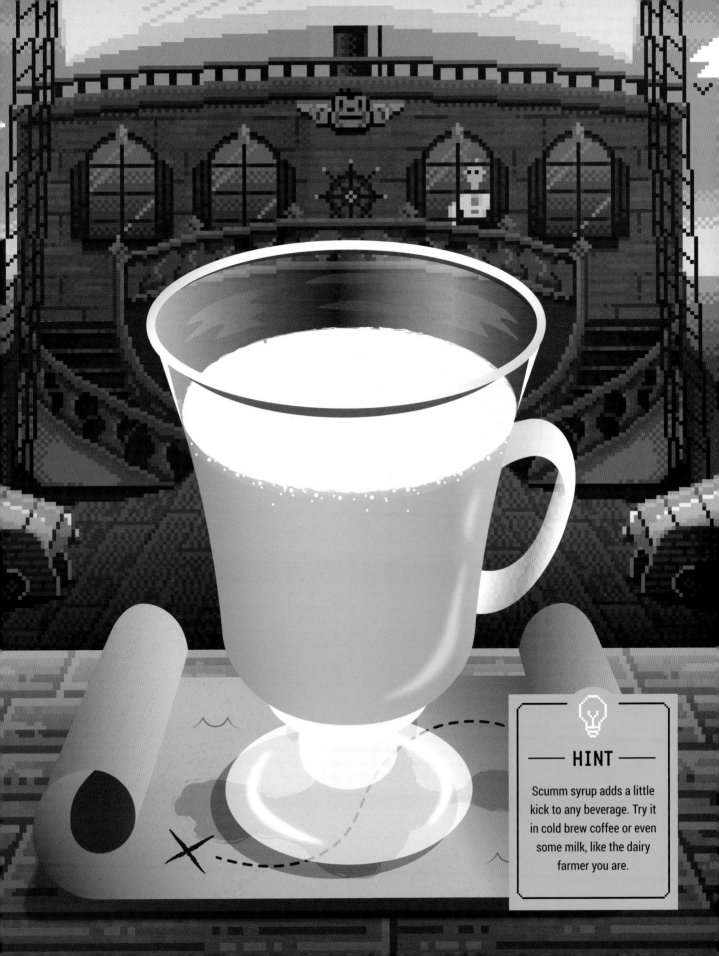

SPICY FOOD
(AKA SUPERSPICY CURRY)

VIDEO GAME: **Kirby's Dream Land** ▪ YEAR: **1992**

| DIFFICULTY: ★ ★ NORMAL | SERVES: 6 TO 8 |

The consumable that eventually became the iconic "Superspicy Curry" started out as "Spicy Food" in *Kirby's Dream Land*. An early example of food giving the player a special ability, Spicy Food allowed Kirby to spit a giant ball of fire. Eventually, Superspicy Curry became a special item in the *Smash Bros.* series (with the same effect). This curry is spicy enough that you'll at least *feel* like you might spit fire, and it includes some tomato flavor because . . . *obviously*.

INGREDIENTS

ROUX

3 tablespoons salted butter or coconut oil, cut into small pieces

2 tablespoons all-purpose flour

2 tablespoons curry powder (I prefer S&B brand)

1 tablespoon garam masala

⅛ teaspoon cayenne pepper, or to taste

CURRY

2 tablespoons neutral oil (such as vegetable or grapeseed oil)

2 pounds (450 g) boneless skinless chicken thighs or soy curls, cut into 2-inch (5 cm) pieces

1 yellow onion, chopped

2 cloves garlic, minced

1 tablespoon peeled and minced fresh ginger

2 bird's eye chili peppers, or to taste, seeds in and finely chopped, plus more sliced for garnish

2 large carrots, chopped

2 Yukon Gold potatoes, peeled and chopped

4 cups (960 ml) prepared dashi stock, chicken broth, or veggie stock

2 tablespoons tomato paste or ketchup

1 Fuji apple, peeled, cored, and grated

Salt and ground black pepper, to taste

Steamed rice, for serving

Fukujinzuke (Japanese curry pickles), for serving

✳ EASY MODE ✳

Use store-bought curry roux cubes instead of making your own. For this recipe, I recommend hot or medium hot Vermont Curry or Kokumaro Curry. Skip the apple if using Vermont Curry; it's sweet enough. Depending on your heat tolerance, if using hot curry roux cubes, you also might want to reduce or skip the bird's eye chili peppers.

1 **To make the roux:** In a small saucepan, melt the butter or coconut oil over low to medium-low heat. When it has melted completely, sprinkle in the flour and mix with a wooden spatula. The mixture will start to bubble and swell. Stirring constantly to avoid burning, cook over very low heat for 15 to 20 minutes, until the roux is a golden-brown color. Add the curry powder, garam masala, and cayenne and stir for 30 more seconds. Remove the roux from the heat, transfer to a small bowl, and set aside.

2 **To make the curry:** In a large, deep skillet or Dutch oven, heat the oil on medium heat. Add the chicken, in batches, and cook until browned, using a slotted spoon to transfer the pieces to a plate as it is browned. Add the onions to the skillet and sauté until softened and slightly browned, about 5 minutes. Add in the garlic, ginger, and chili peppers, and sauté until fragrant, 1 to 2 minutes. Add the carrots and cook, stirring, until slightly softened, 2 to 3 minutes, then add the potatoes and cook for 1 more minute.

3 Add the chicken and any juices back into the skillet, along with the stock, tomato paste, and the apple. Cover and cook over low heat until the carrots and potatoes are tender but still have a bit of resistance, 8 to 10 minutes. If the potatoes are done before the carrots, remove them with a slotted spoon and set aside on a plate.

4 Once the carrots and potatoes are close to the desired doneness, remove the pot from the heat and add the roux to taste, 1 tablespoon at a time, stirring until completely combined before adding the next. Season with salt and black pepper. Reduce the heat to very low, return the pot to the stove, and heat the curry for 4 to 5 minutes, until it reaches desired thickness.

5 Serve the curry hot over fresh steamed rice and Fukujinzuke. Garnish each serving plate with a couple slices of bird's eye chili peppers.

MOD

If you like, use star-shaped vegetable cutters on the carrots to emulate the curry appearance in *Kirby Star Allies* (2018). Or, use star-shaped rice molds for the rice. Both of these nifty gadgets are generally under $10 and easily found online.

YOSHI'S COOKIES

VIDEO GAME: **Yoshi's Cookie** · YEAR: **1992**

DIFFICULTY: ★ ★ ★ EXPERT | YIELD: 50 COOKIES

Mario's trusty dinosaur-like steed in *Super Mario World* (1990) was so popular that he got his own series of spinoff games. The second of these was *Yoshi's Cookie*, a tile-matching puzzle game similar to *Bejeweled* (2001) and *Tetris* (1984)—in fact, Tetris creator Alexey Pajitnov designed the Puzzle Mode levels—but with cookies! This was before Yoshi converted to a more fruit-based diet. *Yoshi's Cookie*, although definitely not the best Yoshi game, can be considered the precursor of casual foodie games like *Candy Crush* (2012).

INGREDIENTS

EQUIPMENT
Flower, heart, circle, and
 square cookie cutters
Yoshi cookie cutter (optional)

VANILLA DOUGH
1½ cups (3 sticks/340 g) unsalted
 butter, softened
2 cups (200 g) confectioners' sugar
4 large eggs, lightly beaten
1 teaspoon kosher salt
2 teaspoons vanilla paste or extract
Few drops of almond extract
 (optional)
1 cup (115 g) almond flour (not to be
 confused with almond meal!)
4 cups (500 g) all-purpose flour,
 plus more for dusting

CHOCOLATE DOUGH
1 cup (125 g) all-purpose flour
3 tablespoons cocoa powder
6 tablespoons unsalted butter,
 softened
¾ cup (75 g) confectioners' sugar
1 large egg, lightly beaten
¼ teaspoon kosher salt
¼ teaspoon vanilla paste or extract
¼ cup (30 g) almond flour

FOR ASSEMBLY
1 egg white, whisked
 (or more as needed)
Cinnamon sugar
Strawberry or seedless
 raspberry jelly
Green pepper or mint jelly
Apricot, marmalade, or peach jam

MOD

The vanilla dough recipe can be used to make any video game–themed cookies you like! Use your favorite gaming-related cookie cutters and color with food coloring or decorate with royal icing.

CONTINUE PLAYING ▷

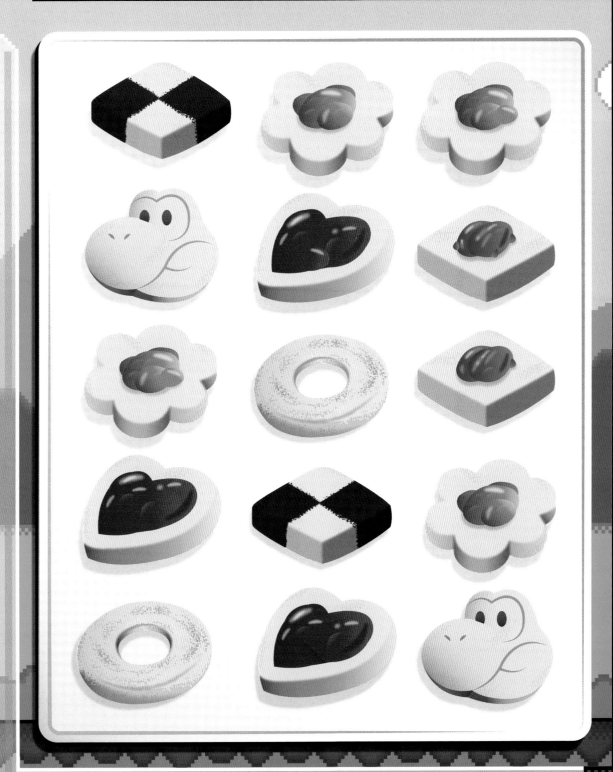

DIRECTIONS

1 To make the vanilla dough: In the bowl of a stand mixer fitted with the paddle attachment or in a large bowl with a handheld electric mixer, beat together the butter and confectioners' sugar on medium speed for 1 to 2 minutes. Slowly add the eggs and mix until incorporated. Add the salt, vanilla, almond extract (if using), and almond flour and mix until combined. Scrape down the sides of the bowl with a rubber spatula when necessary. Add the all-purpose flour, in fourths, and mix until the dough comes together. Be careful not to overmix. Remove the dough from the mixer. Cut away a quarter of the dough and set aside. Mold the larger portion into a ball, wrap it in plastic wrap, and refrigerate. Place the smaller portion between two sheets of waxed paper and use a rolling pin to shape it into an 11 x 4-inch (27 x 10 cm) rectangle that is ½ inch (1 cm) thick. Wrap the rolled dough in plastic wrap and refrigerate for at least two hours, or up to overnight.

2 To make the chocolate dough: In a small bowl, sift together the all-purpose flour and cocoa powder, then repeat the steps above to build the dough, adding the flour-cocoa mixture in place of the all-purpose flour. Portion and shape the dough following the instructions above. Wrap all the dough in plastic wrap and refrigerate for at least two hours, or up to overnight.

3 Once chilled, remove the rectangular portions of dough from the refrigerator. Brush the top of the vanilla dough with the egg white. Place the chocolate dough rectangle on top, pressing gently to adhere them together. Cut the stacked rectangles lengthwise into 4 long strips of dough by cutting first down the center lengthwise, then cutting the two resulting pieces in half lengthwise. Working with 2 strips of dough, brush the cut side of one with egg white. Place the other strip on top so that the vanilla and chocolate doughs form a 2 x 2 checkerboard square, then gently press the strips together to form a log. Repeat this with the other 2 strips of dough to make two checkerboard logs. Wrap the logs in plastic wrap and refrigerate for another 30 minutes.

4 Meanwhile, make the other cookies. Preheat the oven to 350°F (180°C; gas mark 4) and line two cookie sheets with parchment paper and set aside. Remove the reserved vanilla and chocolate dough balls from the refrigerator. Dust the work surface and rolling pin with flour and roll out the vanilla dough until it is ½ inch (1 cm) thick. (You may need to work in batches to prevent the dough from drying out. Keep unused dough wrapped in plastic wrap in the fridge.)

❊ EASY MODE ❊

Don't have time to make the dough from scratch? You can use premade sugar cookie dough. To make the vanilla dough, break up 3 rolls (16½ ounces/467 g each) rolls of premade sugar cookie dough, then knead in 1½ cups all-purpose flour with your hands until well incorporated. To make the chocolate dough, break up 1 roll of premade sugar cookie dough, then knead in 3 tablespoons of cocoa powder plus 3 tablespoons of all-purpose flour with your hands until well incorporated. Continue to shape, refrigerate, and bake the dough per the recipe instructions.

5 Use the cookie cutters to cut the dough into hearts, squares, flowers, circles, and Yoshi's face (if using) and place the shapes on the prepared cookie sheets. Reroll and cut scraps as needed. In the center of each heart, gently press your thumb or a small spoon into the dough to create a shallow heart-shaped indent. (This is where you will add the red jam later.) In the center of each square, use the same method to make a shallow round indent. In the center of each flower, make a shallow round indent. If you want to create flower petals on the flowers, use a sharp knife to press shallow ridges radiating from the center to form the individual petals. If the dough ever gets too soft, wrap it in plastic wrap and let it firm up again in the fridge for 10 minutes.

6 For the circles, use a smaller circle cookie cutter or a bottle cap to cut out a hole from the center, forming a ring. Discard the dough. Fill a shallow bowl with cinnamon sugar. Working one at a time, place the circular cookies into the cinnamon sugar and gently toss to coat.

7 Once the checkerboard cookie log has firmed up, remove it from the refrigerator. Using a sharp knife, cut it into ½-inch (1 cm) slices.

8 Transfer the shaped cookies to baking sheets lined with parchment paper. Again, you may need to do this in batches. Add about ½ teaspoon of the corresponding jellies to the indents in the matching cookies: strawberry for the hearts, green pepper for the squares, and apricot for the flowers. Place the cookie sheets full of complete cookies in the fridge for 10 minutes before putting them in the oven. This will prevent them from losing their shape during baking.

9 Bake the shaped and the checkerboard cookies (usually two cookie sheets full for most ovens) for 10 to 12 minutes, until the tops are set or you see very fine cracks and dimples on the surface. Let cool on the baking sheet for 5 to 7 minutes then transfer them to a cooling rack to cool to room temperature before serving.

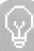

— HINT —

To avoid overbaking, pull the cookies out before the edges brown. When in doubt, err on the side of underbaking and allow the cookies to finish cooking on the hot cookie sheet outside the oven.

GREEN CHEESE

VIDEO GAME: **Ultima VII: The Black Gate** · YEAR: **1992**

| DIFFICULTY: ★ BEGINNER | YIELD: 1 CHEESEBALL |

Ultima VII was known for the fact that the player could combine flour and water and put it in an oven to make bread, a level of immersion that was unprecedented at the time. It became a trend to say "Okay, but can you bake bread?" when reviewing and comparing RPGs. Another notable thing about the *Ultima* series was that food was a necessity. *Ultima VII* introduced the "feeding points" system—an invisible game mechanic that determined whether the party was well fed. If a player didn't have any food in their inventory, or had only low-quality foods, the party weakened and eventually died of starvation, but not before incessantly pestering the player to feed them like a bunch of little kids on a long car trip. A mysterious item called "green cheese" was the best food item in *Ultima VII*, having the maximum amount of feeding points.

INGREDIENTS

2 packages (16 ounces/450 g) cream cheese, slightly softened

2 cups (230 g) grated sharp white cheddar cheese

2 tablespoons grated Parmesan cheese

¼ cup (15 g) green onions

¼ cup (13 g) chopped fresh parsley

¼ cup (10 g) chopped fresh basil

¼ cup (10 g) other fresh green herbs (such as dill, cilantro, oregano, or tarragon)

½ teaspoon onion powder

½ teaspoon garlic powder

1 teaspoon dried minced onions

2 teaspoons Dijon mustard

1 to 2 teaspoons spirulina or matcha powder for color (optional)

½ cup (11 g) finely chopped chives

Salt and ground black pepper, to taste

Freshly baked bread, for serving

Crackers, raw veggies, and apples, for serving (optional)

MOD

Chopped cooked bacon makes a great addition to green cheese. Add it after you add the seasonings and pulse just enough to distribute it evenly throughout the mixture. If you're a fan of goat cheese, replace half a package (4 ounces/115 g) of cream cheese with 4 ounces (115 g) of chevre.

CONTINUE PLAYING ▶

DIRECTIONS

1 In a food processor with the knife blade attached, puree the cream cheese until creamy. Add the white cheddar and Parmesan and pulse until evenly distributed.

2 Add the green onions, parsley, basil, and other fresh green herbs to the cheese mix and pulse until evenly distributed. Add the onion and garlic powders, minced onions, Dijon mustard, and spirulina or matcha (if using). Pulse until combined. Taste and adjust seasoning. Using a rubber spatula, scoop the cheese mixture onto a piece of plastic wrap. Wrap and refrigerate for 30 minutes until firm, or up to 5 days.

3 Once the cheese has set, remove it from the refrigerator and form it into a ball. Spread the chopped chives over a cutting board or other flat surface. Roll the cheese ball in the chives to coat. Cover the ball with plastic wrap again and refrigerate for 30 more minutes, until firm, before serving.

4 Serve with a cheese knife to spread over freshly baked bread ("the sweetest bread thou hast ever tasted!") or an assortment of crackers, veggies, apples, or other accompaniments of your choice.

—— HINT ——

Feeding your party is a challenge in *Ultima VII*, but it doesn't have to be in real life! Cheese balls are always a party-pleaser, and they are both easy to modify and easy to troubleshoot. You can get creative and swap out most of the ingredients or add your own culinary flare, but doing so might cause structural issues. If your cheese ball becomes too runny, add softened unsalted butter, a little at a time, and then chill to firm things back up. If you got a tad carried away with the additions and your ball isn't holding together, simply add 1 tablespoon more cream cheese and 1 teaspoon more butter, repeating as necessary, until it does.

TRASH CAN CHICKEN

VIDEO GAME: **Streets of Rage 2** · YEAR: **1992**

| DIFFICULTY: NORMAL | SERVES: 4 TO 6 |

Trash Can Chicken is Wall Meat's younger, grungier cousin. One of the most well-known food trends in the games of the late '80s and early '90s is succulent meat appearing, perfectly cooked and inexplicably fresh, out of barrels, walls, defeated enemies, and in this case, trash cans. This recipe incorporates the other important foods in this series: beer cans, apples, and pepper. You can make Trash Can Chicken on a grill or in a smoker, or simply in the oven.

INGREDIENTS

BRINE
2 cups (480 ml) chicken broth

2 cups (480 ml) apple cider
or apple juice

¼ cup (32 g) kosher salt

1 can (12 ounces/350 ml) beer,
hard apple cider, or cola

CHICKEN
1 chicken (4 pounds/1.8 kg), giblets
and neck removed

1 can (12 ounces/350 ml) beer, hard
apple cider, or cola, label and tab
removed, plus ½ can (6
ounces/180 ml) more if roasting

2 tablespoons unsalted butter,
melted

Applewood chips (if using a smoker)

DRY RUB
1 tablespoon dark brown sugar

2 teaspoons kosher salt

2 teaspoons ground black pepper

1 teaspoon onion powder

1 teaspoon garlic powder

1 teaspoon ancho chili powder

1 teaspoon smoked paprika

1 teaspoon dried marjoram or thyme

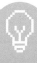

— HINT —

You can purchase "beer
can chicken stands" for
relatively cheap. They're a
bit easier to set up and your
chicken is less likely to fall
over. It also allows you to
customize the liquid used to
steam the chicken since the
can is no longer necessary
to hold up the chicken.

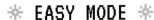

✳ EASY MODE ✳

Use a premade spice rub of your choice rather than making it from scratch.
Perhaps one with applewood smoke flavor, and maybe add a bit of extra black pepper.

CONTINUE PLAYING ▶

DIRECTIONS

1 **To make the brine:** In a medium saucepan, heat the chicken broth, apple cider, and kosher salt over low heat and stir until the salt is dissolved. Remove the pan from the heat and add a can of beer, hard apple cider, or cola. Let the brine cool until it is lukewarm.

2 Place the chicken in a large container that has a lid. Slowly pour the lukewarm brine over the chicken, submerging it as completely as possible. Cover the container so it is airtight and refrigerate for 12 to 24 hours (the longer the better). If the chicken is not fully submerged in the brine, flip it over halfway through the brining time.

3 **Meanwhile, make the dry rub:** In a small bowl, combine the brown sugar, salt, pepper, onion, garlic, and chili powders, paprika, and marjoram or thyme and set aside.

4 Once brining is complete, lift out the chicken and drain all the excess brine from its cavity. Pat the chicken dry with paper towels. Transfer to a deep bowl or roasting tin and thoroughly cover the chicken with the spice rub, then let the flavors absorb for about 30 minutes at room temperature.

5 Open the can of beer/cider or cola and empty out about a quarter of the liquid into a bowl and discard. Sit the chicken cavity-down on the can with its remaining liquid, so the legs are at the bottom and the wings are at the top. The can should be partially inside the cavity, holding the chicken upright.

6 Grill or smoke the chicken. If using a smoker, prepare it with applewood chips (if using). Place a drip pan under the grates, then stand the beer can and chicken directly on the grates over the pan. Close the cover and cook over indirect heat between 250°F and 275°F (120°C and 135°C) for about 1 hour 30 minutes, or until the internal temperature of the chicken is around 165°F (74°C) and the juices run clear. At around the 30-minute mark, brush the chicken with the melted butter every 15 to 20 minutes.

7 Once the chicken is cooked, let it rest for 10 to 15 minutes. Carefully remove the can from the cavity. Transfer the chicken to a serving platter and serve with the legs sticking out on top.

MOD

You can also cook Trash Can Chicken in the oven. Preheat the oven to 350°F (180°C; gas mark 4). Depending on the size of your oven, you may need to remove all but the bottom oven rack to fit the chicken. Stand the can and chicken in a shallow roasting pan and add ½ can of beer to the pan along with the butter. Roast for 45 to 55 minutes, basting the chicken with pan juices once or twice, until the internal temperature of the chicken reads 165°F (74°C). If the skin on top is getting too dark, tent the chicken with aluminum foil. Finish off following the rest of the recipe.

PEANUT CHEESE BAR

VIDEO GAME: **EarthBound** · YEAR: **1994**

| DIFFICULTY: ★ BEGINNER | SERVES: 8 TO 10 |

EarthBound had a number of fascinating food items. It also incorporated a novel game mechanic: the "condiment" system. Condiments were food items that had limited usability on their own but could be combined with certain other food items to increase HP recovery. Although there are many intriguing choices in Eagleland (trout yogurt, anyone?), the Peanut Cheese Bar really embodies the spirit of the game—it seems plausible enough, even nostalgic, but there's really nothing like it in real life! Serve it up with a sprig of parsley (which is apparently the best condiment match) to double your recovery.

INGREDIENTS

1½ cups (150 g) crushed speculoos cookies (such as Biscoff)

2 tablespoons light brown sugar

1 cup (2 sticks/225 g) unsalted butter, melted and cooled, divided

2 cups (230 g) finely shredded cheddar cheese

2 cups (350 g) milk chocolate chips

1 cup (240 ml) heavy whipping cream

½ cup (55 g) unsalted roasted peanuts

Parsley sprigs, for garnish (optional)

MOD

Use graham crackers instead of Biscoff cookies.

DIRECTIONS

1 In a medium bowl, combine the crushed cookies, brown sugar, and ⅓ cup (75 g) of the melted butter and stir until the mixture holds together. If it's too crumbly, add a little more melted butter.

2 Lightly grease an 8 x 8-inch (20 x 20 cm) nonstick baking pan and line the bottom with parchment paper. Press the cookie mixture firmly into the bottom of the pan in an even layer and then refrigerate.

3 In a medium bowl, combine the shredded cheese and ⅓ cup (75 g) of the melted butter until a paste forms. Remove the baking pan from the refrigerator. Spread the cheese mixture over the chilled cookie base, lightly pressing down, to create the second layer. Put the pan back in the fridge.

4 In a large microwave-safe bowl, add the milk chocolate chips and cream. Microwave on high for 20 seconds, then remove the bowl and stir to combine. Repeat until the chocolate has fully melted and the mixture is completely smooth. Add 1 tablespoon of the remaining butter to the chocolate mixture and stir until fully incorporated. Let the chocolate mixture cool slightly, 20 to 30 seconds, until it's still pourable but not hot enough to melt the cheese layer.

5 Remove the chilled pan from the refrigerator. Carefully spread the chocolate mixture over the cheese layer until it is completely covered and the chocolate is smooth. Sprinkle the peanuts evenly over the chocolate layer, then gently press them into the chocolate so they are slightly submerged in it. Place the pan back in the fridge to chill for at least 1 hour until set.

6 Once set, remove the Peanut Cheese Bar from the fridge and use a sharp knife to cut 8 to 10 rectangular bars. Garnish each bar with a sprig of parsley before serving, if you like.

SWEET ROLL

VIDEO GAME: **The Elder Scrolls: Arena** · YEAR: **1994**

DIFFICULTY: ★ BEGINNER	SERVES: 4 TO 6

This coveted baked good has taken its rightful place among the most recognizable foods in video game history. The first mention of the infamous Sweet Roll was in the beginning of *The ES: Arena*, in a hypothetical question posed to the player to determine the character's class. Perhaps unsurprisingly, the question involved a gang of bullies absconding with the prized treat. The Sweet Roll made subsequent appearances throughout the *Elder Scrolls* and *Fallout* games, becoming a healing item in *Oblivion* (2006) and *Skyrim* (2011). They're a cinch to whip up—just make sure no one steals them!

INGREDIENTS

DOUGH

1½ cups (190 g) all-purpose flour

½ cup (100 g) granulated sugar

2 teaspoons baking powder

¼ teaspoon kosher salt

2 tablespoons ground cinnamon

⅓ cup (80 ml) whole milk

1 large egg

2 teaspoons vanilla paste or extract

¼ cup (½ stick/55 g) unsalted
 butter, melted and cooled

FILLING

¼ cup (½ stick/55 g) unsalted
 butter, softened

¼ cup (55 g) packed light
 brown sugar

1 tablespoon ground cinnamon

½ cup (60 g) chopped walnuts

ICING

¼ cup (60 g) cream cheese, softened

1½ cups (150 g) confectioners'
 sugar

2 tablespoons whole milk
 (or more as needed)

— HINT —

We baked our rolls in heatproof glass measuring cups, but if you want smaller rolls, use a tapered mold like a mini Bundt pan, dariole, canelé, or pudding mold. (Just keep an eye on them while baking, though, because the cooking time might be considerably less.)

CONTINUE PLAYING ▶

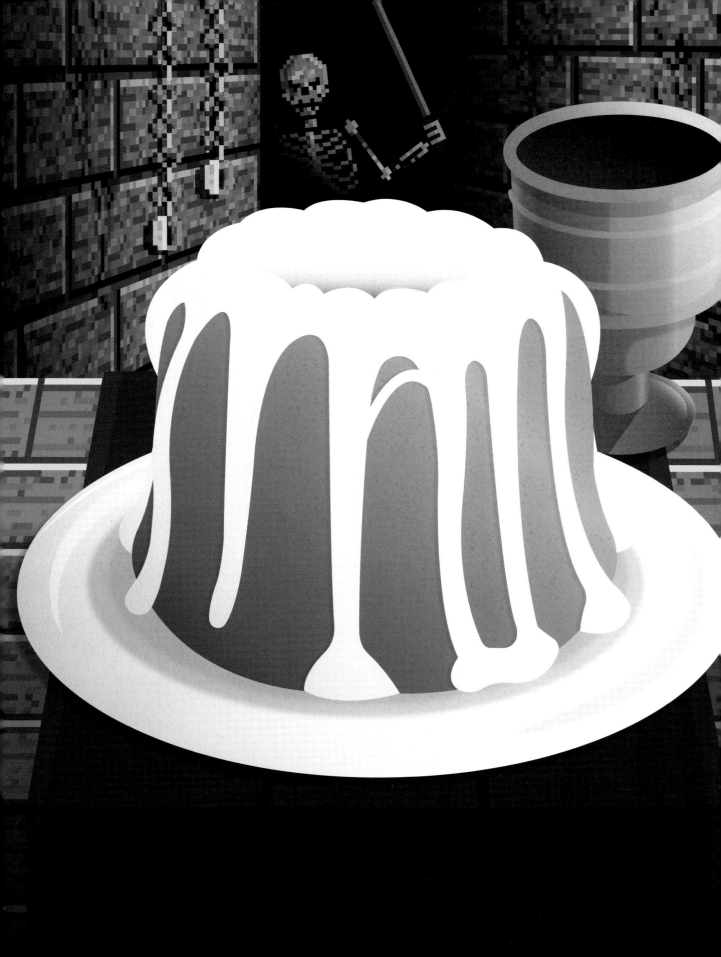

DIRECTIONS

1. Preheat the oven to 350°F (180°C; gas mark 4). Grease two 1-cup (240 ml) glass measuring cups.

2. **To make the dough:** In a large bowl, sift together the flour, sugar, baking powder, salt, and cinnamon. In a medium bowl, whisk together the milk, egg, vanilla, and butter. Add the milk mixture to the flour mixture and stir until thoroughly combined. Pour the batter into each measuring cup, filling to the 1 cup (240 ml) line. Bake for 25 to 30 minutes, until a toothpick or a knife inserted in the center comes out clean.

3. Remove the rolls from the oven. Let cool for 10 minutes, then carefully remove them from the measuring cups. If the rolls stick, gently run a knife around the rolls to separate them from the glass. Transfer the rolls, wide-part down, to a cooling rack to cool completely.

4. **Meanwhile, make the filling:** In a medium bowl, combine the butter, brown sugar, cinnamon, and walnuts. Set aside.

5. Once the rolls have cooled, set them wide-side down, leveling the bottoms if needed. Starting at the tapered top, use a spoon or fork to carve a deep hole (almost to the bottom) into the center of each roll for the filling. Spoon half of the filling mixture into each roll.

6. **To make the icing:** With a wire whisk, whisk together the softened cream cheese, confectioners' sugar, and milk until smooth and thick but pourable. If it's not pourable, add more milk, 1 tablespoon at a time, until it's the right consistency. Pour the icing over the rolls. Let the icing set for 5 to 10 minutes before serving.

MOD

Swap out the walnuts in this recipe for pecans, hazelnuts, pralines, oats, dried fruit, or even chocolate chips! For a spicier sweetroll, add a pinch of allspice, cloves, nutmeg, or ground ginger to the batter along with the cinnamon. And if you don't like cream cheese icing, you can whisk 1 cup (100 g) confectioners' sugar with 2 tablespoons milk, 1 teaspoon of vanilla extract, and a pinch of salt.

The possibilities are endless!

"LEVEL ATE" FLAMIN' YAWN 'N' EGGS

VIDEO GAME: **Earthworm Jim 2** · YEAR: **1995**

| DIFFICULTY: ★ BEGINNER | SERVES: 1 |

Swimming in stews, tunneling through Swiss cheese, and bouncing on cotton-candy clouds . . . Everybody loves food levels! Some early examples were the "milk bottle" area in *Castle of Illusion* (1990) and the two dessert-themed levels in *Zool* (1992). Later, there was "Sugarland Shimmy" in the critically acclaimed *Cuphead* (2017), along with many beloved levels throughout the Mario, Rayman, and Kirby series. In the brilliantly named Level Ate in *Earthworm Jim*, Jim walks along a crispy bacon path, hopping onto bouncy fried egg platforms and dodging random attacks from evil saltshakers by hiding under enormous raw steaks. Finally, he is transported to a giant pizza box to battle Flamin' Yawn, a sentient piece of meat. There's even a secret bonus food level within Level Ate called Totally Forked!

INGREDIENTS

1 to 2 slices thin-sliced bacon

1 beef tenderloin steak (filet mignon),
 6 to 8 ounces (175 to 225 g),
 at room temperature

Salt and ground black pepper,
 to taste

1 tablespoon olive oil

4 tablespoons unsalted butter,
 divided

2 large eggs, at room temperature

MOD

Filets can be pricey, so if getting one would totally fork your budget, any decent steak cut can be used instead. Try a teres major, T-bone (like the game sprite!), ribeye, or New York strip. Cooking times may vary but the method is the same, although you may need extra bacon.

CONTINUE PLAYING ▶

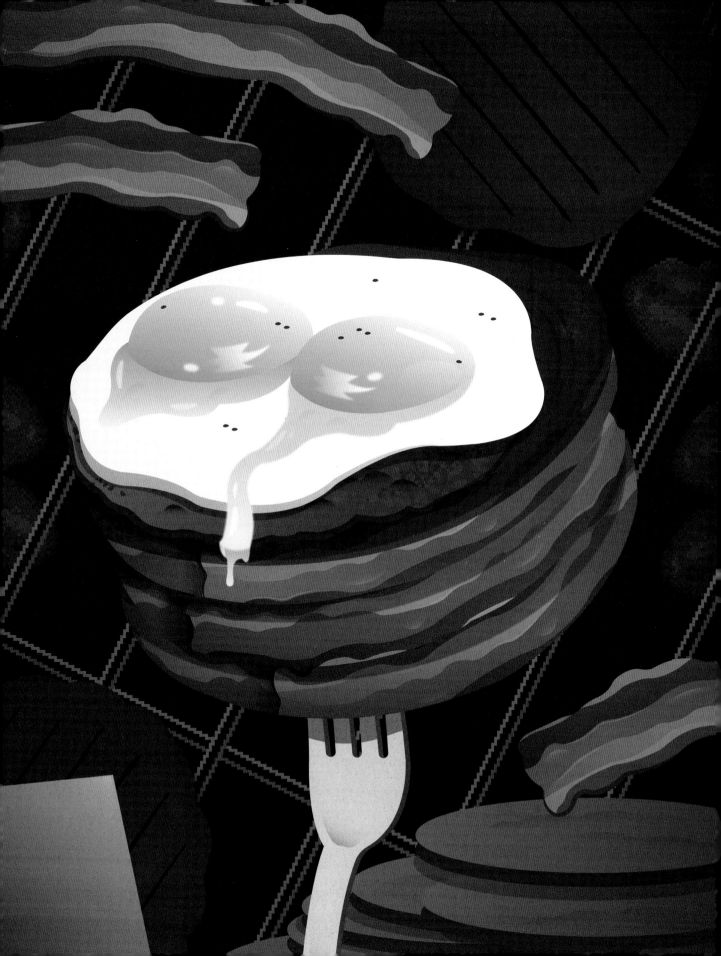

DIRECTIONS

1 Wrap the bacon completely around the outside of the filet and secure it with a piece of butcher's twine or a toothpick. Sprinkle with salt and pepper.

2 Preheat the oven to 450°F (230°C; gas mark 8). Heat an oven-safe skillet over medium-high heat. Add the oil and 2 tablespoons of the butter. When the pan starts to smoke slightly, add the steak. Sear for 2 minutes on each side. Remove the skillet from the heat and transfer it to the oven to finish cooking. Roast until desired doneness, 5 to 7 minutes for medium-rare or until the internal temperature of the steak reaches 130°F (55°C).

3 Remove the steak from the skillet and transfer to a plate to rest for 10 minutes. In the meantime, heat the skillet on medium heat. Add remaining 2 tablespoons butter to the skillet. When melted, crack in the eggs and sprinkle with salt and pepper. Cook for 2 to 3 minutes, until the whites are firm but the yolk is still runny. Do not flip.

4 Transfer the eggs to the serving plate, yolk-side up, placing them either on top of the filet or nestled next to it.

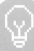

HINT

If grilling the steak, heat your grill to 400°F (200°C). Grill the bacon-wrapped steaks for 5 to 6 minutes on both the top and bottom, flipping once until the bacon is crispy and the steaks reach 130°F (55°C) internal temperature for medium-rare doneness. If necessary, use a long pair of tongs to hold the steaks over the grill with the bacon facing the heat to crisp the bacon up.

JURASSIC PORK SOUP

VIDEO GAME: **Chrono Trigger** · YEAR: **1995**

DIFFICULTY: ★ ★ NORMAL	SERVES: 8 TO 10

In the Japanese version of *Chrono Trigger*, Crono and Ayla have a drinking contest. In the North American translation, the adult beverage became Jurassic Pork Soup, a reference to the 1993 film *Jurassic Park*. Another item at the feast is poi, a Hawaiian staple. Given Ioka Village's tropical atmosphere, the presence of poi, and the sleepy effect the soup has on Crono, it makes sense that the pork soup is pastele stew, a Hawaiian favorite based on Puerto Rican pasteles. This hearty stew will have you eating bowl after bowl, then settling down for a loooong nap!

INGREDIENTS

ACHIOTE OIL
¾ cup (180 ml) extra-virgin olive oil

¼ cup (39 g) achiote seeds

BANANA DUMPLINGS
4 large plantains or
 very green bananas

3 to 4 cups (720 to 960 ml) hot water

¼ teaspoon salt

STEW
3 pounds (1.3 kg) pork shoulder,
 cut into bite-size pieces

1 large yellow onion, chopped

6 cloves garlic, minced

2 Hawaiian, pequin, or Thai chili
 peppers

2 stalks celery, finely diced

1 bunch cilantro, chopped,
 plus more for serving

4 cups (960 ml) chicken broth,
 plus more if needed

1 bay leaf

1 can (8 ounce/225 g) tomato sauce

2 tablespoons tomato paste

1 tablespoon ground cumin

2 teaspoons dried oregano

1 can (6 ounces/180 g) whole pitted
 black olives, undrained

Salt and ground black pepper,
 to taste

Cooked rice, for serving (optional)

CONTINUE PLAYING ▶

◀ 43 ▶

DIRECTIONS

1 **To make the achiote oil:** In a small saucepan over medium heat, heat the olive oil and achiote seeds until the oil just takes on a reddish-orange color, 5 to 7 minutes. Remove from heat and set aside to cool to room temperature.

2 **To make the banana dumplings:** Plantains and green bananas are hard to peel, so to loosen the peel, insert the tip of a sharp knife just through the peel and slice lengthwise down two opposite sides of each banana. Soak the bananas in hot water for about 10 minutes, then remove the peels. Using the small holes of a grater, grate the bananas into a medium bowl. Add ½ cup (120 ml) of the cooled achiote oil and the salt and stir in. Set aside.

3 In a 3-quart (2.8 L) saucepan, bring 3 to 4 cups (720 to 960 ml) of salted water to a boil. Using an ice cream scooper or a large spoon, form the banana mixture into meatball-size balls and drop them into the boiling water, and boil until they float. Then remove them with a slotted spoon and set aside on a plate. It's okay if some break; they will thicken the soup.

4 **To make the stew:** Sprinkle the pork with salt and black pepper. In a Dutch oven or a large saucepot, heat 2 tablespoons of achiote oil over medium-high heat. Add the pork, in batches, and cook until the meat is browned, adding more achiote oil as needed and using a slotted spoon to transfer the meat to a bowl as it browns. Don't overcrowd the pot. Set the browned pork aside.

5 Add the onions to the Dutch oven. Sauté until translucent, scraping off any browned bits on the bottom of the pot, 2 to 3 minutes. Add the garlic and cook until fragrant, about another minute. Add the chili peppers, celery, and cilantro and cook for another 1 to 2 minutes, stirring occasionally, until the cilantro is wilted and the vegetables begin to soften.

6 Return the pork to the pot along with the broth, bay leaf, tomato sauce, tomato paste, cumin, oregano, salt and black pepper, and the olives and their liquid. Simmer uncovered for 30 to 45 minutes, until the pork has softened. Periodically skim off any excess fat or scum that floats to the top.

7 Fold in the banana dumplings and cook for another 10 to 15 minutes until the soup has thickened. If it becomes too thick, add more broth. Taste and adjust seasonings.

8 To serve, ladle the stew into bowls and garnish with fresh cilantro. Serve with a side of rice, if desired.

❋ EASY MODE ❋

Buy achiote oil (sometimes called annatto oil) premade from your local Hispanic or Caribbean market. You may also be able to find it in the international section of your supermarket.

JILL SANDWICH

VIDEO GAME: **Resident Evil** ▪ YEAR: **1996**

DIFFICULTY: ★ BEGINNER	SERVES: 1 OR 2

The awkward Japanese-to-English translations in '90s games are delightful and oh-so-nostalgic, especially when the questionable voice dubs really amplify the awkwardness. A particularly cringeworthy moment, Barry's little joke about Jill's near-sandwich experience has become a popular meme in the gaming community. It's even referenced in other survival-horror titles like *Dead Rising* (2006) and *Dead by Daylight* (2016). Obviously, the Jill Sandwich is a metaphor, or perhaps a state of mind . . . Besides the essence of Jill Valentine, what this sandwich consists of is up to interpretation. Perhaps the "Jill" in a Jill Sandwich could become an acronym, like BLT or PB&J! Introducing the JILL sandwich: jam, ice cream, lemon curd, and ladyfingers!

INGREDIENTS

8 ladyfinger cookies (2 segments of 4 connected ladyfingers)

3 tablespoons raspberry liqueur (optional)

2 to 3 tablespoons lemon curd

2 large scoops vanilla ice cream, slightly softened

2 to 3 tablespoons raspberry or strawberry jam

Fresh raspberries or sliced fresh strawberries, for serving (optional)

Fresh mint leaves, for serving (optional)

Confectioners' sugar, for dusting

DIRECTIONS

1 Lay both segments of connected ladyfingers sugar-side down on a serving plate. Using a pastry brush, brush on the raspberry liqueur (if using).

2 Spread the lemon curd over top of the liqueur-brushed side of 1 segment of the ladyfingers, then scoop the ice cream onto the lemon curd.

3 Use a butterknife or spoon to spread the jam over the liqueur-brushed side of the remaining segment of ladyfingers. Place the jam-covered segment, jam side down, over the ice cream to form a sandwich, aligning the layers of ladyfingers. Press down gently. Transfer to the freezer to set for 10 minutes before serving.

4 To serve, top with the fresh berries and mint sprigs, if desired, and dust with confectioners' sugar.

MANA POTION

VIDEO GAME: **Diablo** · YEAR: **1996**

DIFFICULTY: ★ BEGINNER	SERVES: 2 OR 3

Descending into labyrinthian catacombs whilst fighting off hordes of undead is grueling, no matter how good the music is. In any dungeon crawler, you'll always need a few potions to keep your health and mana up. *Diablo*'s mana potion is an early example of another unspoken video game rule: Much like health potions are almost always red, magic and mana potions are almost always blue. The electrolytes from the coconut water will be useful for lengthy dungeon crawls, but maybe skip the alcohol if you plan on fighting any demon hordes.

INGREDIENTS

- ½ cup (120 ml) blue curaçao liqueur or nonalcoholic blue curaçao syrup
- 1 teaspoon coconut or vanilla extract (optional)
- 1 tablespoon lemon or lime juice
- ¼ cup (60 ml) white rum (optional)
- ¼ cup (60 ml) coconut or vanilla rum (optional)
- Pinch of edible white luster dust (optional)
- ¾ cup (180 ml) cold colorless water, plus more for topping (optional)
- ¾ cup (180 ml) cold lemon lime soda, plus more for topping (optional)

DIRECTIONS

1. In a large pitcher filled with ice, stir all the ingredients together until mixed well.

2. Strain into glass bottles to serve. Top each off with more coconut water or lemon lime soda, if desired.

— MOD —

Change up the flavor of this magic potion by using blue cotton candy syrup or blue raspberry syrup in place of the curaçao.

PARAMITE PIES

VIDEO GAME: **Oddworld: Abe's Oddysee** · YEAR: **1997**

DIFFICULTY: ★ ★ NORMAL	YIELD: 6 PIES

Food plays a major role in *Oddworld*'s odd tale. In the game, you control Abe, one of the many creatures enslaved by Rupture Farms, a meat factory that produces meaty snacks made from the very same creatures they force to work in their factories. But knowing the horrifying truth behind these meaty treats doesn't make them look any less enticing. Curse your stellar advertising, Rupture Farms!

INGREDIENTS

SHORTCRUST PASTRY
2⅔ cups (330 g) all-purpose flour, plus more for dusting

1 cup (2 sticks/225 g) cold unsalted butter, cut into approximately ½-inch (1 cm) cubes

1 teaspoon kosher salt

6 to 8 tablespoons ice water

2 sheets (9¾ x 10½ x 3½-inch/ 24 x 27 x 9 cm) frozen puff pastry, thawed (for top crusts)

1 tablespoon lukewarm water

1 large egg, beaten (for egg wash)

FILLING
1 tablespoon extra-virgin olive oil

1 large yellow onion, finely chopped

4 cloves garlic, minced

2 pounds (900 g) lean ground beef or pork, or a mixture of both

1 tablespoon cornstarch

¾ cup (180 ml) beef broth

¾ cup (180 ml) tomato sauce

2 tablespoons Worcestershire sauce

3 tablespoons okonomiyaki or barbecue sauce, or to taste

1 teaspoon beef-flavor instant bouillon

¼ teaspoon ground nutmeg

Salt and ground black pepper, to taste

❋ EASY MODE ❋

Although not as flaky and buttery as handmade pastry, the shortcrust pastry can be purchased premade.

CONTINUE PLAYING ▶

DIRECTIONS

1 **To make the shortcrust pastry:** In a food processor fitted with the knife blade, add the flour, butter, and salt and pulse until the mixture resembles fine crumbs. Add the ice water, 1 tablespoon at a time, and pulse until the mixture begins to form large clumps. Turn the pastry out onto a lightly floured worksurface and gently knead to bring together. Use your hands to form the pastry into a disc, wrap it in plastic wrap, and refrigerate for at least 2 hours.

2 **To make the filling:** In a large skillet, heat the oil over medium heat. Add the onion and cook until soft and translucent, 2 to 3 minutes. Add the garlic and cook until fragrant, about another minute. Add the ground beef or pork and cook for 4 minutes, stirring and breaking up pieces with a wooden spoon, until browned and no pink remains. Drain off any excess grease.

3 In a small bowl, use a wire whisk to whisk together the cornstarch and 1 tablespoon of the broth until it forms a paste. To the skillet with the beef, add the cornstarch paste along with the remaining broth, and the tomato, Worcestershire, and okonomiyaki sauces, then the bouillon, nutmeg, and salt and pepper. Bring to a boil then reduce heat to medium-low. Simmer until thickened and reduced, about 8 minutes. Taste and adjust seasoning. Remove from heat and let the filling cool to room temperature.

4 Preheat the oven to 375°F (190°C; gas mark 5). Grease 6 fluted mini pie tins or tart pans with butter.

5 Lightly flour a worksurface and rolling pin. Roll out the shortcrust pastry to about ⅛ inch (3 mm) thick. Line the bases and sides of each tin with the pastry, cutting and rerolling as needed. Divide the beef mixture evenly among the 6 dough-lined tins. Brush the rim of each tin with lukewarm water. From the thawed puff pastry, cut out six 5-inch (17 cm) circles and drape them over the meat to form the top of the pies. Press the edges to seal and trim any excess. You can use a fork to crimp the edge of the puff pastry, if you like. In a small bowl, beat the egg. Then dip a brush into the egg and brush the egg wash over the pastry. Use a sharp knife to cut a small circle of slits in the center of the pie crust to vent.

6 Set the pies on a baking sheet and transfer to the oven. Bake for 30 to 35 minutes, until the crust is golden brown and flaky. If the top crusts are browning too quickly, drape the pies with aluminum foil. Once baked, remove the baking sheet from the oven and let the pies cool for 10 to 15 minutes. Remove from the pie molds before serving.

MOD

These Paramite Pies are super versatile. For a different flavor, try adding curry, berbere, or taco seasoning.
You can also add veggies like peas, finely chopped carrots, or potatoes.
Add these along with the liquids after the meat has browned.

TODAY'S SPECIAL

VIDEO GAME: **Final Fantasy VII** · YEAR: **1997**

DIFFICULTY: ★ ★ ★ EXPERT	SERVES: 4 TO 6

In video games, sometimes you need to eat at a diner and compliment the chef to get a pharmacy credit so you can buy some digestives for a lady having gastrointestinal troubles, who will reward you with some sexy cologne so you can seduce a mafia boss . . . Okay, maybe that was only this one time. At the Wall Market diner in *FFVII*, the food choices (in the English translation) are a Korean BBQ plate, a sushi plate, or "Today's Special." It's not specified what the special might be, so why not combine the two other dishes into one? Gimbap is sometimes called "Korean sushi" because of its similarities to Japanese maki rolls. One of the fillings in gimbap is usually beef bulgogi, a Korean BBQ staple. It'll be super easy to compliment the chef (you!) and not compare your meal to any dog food you may or may not have eaten in the past . . . Serious question, how much experience do you think Cloud has eating dog food?

INGREDIENTS

BULGOGI

1 small white onion, thinly sliced

½ Asian pear, grated
 (about ½ cup/75 g)

2 green onions, chopped

2 cloves garlic, minced

¼ cup (60 ml) soy sauce

¼ cup (55 g) packed
 light brown sugar

2 tablespoons mirin

1 tablespoon toasted sesame oil

½ teaspoon ground black pepper

½ teaspoon salt

1 pound (450 g) thinly sliced
 beef ribeye

1 to 2 tablespoons neutral oil (such
 as vegetable or grapeseed oil)

RICE

1 tablespoon rice vinegar

2 teaspoons toasted sesame oil

½ teaspoon kosher salt

4 cups (800 g) cooked short-grain
 rice (see HINT on page 55)

GIMBAP

1 package (10 ounces/300 g)
 spinach, blanched and drained

2 cloves garlic, minced

2 teaspoons toasted sesame oil

Salt, to taste

1 large carrot, cut into 2 x ¼-inch
 (5 cm x 5 mm) matchstick strips

2 tablespoons neutral oil (such as
 vegetable or grapeseed oil)

3 medium eggs, beaten

4 sheets roasted seaweed
 (such as laver, gim, or nori)

5 strips danmuji (yellow pickled
 radish), cut into matchsticks

2 teaspoons sesame seeds

CONTINUE PLAYING ▶

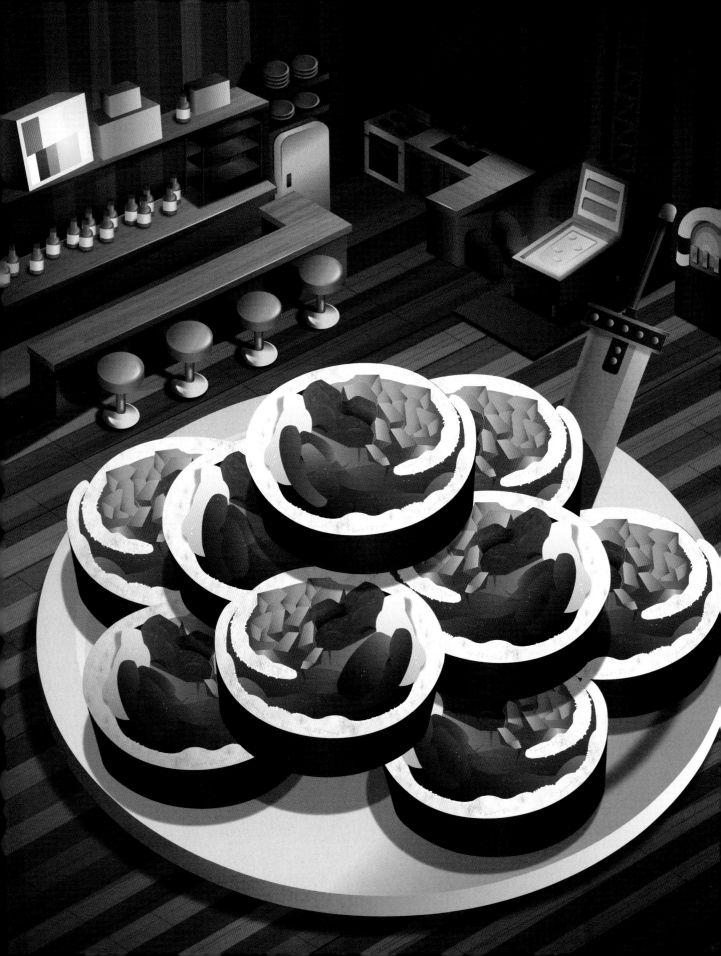

DIRECTIONS

1 **To make the bulgogi:** In a medium bowl, mix the white onion, Asian pear, green onions, garlic, soy sauce, brown sugar, mirin, sesame oil, salt, and pepper into a marinade. Put the sliced ribeye in a zip-top plastic bag and pour in the marinade, making sure all the meat is covered by the marinade. Seal the bag and refrigerate. Let the meat marinate in the refrigerator for at least 1 hour, up to overnight.

2 Once the meat has marinated, heat the neutral oil in a grill pan over medium-high heat. Working in batches, add the ribeye slices to the grill pan in a single layer and cook, flipping once, until charred and cooked through, 1 to 2 minutes per side. (Cooking time may vary depending on thickness.) Add more oil as needed between batches.

3 **To prepare the rice:** In a small bowl, add the rice vinegar, sesame oil, and salt, and stir. Pour into the cooked rice and toss. Set aside.

4 **To prepare the gimbap:** In a small bowl, combine the blanched spinach, garlic, and toasted sesame oil and sprinkle with salt. Set aside. In another bowl, sprinkle the carrot with salt and let sweat for 8 to 10 minutes. In a small skillet, heat 1 tablespoon of the neutral oil over medium heat. Squeeze the excess water from the carrots, then add them to the pan and sauté for about 1 minute. Transfer to a bowl and set aside.

5 Sprinkle the beaten eggs with salt. Add the rest of the neutral oil to the skillet and heat over low heat. Pour the beaten eggs into the pan, tilting the skillet so the eggs cover the bottom. Once the bottom of the eggs have set, remove the skillet from the heat and flip the eggs over with a spatula. With the skillet off the heat, let the eggs continue to cook slowly in the still-hot pan until done, about 5 minutes. Once cooked through, cut the eggs into ½-inch (1 cm) strips.

6 **To assemble the gimbap:** Place a sheet of seaweed on a bamboo mat or a piece of parchment paper. Spread about ¾ cup (110 g) of the cooked rice evenly over the seaweed, leaving about 2 inches (5 cm) on one side. Place one-quarter of the bulgogi, egg strips, spinach, carrots, and danmuji in the center of the rice.

7 Using the bamboo mat for leverage, roll the seaweed around the rice and fillings. Seal the roll by running wetted fingers along the 2-inch (5 cm) section of seaweed and pressing to close. Squeeze the mat, pressing gently on the top and sides, to compress and fully seal the roll. Wrap the roll tightly in plastic wrap and refrigerate for about 20 minutes, or up to overnight. Repeat with the remaining 3 sheets of seaweed and remaining ingredients.

8 Remove the rolls from the fridge and unwrap. With a very sharp knife, cut each roll into ½-inch-thick (1 cm) rounds, wiping the knife clean every few cuts. Sprinkle sesame seeds over the sliced gimbap before serving.

── HINT ──

Before cooking the rice, make sure to rinse it thoroughly. When cooking it, use slightly less water than usual; this amount will vary somewhat but usually it's a 1:1 ratio of rice to water.

RATION

VIDEO GAME: **Metal Gear Solid** • YEAR: **1998**

DIFFICULTY: ★ BEGINNER	SERVES: 2 TO 4

Rations are the default consumables in almost every *Metal Gear* game. Replenishing either health or stamina, they help to immerse players in the game's military lore. Rations are also used for puzzle-solving in *MG2: Solid Snake*. In *MGS3: Snake Eater* they are used as a more . . . conventional (?) alternative to snakes, spiders, and frogs. In real life, military rations—also known as "meals, ready to eat" or MREs—generally contain high-calorie, shelf-stable foods and drinks designed to give a human enough energy for one day. Solid Snake is a soldier in the U.S. Army, where chili mac has been one of the most popular MREs for decades. It also includes many of the foods mentioned as part of rations (beef, beans, cheese, pasta, chocolate, and coffee) in the *Metal Gear* series. So . . . how does it taste?

INGREDIENTS

CHILI MAC

1 tablespoon extra-virgin olive oil

1 yellow onion, chopped

2 cloves garlic, minced

1 red bell pepper, seeded and
 chopped

1½ pounds (675 g) lean ground beef
 or pork

1 can (28 ounces/800 g) crushed
 tomatoes

1 can (14½ to 16 ounces/410 to 450 g)
 dark red kidney beans

2 cups (480 ml) beef broth

2 tablespoons chili powder

2 teaspoons paprika

2 teaspoons ground cumin

2 teaspoons onion powder

2 teaspoons garlic powder

1 teaspoon cocoa powder
 and/or instant coffee (optional)

8 ounces (225 g) elbow macaroni,
 cooked al dente

1 or 2 slices American cheese
 (optional)

1 cup (115 g) shredded medium
 cheddar cheese (optional)

Salt and ground black pepper,
 to taste

SERVING SUGGESTIONS

Tuna or sardine can, for plating

CalorieMate Block
 (Yes, they are real!)

Crackers with cheese spread
 or peanut butter

Beef jerky or a pepperoni stick

Trail mix or mixed nuts

Prepackaged cakes or cookies

Electrolyte beverage

CONTINUE PLAYING ▶

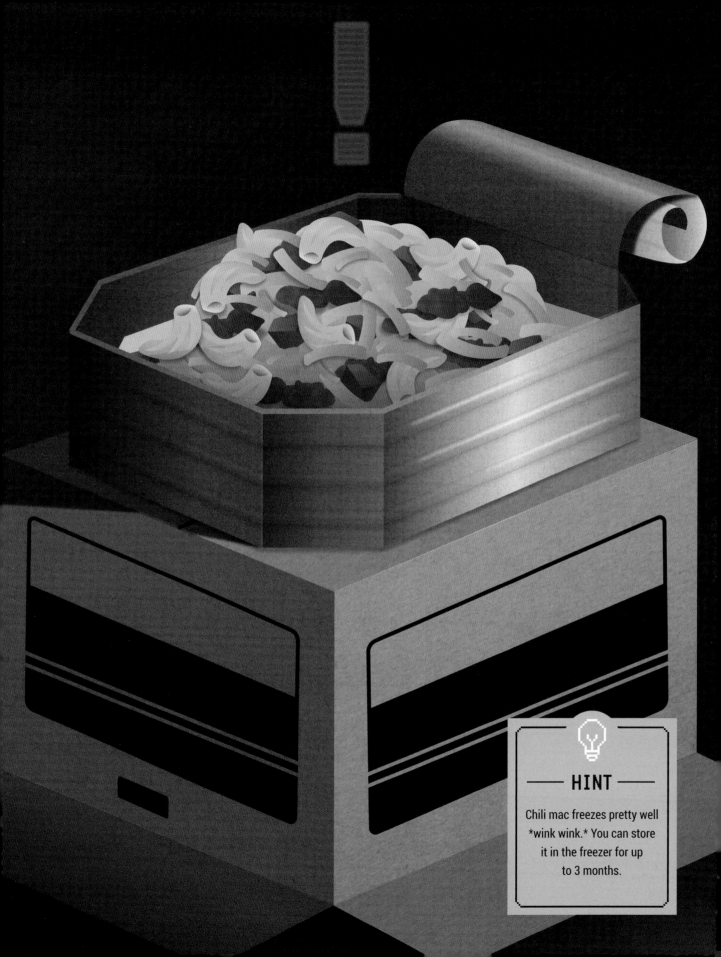

HINT

Chili mac freezes pretty well *wink wink.* You can store it in the freezer for up to 3 months.

DIRECTIONS

1 In a large saucepot or Dutch oven, heat the olive oil over medium-high heat. Add the onion and cook for 1 minute. Add the garlic and cook until fragrant, about 1 minute more, and then the red bell pepper. Continue to cook the vegetables until the onion is translucent and the bell pepper has softened slightly, about 3 minutes.

2 Add the ground beef or pork and stir with a wooden spoon to break up the bigger pieces and mix with the vegetables. Cook until the beef is well browned, 8 to 10 minutes.

3 Add the tomatoes, beans, broth, and the chili, paprika, cumin, onion, garlic, and cocoa or coffee powders, and stir to combine. Bring everything to a simmer over medium-high heat, then reduce the heat to medium. Cover and cook for 10 to 12 minutes, then add the cooked macaroni and cook for 2 to 3 minutes more, until the macaroni is tender and the sauce has thickened somewhat.

4 Remove the pot from the heat. Add the American cheese (if using), stirring until it melts completely into the sauce. Taste and adjust seasoning. Sprinkle in the cheddar cheese (if using), then put the lid back on the pot until the cheese melts, about 2 minutes.

5 Serve in a tin can—such as a tabbed tuna can or square sardine can—with the label removed alongside an assortment of nonperishable snacks and an electrolyte beverage.

MOD

Make this one vegetarian or vegan by replacing the beef with crumbled tempeh, textured vegetable protein, or other vegan ground beef substitute; swap the beef broth with mushroom stock and the cheese with nutritional yeast or other cheese substitutes.

BATWING CRUNCHIES

VIDEO GAME: **EverQuest** · YEAR: **1999**

DIFFICULTY: ★ BEGINNER	SERVES: 15 TO 20

EQ set the standard for all subsequent MMORPGS in many ways. Although it wasn't the first to implement a food crafting system, *EQ* is notable for the sheer variety of craftable items in the baking tradeskill. Sure, the crafting mechanic (at the time) was almost as punishing as running naked over two continents to get back to your body, and many of the craftable items were a tad . . . grotesque? But goshdarnit, there sure were a lot of them! Using only two ingredients—frosting and batwings—Batwing Crunchies are one of the most efficient items for grinding up the baking skill. These pleasantly textural treats will give you the sensation of eating a sweet, crunchy batwing—without the grind.

INGREDIENTS

1 cup (175 g) dark chocolate chips

⅓ cup (60 g) peanut butter

1 tablespoon unsalted butter, melted

Pinch of kosher salt

¼ teaspoon black oil-based food coloring or gel food coloring (optional)

¾ cup (75 g) chow mein noodles (the crunchy snack-food kind!)

¾ cup (30 g) lightly crushed pretzels

½ cup (70 g) toffee bits and/or chopped nuts

Fleur de sel, sea salt, and/or sanding sugar (optional)

DIRECTIONS

1. In a large microwave-safe bowl, add the chocolate chips, peanut butter, and butter. Microwave on high for 20 seconds, then stir to combine. Repeat as needed until the chocolate has fully melted and the mixture is smooth. Stir in the salt and black oil-based food coloring (if using).

2. Add the chow mein noodles, pretzels, and toffee or nuts. Stir until evenly coated with the chocolate-peanut butter mixture.

3. Line a baking sheet with parchment paper. Using an ice cream scooper, scoop balls of crunchies onto the prepared pan. Sprinkle each crunchy with fleur de sel (if using). Transfer the baking sheet to the fridge to chill until set, 15 to 20 minutes. Batwing Crunchies will keep in the fridge for about 2 weeks, but they will be pretty hard once completely chilled, so let them soften for 20 minutes before serving again.

— HINT —

Oil-based and gel food coloring work best for chocolate because liquid or water-based food coloring can make the chocolate seize and become grainy.

CORN PASTA

VIDEO GAME: **Harvest Moon 64** ▪ YEAR: **1999**

DIFFICULTY: ★ BEGINNER	SERVES: 6 TO 8

In this retro farm-simulating RPG, the player can give their harvested crops to various townsfolk, who in turn will give the player a recipe for a meal that features that ingredient. Those recipes are collected in a cookbook, the completeness of which is part of the game's ending criteria. Basil gives the player the recipe for corn pasta after you give him an ear of corn. Fresh basil really does complement corn!

INGREDIENTS

3 ears fresh yellow corn, shucked

4 tablespoons unsalted butter, divided

8 green onions, chopped, whites and greens separated

¼ cup (60 ml) chicken or vegetable stock

2 tablespoons heavy whipping cream or whole milk

1 package (16 ounces/450 g) short pasta (such as orecchiette, conchiglie, fiorelli, or farfalle)

15 leaves fresh basil, chiffonade (see HINT on page 83), plus more for garnish

½ cup (50 g) grated Parmesan cheese, plus more for garnish

2 teaspoons lemon zest

½ teaspoon red pepper flakes (optional)

Salt and ground black pepper, to taste

DIRECTIONS

1. Using a sharp knife, remove the corn kernels from the cobs and set the kernels aside in a bowl. Discard all but one of the hulled cobs.

2. Heat 1 tablespoon of the butter in a large skillet over medium-high heat. Add the white parts of the green onions and a pinch of salt, cook, and stir until tender, 1 to 2 minutes. Add all but ½ cup (85 g) of the corn kernels along with the stock and the reserved corn cob. Simmer until the corn is tender, 3 to 4 minutes. Remove from the heat and remove and discard the cob.

3. Transfer the mixture to a blender. Cover, with the center part of the blender cover removed to let steam escape, and puree until smooth. Add the cream and pulse to combine. Set aside.

4. Bring a large saucepot of well-salted water to a boil. Cook the pasta as the label directs, until just under al dente (see HINT on page 94). Drain the pasta, reserving 1 cup (240 ml) of the hot pasta water.

5. Reheat the large skillet over medium-high heat. Add the remaining 3 tablespoons butter and melt. Once it bubbles, add the reserved corn kernels. Cook until tender, 1 to 2 minutes. Add the corn puree and cook until heated through, about 1 minute.

6. Reduce the heat to medium. Add ¼ cup (60 ml) of the reserved pasta water along with the cooked pasta and toss to coat. Cook for 1 minute. If the sauce is too thick, add more pasta water until the sauce reaches the desired consistency. Remove from heat.

7. Stir in the basil, onion greens, Parmesan cheese, lemon zest, and red pepper flakes (if using). Taste and adjust seasoning if necessary. Transfer to serving bowls and garnish each plate with more basil and grated Parmesan.

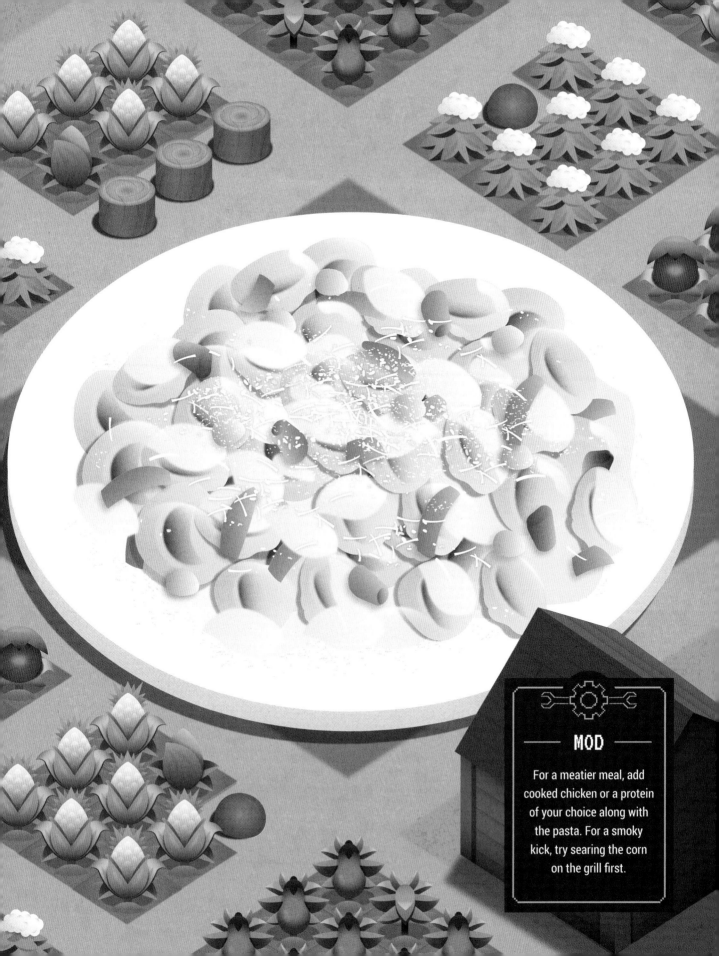

COQ AU VIN

VIDEO GAME: **Deus Ex** ▪ YEAR: **2000**

| DIFFICULTY: ★ ★ NORMAL | SERVES: 4 TO 6 |

Ah, the found recipe. This delightfully food-centric trend is present in *Portal* (2007), *Skyrim* (2011), *The Witcher* (2007), *Dishonored* (2012), and many more titles. For no discernible reason other than apparently funsies, the player finds a hidden note somewhere in the game that contains a workable(-ish) recipe. In *Deus Ex*, a book containing a recipe for coq au vin is found in the Enfant Terrible Café. It's missing some important steps and a few key ingredients. This recipe fills in the blanks without making too many unasked-for augmentations.

INGREDIENTS

BOUQUET GARNI (see HINT)

1 leek

1 small stalk celery

2 bay leaves

6 sprigs thyme

5 sprigs flat-leaf parsley

STEW

1 whole chicken (about 4 pounds/ 1.8 kg), cut into 9 pieces (2 legs, 2 thighs, 2 whole wings, 3 breast pieces)

Salt and ground black pepper, to taste

2 tablespoons unsalted butter, plus more as needed

4 to 6 slices thick-cut bacon, cut into 4-inch (10 cm) pieces

10 ounces (300 g) pearl onions, peeled

12 cremini mushrooms, washed (optional)

4 cloves garlic, minced

1 tablespoon brandy, cognac, or red wine vinegar

1 tablespoon all-purpose flour

¾ cup (180 ml) chicken stock

2 cups (480 ml) dry red wine

1 tablespoon red wine vinegar

Freshly baked bread, for serving

❄ EASY MODE ❄

Buy the chicken pre-cut or have a butcher cut it up for you.

DIRECTIONS

1 **To make the bouquet garni:** Cut the dark green parts off the leek. Slice the white and light green parts and set aside in a bowl. From the dark green parts, reserve two large outer leaves and discard the rest. In the center of one leaf, place the celery, bay leaves, thyme, and parsley. Roll the leek leaf over the pile, then wrap the tube inside the other leek leaf. Tightly tie twine around both ends and the middle of the bouquet garni to secure, making sure the knots are tight enough not to come undone during cooking.

2 **To make the stew:** Pat the chicken pieces dry with paper towels and sprinkle with salt and pepper. Melt the butter in a large skillet over medium-high heat. Add the chicken pieces, in batches, and cook until browned. Add more butter if needed. Use a slotted spoon to transfer the chicken pieces into a large Dutch oven as they brown, and set aside.

3 Add the bacon to the skillet. Cook over medium-high heat until the fat has rendered and the pieces have crisped. Transfer the crisped bacon to a paper towel-lined plate to drain. Keep the bacon fat in the frying pan. Add the reserved white and light green parts of the leek to the pan and cook over medium heat until lightly browned. Add the pearl onions and mushrooms (if using) and cook until the onions are soft and the mushrooms are browned and juicy, 6 to 8 minutes. Sprinkle with salt and pepper. Add the minced garlic and cook until fragrant, 1 minute more. Add the brandy to deglaze the pan, stirring until all the browned bits are loosened from the bottom of the pan. Remove the skillet from the heat.

4 Sprinkle the flour over the chicken in the Dutch oven and stir to coat. Add the stock, bouquet garni, wine, and salt and pepper. Heat the Dutch oven over low heat, bring to a simmer, then cover and simmer for about 30 minutes, until the chicken is just cooked through. Add the cooked vegetables, bacon, and vinegar to the pot and simmer uncovered for another 15 to 20 minutes, until the sauce has thickened to a gravy-like consistency.

5 Degrease the stew: Gently lay a paper towel flat on the surface of the stew, let it absorb any grease, then quickly peel it off. Repeat with more paper towels as needed until the surface is oil-free.

6 Ladle into bowls and serve with freshly baked bread.

—— HINT ——

A bouquet garni, French for "garnished bouquet," is a bundle of herbs, usually secured with string, used for flavoring soups, stews, casseroles, and stocks and removed before serving.

BUTTER CAKE

VIDEO GAME: **Silent Hill 2** · YEAR: **2001**

DIFFICULTY: ★ ★ NORMAL	SERVES: 15 TO 20

Even the tortured manifestations of human guilt like cake and butter! Sometimes an innocuous item, meant to simply add detail to the environment, can take on a life of its own outside the game developer's intention. It has become a fan-made sidequest of sorts to try to locate all the boxes of Butter Cakes in each *SH* game. Hidden in various locations around Silent Hill throughout the series, Butter Cakes have been an insidious and persistent presence in the series . . . perhaps Butter Cakes are the true source of the town's corrupted aura?

INGREDIENTS

BOTTOM LAYER

¾ cup (1½ sticks/170 g) unsalted butter, melted and cooled, plus more for greasing

2½ cups (315 g) all-purpose flour

1 cup (200 g) granulated sugar

½ cup (60 g) almond flour

1 tablespoon baking powder

½ teaspoon kosher salt

2 large eggs

1 teaspoon vanilla paste or extract

1 teaspoon butter flavoring (optional)

1 to 2 tablespoons whole milk, as needed

TOP LAYER

1 package (8 ounces/225 g) cream cheese, softened

2 large eggs, lightly beaten

¼ cup (½ stick/55 g) salted butter, softened

1 teaspoon butter flavoring (optional)

3½ cups (350 g) confectioners' sugar, plus more for dusting

❄ EASY MODE ❄

Cake always tastes better when made from scratch, and you have much more control over the sweetness levels. However, to save time, you can use your favorite boxed yellow cake mix for the bottom layer. Use a handheld electric mixer to beat together the cake mix, 1 egg, and ½ cup (1 stick/115 g) of softened unsalted butter until smooth.

CONTINUE PLAYING ▶

DIRECTIONS

1 Preheat the oven to 350°F (180°C; gas mark 4). Line a 9 x 13-inch (23 x 33 cm) oblong cake pan with parchment paper and grease with butter. Set aside.

2 **To make the bottom layer:** In a food processor fitted with the knife blade, add the flour, sugar, almond flour, baking powder, and salt. Pulse to combine. Add the eggs, vanilla, melted butter, and butter flavoring (if using). Process until a soft, crumbly dough forms. If the dough seems too dry, add 1 to 2 tablespoons of milk.

3 Transfer the dough to the prepared cake pan. Lightly press the dough into the pan so it evenly covers the bottom, but don't pack it down too much. Set aside.

4 **To make the top layer:** In a large bowl, add the cream cheese, eggs, butter, and butter flavoring (if using). Using a handheld electric mixer, beat on low speed until smooth, scraping down the sides of the bowl with a spatula. Continue to beat on low speed and add the confectioners' sugar, about 1 cup (100 g) at a time, and beat until smooth. Scrape the bowl with a rubber spatula and beat one more time to make sure there are no clumps.

5 Pour the cream cheese mixture over the bottom layer in the pan. Bake on the middle rack in the oven for 50 to 60 minutes, until the top is golden and puffed in the center. If the top starts to darken before it puffs up, lay a loose piece of foil over the pan to stop the browning, and continue baking.

6 Remove from the oven and allow the cake to cool completely in the pan. Dust with confectioners' sugar and cut into even square pieces to serve.

—— HINT ——

The bottom layer of this cake has a dense, almost cookie-like texture, so it's normal for the dough to be somewhat crumbly. As long as it holds together when you press it into the pan, it's all good and you probably won't start to hear any ominous radio static.

ELIXIR SOUP

VIDEO GAME: **The Legend of Zelda: The Wind Waker** · YEAR: **2002**

DIFFICULTY: ★ BEGINNER	SERVES: 5 TO 7

In video games, as in life, food can represent love. In *The Wind Waker*, Link's grandmother falls ill and Link must find her a cure. Once his grandmother is revived, as a gesture of love and gratitude, she makes Link his favorite soup. The bright-yellow Elixir Soup restores both Link's magic and health, making it the best consumable in the game, and Link drinks it with a big smile instead of his usual grimace, so this beloved meal must be both nutritious and delicious!

INGREDIENTS

6 tablespoons unsalted butter, divided

1 yellow onion, chopped

4 cloves garlic, minced

2 medium yellow squash (1 pound/450 g), chopped

2 carrots, peeled and chopped

¼ cup (25 g) chopped cauliflower

2 turnips, peeled and chopped

¼ cup (60 ml) fresh lemon juice

1 to 2 tablespoons aji amarillo paste, to taste, or 1 to 2 yellow chili peppers, seeded and finely chopped

4 cups (960 ml) chicken or vegetable stock

1 teaspoon turmeric or yellow food coloring

1 teaspoon lemon zest

Salt and ground black pepper, to taste

Chives, finely chopped, for garnish

DIRECTIONS

1. In a large saucepot over medium heat, melt 2 tablespoons of the butter. Add the onion and cook until it turns translucent, 2 to 3 minutes. Add the garlic and cook until fragrant, about 1 minute more.

2. Add the remaining 4 tablespoons butter, along with the squash, carrots, cauliflower, turnips, lemon juice, aji amarillo, and 2 cups (480 ml) of the stock and bring to a boil. Reduce the heat to low and simmer until the vegetables are very tender, 10 to 15 minutes.

3. Remove the soup from the heat and let cool for about 10 minutes, or until just warm and safe to handle.

4. Carefully pour the soup into a blender, cover, and with the center part of the blender cover removed to let steam escape, puree until smooth. (You can also use an immersion blender directly in the pot.) Return the soup to the pot. Simmer on low heat for 4 to 5 minutes more, adding more stock until you achieve the desired consistency. Stir in the turmeric and lemon zest and sprinkle with salt and pepper. Remove from the heat.

5. Transfer the soup to your serving vessel—preferably a corked glass bottle. Garnish with the chopped chives. Drink with a smile!

POKÉBLOCKS

DIFFICULTY: ★ BEGINNER | YIELD: 60 TO 70 POKÉBLOCKS

Introduced in *Generation III*, Pokéblocks are candy blocks used to prepare Pokémon for battle. These colorful confections marked the series' first foray into the art of cooking. A fairly complex algorithm to determine the flavor and effectiveness of Pokéblocks, it factors in how well the player performs in the cooking minigame and the type of berries used. Berries continue to be an important part of the Pokédiet, used to make Pokéblocks, Poképuffs, poffins, even curry! Whatever the flavor, these colorful cube-shaped confections will bring all the Pokémon to the yard.

INGREDIENTS

½ package (4 ounces/115 g) cream cheese, softened

2 tablespoons salted butter, softened

½ teaspoon vanilla extract

½ teaspoon butter flavoring (optional)

4 to 6 cups (400 to 600 g) confectioners' sugar, plus more for dusting

Liquid or gel food coloring in desired colors

½ teaspoon each of fruit flavorings and extracts (such as strawberry, mango, or lychee)

Sprinkles (optional)

DIRECTIONS

1 Line a baking sheet with wax paper and set aside. In a medium bowl, stir together the softened cream cheese, softened butter, vanilla, and butter flavoring (if using). Stir in 4 cups (400 g) of the confectioners' sugar and add more, a quarter at a time, until a dough forms. (Don't be afraid of adding too much sugar; these are candies!)

2 Divide the dough into separate smaller bowls, one per each food coloring and flavor combination you choose. Add your chosen food coloring and flavor combinations to each one and stir to combine. If the colors and flavors cause the dough to become too wet, add more confectioners' sugar.

3 Wrap all but one bowl in plastic wrap to prevent drying. Dust a clean work surface with confectioners' sugar. Working one dough at a time, roll a palm-sized portion of dough into a long, thin cylinder, about ½ inch (1 cm) thick.

4 Roll the cylinder in the sprinkles (if using). Lay the cylinder on your work surface and use your hands or the flat side of a knife to shape it into a long rectangle, then use a sharp knife or a pizza cutter to slice the rectangle into ½-inch (1 cm) cubes. Transfer the cubes to the prepared baking sheet. Repeat with the remaining dough. Let the candies dry at room temperature until hardened, a few hours or overnight.

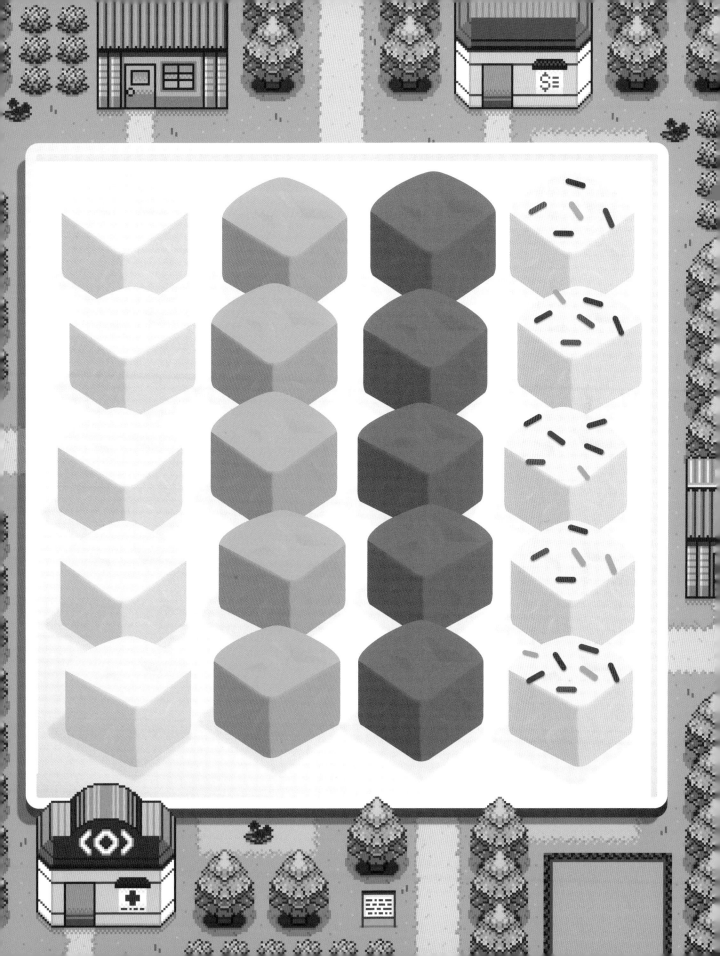

STARKOS

VIDEO GAME: **Beyond Good and Evil** · YEAR: **2003**

DIFFICULTY: ★ ★ ★ EXPERT | YIELD: 20 STARKOS

In this culty Ubisoft title, Jade and her porcine companion, Peyj, uncover a nefarious government conspiracy—and eat a whole bunch of Starkos along the way. Starkos are fairly standard for a healing item, recovering one unit of health for each one eaten. The ubiquitous and entirely synthetic handheld snack, one of only two food items found in the vending machines in Hillys, serves to emphasize the lack of food options on the planet. Starkos look sort of like triangular yellow hand pies and are apparently served with a kind of guacamole, according to those wild *Tonic Trouble* (1999) racetrack commercials. Because Hillys is also a multicultural melting pot, this Starkos is a hybrid of an empanada, a samosa, and a Jamaican patty.

INGREDIENTS

DOUGH

4 cups (500 g) all-purpose flour,
 plus more for dusting

2 teaspoons ground turmeric

1 tablespoon granulated sugar

1 teaspoon kosher salt

1⅓ cups (275 g) lard or shortening

1 tablespoon apple cider vinegar

1 cup (240 ml) ice water

1 large egg, beaten, for washing

FILLING

1 tablespoon unsalted butter

1 carrot, finely chopped

6 green onions, sliced

4 cloves garlic, minced

1 habanero or Scotch bonnet
 chili pepper, seeded and chopped
 (optional)

¾ cup (105 g) raisins or currants
 (optional)

1 pound (450 g) lean ground beef

1 cup (240 ml) beef broth

1 teaspoon chicken bouillon

1 tablespoon ground allspice

2 teaspoons curry powder

2 teaspoons ground cumin

2 teaspoons dried thyme

1 teaspoon garam masala

½ cup (75 g) green olives, chopped

½ cup (50 g) plain dried bread
 crumbs

2 cups (220 g) shredded mozzarella
 cheese

Salt and ground black pepper,
 to taste

GUACAMOLE

3 to 4 ripe avocados,
 pitted and peeled

¼ cup (60 ml) fresh lime juice
 (from 2 limes)

½ teaspoon salt

½ habanero or Scotch bonnet chili
 pepper, seeded and minced

½ red onion, finely diced

1 clove garlic, minced

½ cup (85 g) chopped mango

½ cup (20 g) chopped fresh cilantro

¼ cup (13 g) chopped fresh mint
(optional)

DIRECTIONS

1 **To make the dough:** Sift together the flour, turmeric, sugar, and salt. Add the flour mixture to a food processor fitted with the knife blade, then add the lard in chunks and pulse until the mixture resembles fine crumbs. Add the vinegar and ½ cup (120 ml) of the ice water and pulse until the dough starts to come together. (It's okay if it's not totally holding together yet.)

2 Turn the dough out onto a lightly floured work surface. Work the dough just enough to form a ball. Add more iced water if needed for the dough to hold together, but not so much that it becomes sticky or tacky. Add more flour if it's sticking to your hands. With a floured rolling pin, roll out the dough and form it into a log. Cut the log into 20 equally sized portions, transfer the portions to a baking sheet, and wrap securely with plastic wrap. Place the dough in the refrigerator to rest for 30 minutes to an hour.

3 **Meanwhile, make the filling:** In a large skillet, melt the butter over medium heat. Add the carrot, green onions, garlic, habanero, and raisins (if using). Sauté, stirring occasionally, for 2 to 3 minutes, until the veggies soften somewhat. Add the beef and mix with a wooden spoon, breaking up any large bits. Once the beef has browned, drain the excess fat from the skillet, leaving roughly a tablespoon in the pan. Add the broth, bouillon, allspice, curry powder, cumin, thyme, and garam masala and stir to thoroughly incorporate. Continue cooking over medium heat for 3 to 5 minutes, until the vegetables are soft and the liquid has mostly been absorbed. Stir in the olives and cook for 1 minute more. Taste and adjust seasonings. Remove from the heat and stir in the bread crumbs. Set mixture aside to cool. Once cooled, stir in the cheese.

4 Preheat the oven to 350°F (180°C; gas mark 4). Remove the dough from the refrigerator. With a floured rolling pin, roll out one piece at a time into a 5-inch (13 cm) square about ⅛ inch (3 mm) thick. You can use a knife or a large square cookie cutter to get really precise edges. Add 1 heaping tablespoon of the filling mixture into the center of each square of dough. Fold the dough over the filling to create the triangle shape, leaving a ½-inch (1 cm) border. Wet the edges of the dough with a very small amount of water. Pinch the edges together to seal. Place the Starkos onto a baking sheet lined with parchment paper and brush each with egg wash. Cut a tiny slit in the center of each to vent. Bake for 20 to 25 minutes until crisp and golden. Transfer to a cooling rack and let cool for 10 to 15 minutes.

5 **Meanwhile, make the guacamole:** In a medium bowl, add the avocados, lime juice, and salt and mash with a fork to the desired consistency. Stir in the chili pepper, onion, garlic, mango, cilantro, and mint (if using). Let the flavors mingle for a minute or two before serving with the Starkos.

MOD

If habaneros or Scotch bonnets are too hot for you, replace them with another kind of chili pepper or skip them entirely.

GRILLED CHEESE

VIDEO GAME: **The Sims 2** ▪ YEAR: **2004**

DIFFICULTY: ★ BEGINNER	YIELD: 4 GRILLED CHEESES

It's no shock that food is a big part of this beloved life-simulation series. Sims have a hunger meter that must be kept reasonably full or else they will suffer symptoms ranging from hangry to dead. *The Sims 2* not only introduced a more complex cooking mechanic but also a secret food-centric life aspiration for your Sims: the grilled cheese aspiration! These grilled cheese-obsessed Sims desire nothing but to live, breathe, and eat grilled cheese sandwiches. It's so relatable that you may find yourself wondering, *Am I a grilled cheese Sim?* This sandwich is a perfect middle ground between bougie and basic that won't use up too many simoleons . . . Alas, the motherlode cheat doesn't exist in real life.

INGREDIENTS

½ cup (1 stick/115 g) unsalted butter, softened

2 cloves garlic, minced

1 tablespoon chopped fresh flat-leaf parsley

8 slices shokupan or Texas toast

2 tablespoons grated Parmesan cheese

4 slices sharp cheddar cheese

4 slices Gouda cheese

½ cup (55 g) shredded Gruyère

DIRECTIONS

1 In a small bowl, combine the butter, garlic, and parsley. Spread 1 tablespoon of the butter mixture on 1 side of each slice of bread. Sprinkle each slice with ½ tablespoon of the Parmesan.

2 Heat a small or medium skillet over medium-low heat. Place 1 slice of bread, buttered side down, in the skillet. On the unbuttered side, stack 1 slice each of the cheddar and the Gouda, then sprinkle on 2 tablespoons of the Gruyère. Top with another slice of bread, buttered side facing up.

3 Continue cooking until the bread on the bottom is a rich golden brown, about 3 minutes, then use a spatula to flip the sandwich and press down lightly to help the cheese melt into the bread. Cook until the bottom is also a rich golden brown, another 3 minutes.

4 Transfer the sandwich to a serving plate and cut it in half diagonally before serving. Repeat with the remaining ingredients.

❉ EASY MODE ❉

You can make two sandwiches simultaneously in a larger skillet, but make sure both sandwiches are being cooked evenly when using this shortcut. Wouldn't want to start any kitchen fires!

KOOPASTA

VIDEO GAME: **Paper Mario: The Thousand-Year Door** · YEAR: **2004**

DIFFICULTY: ★ BEGINNER | SERVES: 4

In the *Paper Mario* series, Mario gets a personal chef. The first is a sweet old toad named Tayce T., but in *The Thousand-Year Door*, it's the much less amiable but equally charming Zess T. Zess hasn't forgiven Mario for stepping on her contact lens. Initially, the delightfully grumpy chef can cook only one ingredient at a time—until Mario brings her a very special cookbook. Then, Zess T. can combine two ingredients, elevating the culinary possibilities. One of those dishes is Koopasta, made by combining a "turtley leaf" with a "fresh pasta bunch." It's a green pasta with a leaf on top and is reminiscent of those iconic Mario turtle shells. Make sure to sing "Doodle-de-doo-dah!" while you cook and tell yourself, "Go on, take it, Stompy!" before tucking in.

INGREDIENTS

2 cups (40 g) packed fresh baby spinach, plus 4 leaves for garnish

12 ounces (350 g) capellini, spaghetti, or linguine

½ cup (65 g) shelled raw unsalted pistachios, pepitas, or sunflower seeds

⅓ cup (80 ml) extra-virgin olive oil

2 cloves garlic, chopped

1 small lemon

¾ cup (30 g) chopped mixed fresh green herbs (such as basil, parsley, chives, oregano, or mint)

½ jalapeño or Anaheim chili pepper, seeded and chopped

½ cup (50 g) grated Parmesan cheese, plus more for serving

½ teaspoon red pepper flakes, or to taste (optional)

2 tablespoons unsalted butter

Salt and ground black pepper, to taste

— HINT —

When boiling pasta, the water should be as salty as Zess T.—which is to say, about as salty as ocean water.

CONTINUE PLAYING ▷

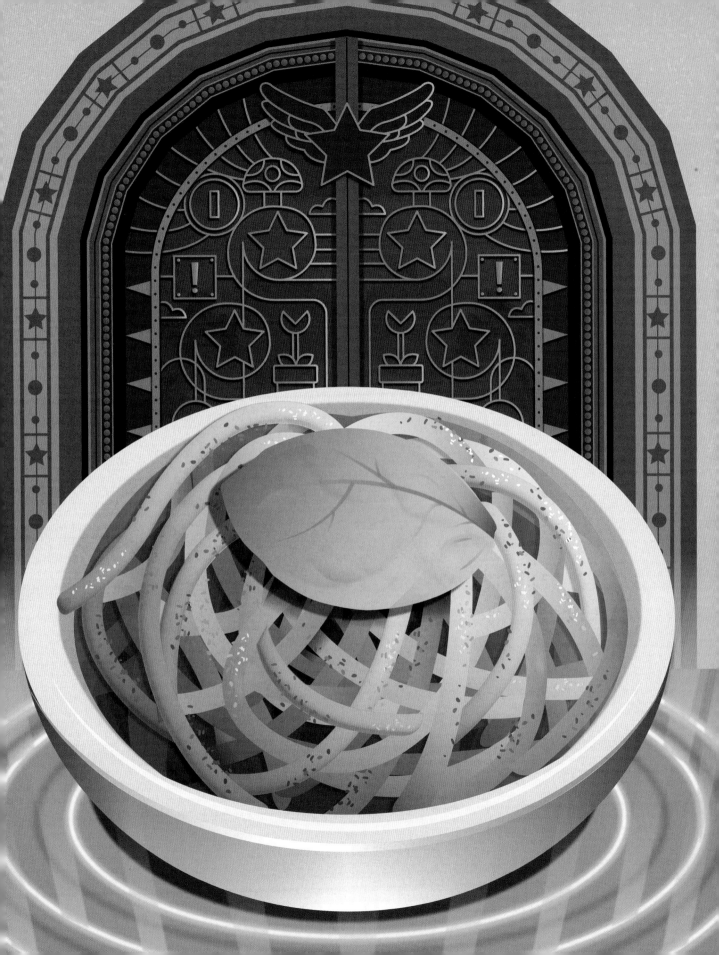

DIRECTIONS

1 Bring a large saucepot of well-salted water to a boil. Add the spinach and blanch until bright green and wilted, about 30 seconds. Keep the water boiling but remove the spinach with a slotted spoon or a pair of tongs and place in a small bowl. Rinse the spinach with cold water and squeeze out as much water as possible. Set the spinach aside. Add the pasta to the boiling water and cook as the label directs, until al dente (see HINT on page 94). Reserve 1 cup (240 ml) of the pasta water and set aside. Drain the pasta and transfer to a large bowl. Set aside.

2 In a blender, add the pistachios, olive oil, garlic, and ⅓ cup (80 ml) of the reserved pasta water and puree until very smooth. From the lemon, grate about 3 teaspoons of zest and squeeze 3 tablespoons of juice. Add the spinach, herbs, chili pepper, Parmesan cheese, red pepper flakes (if using), lemon zest and juice to the blender and puree. If necessary, add 1 tablespoon of pasta water at a time, as needed, until smooth. Season with salt and black pepper.

3 Pour the puree over the cooked pasta and toss to combine. Add the butter and ¼ cup (60 ml) of the reserved pasta water and toss until the butter melts. If the mixture is dry, add more pasta water, 1 tablespoonful at a time, until the pasta is evenly coated with the green sauce.

4 Divide the pasta among the serving bowls. Top with more grated Parmesan and a few grinds of black pepper, if desired. Garnish each serving with a leaf of baby spinach.

MOD

If you're not a fan of spinach, substitute another leafy green, such as kale, sorrel, arugula, or mustard greens. If you do skip the spinach, just use fresh basil for the "turtley leaf" garnish.

SMOKED DESERT DUMPLINGS

VIDEO GAME: **World of Warcraft** ▪ YEAR: **2004**

DIFFICULTY: ★ ★ ★ EXPERT	YIELD: 18 TO 20 DUMPLINGS

Few consumables in vanilla *WoW* sounded quite as scrumptious as Smoked Desert Dumplings. After almost two decades and ten expansions, *WoW* has amassed hundreds of food items with varying degrees of real-world appeal, but Smoked Desert Dumplings remain a stand-out, both in terms of potential real-world deliciousness and in-game usefulness. Players can obtain the recipe for this dish as a reward from the Desert Recipe quest in Cenarion Hold in the contested Silithus region. Eating it will make you nostalgic for the days when Leeroy Jenkins, the Onyxia wipe incident, and Chuck Norris were the hottest topics in Barrens chat.

INGREDIENTS

DUMPLINGS

6 ounces (175 g) ground pork

4 slices thick-cut bacon, finely chopped

1 small egg

2 green onions, finely chopped

1 tablespoon peeled and minced fresh ginger

½ teaspoon sesame oil

1 teaspoon soy sauce

2 teaspoons Shaoxing wine or dry sherry

¼ teaspoon kosher salt

½ teaspoon granulated sugar

¼ teaspoon Chinese five-spice powder

¼ teaspoon ground white pepper

18 to 20 wonton wrappers

SAUCE

3 tablespoons light soy sauce

½ teaspoon mirin

½ cup (120 ml) chili crisp oil

2 teaspoons black vinegar or rice vinegar

1 teaspoon Chinese or Japanese sesame seed paste or tahini

2 teaspoons granulated sugar

4 cloves garlic, minced

Salt and ground white or Szechuan pepper, to taste

TOPPINGS

Pinch of ground Lapsang Souchong tea leaves, smoked sea salt, or smoked paprika (optional)

1 green onion, sliced on a bias

CONTINUE PLAYING ▶

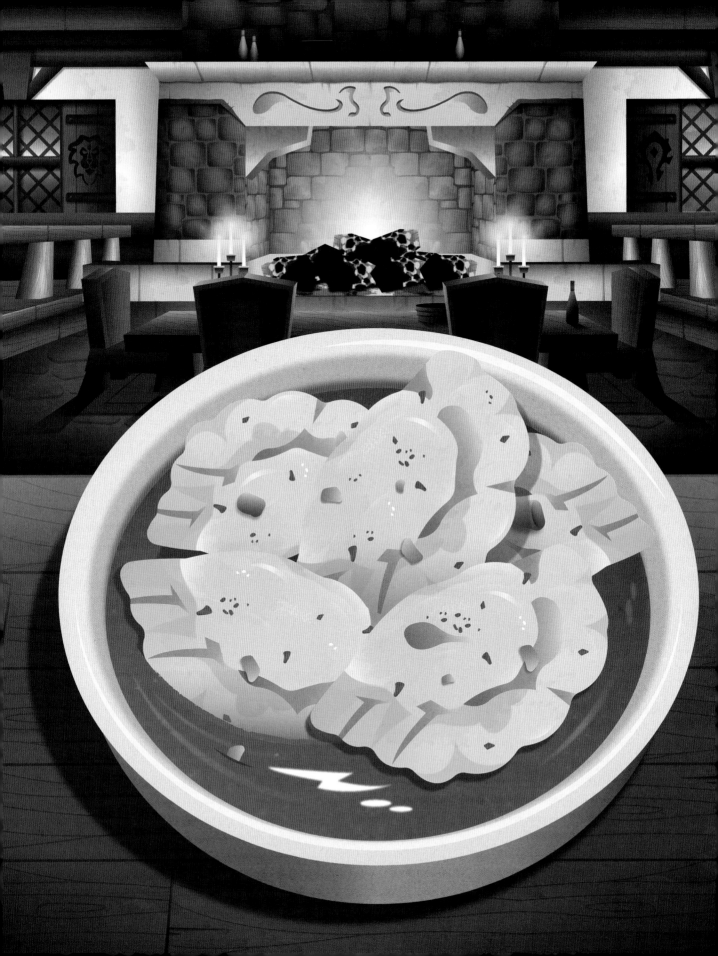

DIRECTIONS

1 **To make the dumplings:** Line a baking sheet with parchment paper and set aside. In a large bowl, combine the ground pork, bacon, egg, green onions, ginger, sesame oil, soy sauce, Shaoxing wine, salt, sugar, five-spice powder, and white pepper to make the filling.

2 Lay 1 wonton wrapper on a clean work surface. Add 2 teaspoons of filling to the center. Dip your fingers in water, then wet the edges of the wrapper. For round wrappers, fold the wrapper in half, forming a half circle around the filling, and press the edges to seal. For square wrappers, fold the sides up to form a pyramid-shaped pouch around the filling, and pinch the edges together to close. Repeat with the remaining filling and wrappers. Transfer the dumplings to the prepared baking sheet. Bring a large saucepot of water to a boil.

3 **Meanwhile, make the sauce:** In a small bowl, combine the soy sauce, mirin, chili crisp oil, vinegar, sesame paste, sugar, garlic, and salt and pepper. Taste and adjust the seasoning. (If you like spicy, add more chili crisp oil.) Set aside.

4 Once the water boils, reduce the heat to a steady low boil and cook the dumplings in batches, stirring continually so they do not stick together, until they float to the top and the wrappers look translucent, about 2 minutes. As the dumplings finish cooking, use a slotted spoon to transfer them to the serving bowls. Add ¼ cup (60 ml) of the hot dumpling water to the sauce and stir to combine.

5 Divide the sauce among the serving bowls, pouring it over the dumplings. Top with the ground Lapsang Souchong leaves (if using) and green onion, and serve!

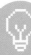

HINT

The less-common ingredients in this recipe, such as black vinegar and Lapsang Souchong, can be found in most Asian grocery stores or online. Black vinegar is made from fermented black sticky rice and may also be called Chinkiang vinegar, black rice vinegar, or dark vinegar. It is sweeter and more malty than regular vinegar. Lapsang Souchong is a kind of black tea that is smoked over a pinewood fire. It has an intense smoky flavor.

PIZZA

VIDEO GAME: **Devil May Cry 3** · YEAR: **2005**

| DIFFICULTY: ★ ★ NORMAL | SERVES: 8 TO 10 |

Some people think pineapple is the ultimate pizza sin, but not the son of Sparda. Pizza was Dante's first companion, and its presence in Dante's shop (and his mouth) has been a constant in the series. If you look closely at the pizza in the first few games, it's topped with pepperoni and what looks like jalapeños or olives—and we know Dante's feelings about olives. This recipe adds some hot honey, because the spicy-sweet thing jibes with Dante's whole vibe. Now you can have your own wacky-woohoo pizza adventures making Dante's pizza from scratch!

INGREDIENTS

SAUCE

1 can (6 ounces/175 g) tomato paste

½ cup (120 ml) room-temperature water

2 teaspoons dried Italian seasoning

½ teaspoon garlic powder

½ teaspoon onion powder

½ teaspoon granulated sugar

½ teaspoon salt

¼ teaspoon ground black pepper

DOUGH

3¼ cups (405 g) all-purpose flour, divided

2 packets (½ ounce/14 g) instant yeast

1½ teaspoon kosher salt

1⅓ cups (320 ml) warm water (120°F/50°C)

1 tablespoon honey

⅓ cup (80 ml) olive oil

TOPPINGS

1½ cups (165 g) shredded mozzarella cheese

½ cup (55 g) shredded medium cheddar cheese

¾ cup (105 g) pepperoni slices

1 jalapeño, thinly sliced, or ⅓ cup (85 g) pickled jalapeños

Hot honey, to taste (optional)

4 leaves fresh basil, chiffonade (optional)

Red pepper flakes, to taste (optional)

✳ EASY MODE ✳

Use premade pizza dough and/or jarred pizza sauce. It's still more economical than takeout!

DIRECTIONS

1 **To make the sauce:** In a medium bowl, combine the tomato paste, water, Italian seasoning, garlic and onion powders, sugar, salt, and pepper. Set aside and let flavors meld.

2 **To make the dough:** Combine 2 cups (250 g) of the flour with the yeast and salt. Add the water, honey, and oil and stir until well combined, about 1 minute. Add the remaining 1¼ cups (155 g) flour slowly, a little at a time, until a soft, sticky ball of dough forms. On a lightly floured surface, knead the dough until it's smooth and elastic. Add more flour, 1 tablespoon at a time, as needed. Transfer the dough to a bowl and let it rest, wrapped in plastic wrap, at room temperature for about 20 minutes, or up to 1 hour.

3 Preheat the oven to 425°F (220°C) and grease two 12-inch (30 cm) pizza pans, or heat two pizza stones or oven-safe skillets. Halve the dough and place one piece in each pan. Use a pastry roller to roll out the dough to fit the pans.

4 Spread half the sauce evenly over each piece of dough using the back of a spoon. Sprinkle each pizza with half of the cheeses, then top with half of the pepperoni and jalapeños. Bake until the crusts are browned and the cheese is bubbly, 15 to 20 minutes, rotating the pans between the upper and lower racks halfway through baking. If the cheese starts to brown before the crust is done, tent the pans with aluminum foil.

5 Remove the pizzas from the oven and let cool for 5 to 10 minutes. Drizzle with the hot honey and sprinkle with basil and red pepper flakes, if desired. Slice the pizzas using a pizza cutter and serve!

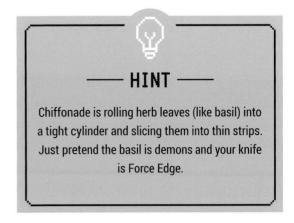

— HINT —

Chiffonade is rolling herb leaves (like basil) into a tight cylinder and slicing them into thin strips. Just pretend the basil is demons and your knife is Force Edge.

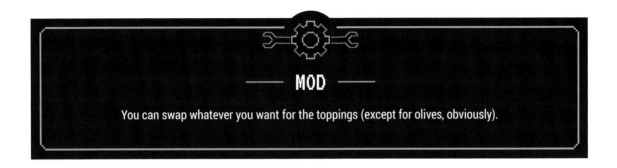

— MOD —

You can swap whatever you want for the toppings (except for olives, obviously).

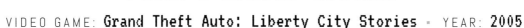

THE FOWL WRAP

VIDEO GAME: **Grand Theft Auto: Liberty City Stories** · YEAR: **2005**

| DIFFICULTY: ★ ★ NORMAL | YIELD: 4 WRAPS |

Like most things in the *GTA* universe, food is used for parody. Fast food was introduced to the *GTA* series in *Vice City* (2002). Since then, some pretty entertaining fast-food items have appeared throughout the years, like the terrifying Heart Stopper burger—an affront to both physics and arteries—and the 2lb Foaming Beef-ish Bazooka found on Taco Bomb's website. The Fowl Wrap, by comparison, seems almost tame. On the menu at Cluckin' Bell, a monstrous hybrid of Taco Bell and KFC, it seems to be some kind of Tex-Mex fried chicken wrap. Now you can really taste the cock!

INGREDIENTS

SPECIAL SAUCE
¼ cup (60 g) mayonnaise

¾ cup (180 g) sour cream

2 chipotle peppers in adobo sauce

1 tablespoon ketchup

1 tablespoon lime juice

1 clove garlic

1 teaspoon granulated sugar

Salt and ground black pepper,
to taste

CHICKEN TENDERS
1½ cups (190 g) all-purpose flour

2 teaspoons taco seasoning

¾ teaspoon kosher salt

½ teaspoon ground black pepper

1 large egg

2 teaspoons hot sauce

2 tablespoons water

1 pound (450 g) chicken tenders

Neutral oil (such as vegetable or
canola oil), for deep-frying

WRAPS AND TOPPINGS
4 large burrito-size flour tortillas

¼ to ½ cup (60 to 120 g) sour cream

1 to 2 cups (55 to 110 g)
shredded lettuce

1 to 2 cups (112 to 224 g) Mexican-
style shredded cheese blend

¼ to ½ cup (45 to 90 g) pico de
gallo or chopped tomatoes

¼ to ½ cup (45 to 90 g) cooked black
beans, rinsed and drained
(optional)

¼ cup (65 g) pickled jalapeños
(optional)

✷ EASY MODE ✷

You can use premade frozen chicken tenders. It won't be as zesty but it'll give the wrap
an "authentic" processed flavor.

CONTINUE PLAYING ▶

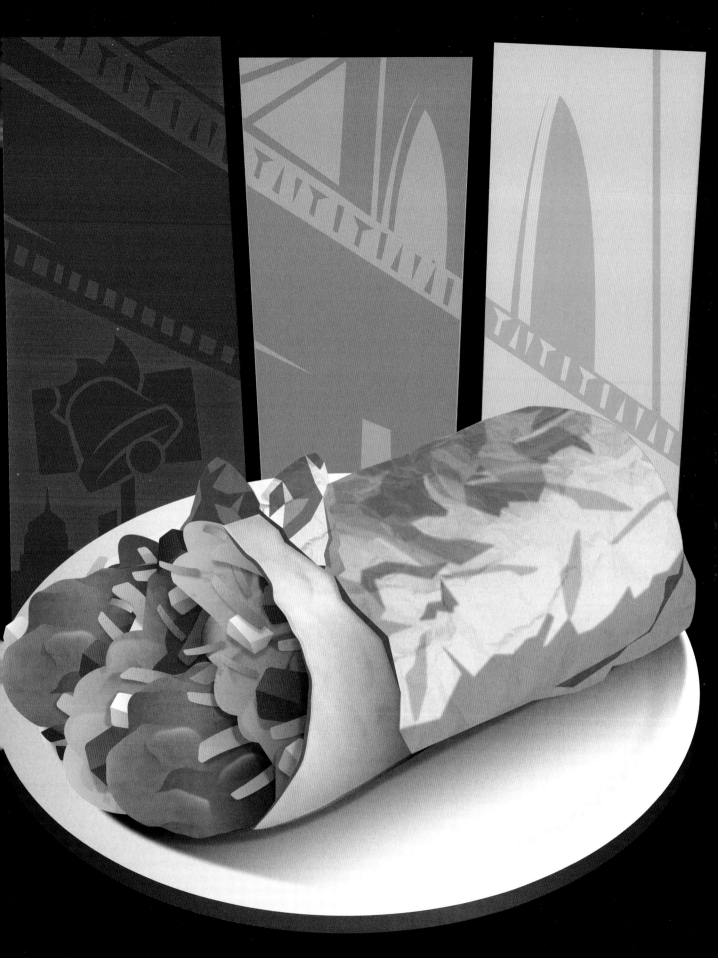

DIRECTIONS

1 **To make the special sauce:** In a small bowl, use a wire whisk to whisk together the mayonnaise, sour cream, chipotle peppers, ketchup, lime juice, garlic, sugar and salt and black pepper until smooth. Set aside.

2 **To make the chicken tenders:** In a large bowl, with a wire whisk, whisk together the flour, taco seasoning, salt, and black pepper. In a medium bowl, with a wire whisk, beat together the egg, hot sauce, and water. Dredge the chicken tenders in the seasoned flour, coating them on all sides and shaking off any excess. Dip the coated chicken tenders in the egg mixture, allowing the egg to drip off. Then dredge the chicken tenders back through the seasoned flour. Set the coated chicken pieces to the side to rest for about 5 minutes.

3 Line a plate with paper towels and set aside. In a deep fryer or heavy-bottomed pot, heat 4 to 6 cups of oil to 365°F (185°C) or until a bit of flour dropped into the oil sizzles immediately. Working in batches of 4 to 5 pieces at a time, cook the chicken tenders, rotating, until all sides are golden brown and the internal temperature of the chicken is at least 165°F (74°C), about 8 minutes. If the outside cooks too fast, reduce the heat. Transfer the pieces as they cook to the prepared plate to drain and cool, 5 to 10 minutes, until safe to touch.

4 **To assemble the wraps:** Warm the tortillas by placing them on a microwave-safe plate and microwaving in 30-second bursts until softened and heated through. Lay 1 heated tortilla on a clean work surface and cover with one-quarter of the special sauce. Add one-quarter of the chicken, followed by one-quarter each of the sour cream, lettuce, cheese, pico de gallo or tomatoes, and beans and jalapeños (if using). Roll the tortilla into a burrito. Repeat with the remaining tortillas, chicken tenders, and toppings. Serve wrapped in parchment paper and/or foil.

MOD

Cook the chicken tenders in an air fryer set to 350°F (180°C) for 13 to 15 minutes on one side, then flip and cook for 10 to 12 minutes on the other side.

SEA SALT ICE CREAM

VIDEO GAME: **Kingdom Hearts II** · YEAR: **2005**

DIFFICULTY: ★ ★ NORMAL	SERVES: 8 TO 12

In *Kingdom Hearts II*, Sea Salt Ice Cream is a symbol of friendship. The perfect combination of salty and sweet, it's a taste of endless summer days in a sleepy seaside town. Enjoy it with your best buddies at twilight! Fun fact: In the 1989 *DuckTales* video game, Scrooge McDuck ate ice cream to restore his health. In *Kingdom Hearts*, Scrooge McDuck tries to re-create the original Sea Salt Ice Cream recipe from his youth. Well, *bless me bagpipes!*

INGREDIENTS

EQUIPMENT
Ice cream maker (optional, see MOD)

Popsicle molds and sticks (optional, for Popsicles only)

ICE CREAM
5 cups (1.2 L) heavy whipping cream

2½ cups (600 ml) whole milk

1 teaspoon vanilla paste or extract

1½ cups (300 g) granulated sugar, divided

Sea salt, to taste (between 1 and 2 teaspoons)

12 large egg yolks

Blue gel food coloring or blue spirulina

Nonstick spray (optional, for Popsicles only)

— MOD —

If you are not using an ice cream maker, place the chilled ice cream base in a frozen stainless-steel bowl and let the mixture sit until the edges start to freeze, 15 to 20 minutes. Use a rubber spatula or whisk to rapidly stir the ice cream, scraping and mixing in the frozen edges. Return the stainless-steel bowl to the freezer. Vigorously stir the ice cream every 30 minutes until it is firm, 4 to 6 times.

CONTINUE PLAYING ▶

STATION

DIRECTIONS

1 In a large saucepot over medium-low heat, combine the cream, milk, vanilla, and 1 cup (200 g) of the sugar and cook at barely a simmer, stirring frequently with a wooden spoon, for about 15 minutes. Stir in the sea salt, ¼ teaspoon at a time, tasting after each addition, until there's a subtle salty aftertaste. Remove the pot from the heat and set aside.

2 In a large bowl, with a handheld electric mixer on the lowest speed or with a wire whisk, lightly beat the egg yolks, then gradually beat in the remaining ½ cup (100 g) sugar until it is completely dissolved and the eggs are thick and pale yellow. Slowly beat in about 4 cups (960 ml) of the hot cream mixture. Once the hot cream has been completely incorporated into the egg yolk mixture, pour it all back into the pot with the rest of the cream. Reduce the heat to low.

3 Add a few drops of the blue food coloring, a little at a time, and stir constantly until the color is right and the ice cream base thickens, about 12 minutes. Make sure not to boil. Transfer the ice cream base to a large bowl. Wrap with plastic wrap and chill in the refrigerator until cold, about 2 hours, or up to overnight.

4 If using an ice cream maker, transfer the chilled ice cream base to your machine and churn as the manufacturer's instructions direct—it should come out like soft serve. Spoon it into a freezerproof container and place in the freezer until ready to serve.

5 For an authentic touch, use the ice cream base to make Popsicles. Just spray the insides of Popsicle molds with nonstick spray and divide the ice cream base between the molds. Add the sticks and freeze for at least 4 hours.

SUPERB SOUP

VIDEO GAME: **The Legend of Zelda: Twilight Princess** • YEAR: **2006**

DIFFICULTY: ★ ★ NORMAL	SERVES: 4 TO 6

Zelda is a good series for soups. In *Twilight Princess*, the puzzle-solving for Snowpeak Ruins incorporates food and cooking. After Yeto locates some very stinky fish for a special soup to heal his sick wife, he sends Link to fetch the other ingredients (a pumpkin and some goat cheese) hidden throughout the dungeon. The soup's flavor and healing powers increase with each ingredient until the soup becomes Superb Soup, a very useful consumable item that heals eight hearts. This recipe pairs Arctic char, a delicate coldwater fish, with kabocha squash (aka Japanese pumpkin) and some fresh chevre.

INGREDIENTS

SOUP

2 pounds (900 g) kabocha squash (about 1 squash) or sugar pumpkin, seeded and quartered

1 white onion, quartered

6 baby carrots

4 cloves garlic, skin on

¼ cup (60 ml) extra-virgin olive oil

1 sprig thyme

½ teaspoon ground cumin

¼ teaspoon hot paprika

4½ cups (1 L) fish, chicken, or vegetable stock, divided

4 ounces (115 g) chevre, plus more for topping (optional)

½ cup (120 ml) heavy whipping cream (optional)

Salt and ground black pepper, to taste

SERVING SUGGESTIONS (OPTIONAL)

2 Arctic char fillets (about 8 ounces/225 g each), skin on

2 tablespoons unsalted butter

1 to 2 tablespoons pepitas

1 sprig flat-leaf parsley, finely chopped

MOD

If you have a smoker, try smoking the Arctic char with your favorite wood (maple, alder, pecan) over indirect heat for about 25 minutes, or until the fish flakes easily when tested.

DIRECTIONS

1 **To make the soup:** Preheat the oven to 350°F (180°C; gas mark 4) and line a baking sheet with parchment paper. In a large bowl, add the squash, onions, carrots, and garlic and toss with the olive oil. Sprinkle with salt and pepper. Arrange the vegetables on the prepared baking sheet. Roast the vegetables until soft and the edges are brown, 30 to 40 minutes. Let cool until safe to touch, about 15 minutes. Peel the garlic and remove and discard the tough skins from the squash. In a large saucepot over medium heat, combine the roasted veggies, thyme, cumin, paprika, and 3 cups (720 ml) of the stock and simmer for 20 to 30 minutes.

2 **Meanwhile, prepare the fish (if using):** Sprinkle the filets with salt and pepper. Melt the butter in a skillet over medium-high heat until it starts to bubble. Place the fillets skin-side down in the skillet and cook, basting periodically with the melted butter, until the skin is crisp and the fish flakes easily, 2 to 3 minutes per side. Transfer the fish to a plate and set aside.

3 Once the vegetables are tender, remove and discard the sprig of thyme. Carefully pour the soup into a blender, cover, and, with the center part of the blender cover removed to let steam escape, blend until smooth. (You can also use an immersion blender directly in the pot.) Blend in the chevre and cream (if using), bit by bit, tasting in between each addition, until the desired flavor is reached. If necessary, thin the soup out with the remaining stock. Taste and adjust the seasoning. Return the blended soup to the pot and reheat to serving temperature, stirring frequently to prevent burning.

4 Serve ladled into shallow bowls, topped with a portion of fish (if using) and garnished with pepitas, parsley, and more chevre, if desired. Alternatively, serve just the soup ladled into glass bottles.

❋ EASY MODE ❋

If you don't want to bother with breaking down a squash or pumpkin, you can make this soup with 1 can (15 ounces/425 g) of pumpkin puree instead. Add it to the blender along with the roasted veggies.

SPAGHETTI NEAPOLITAN

VIDEO GAME: **Cooking Mama** ▪ YEAR: **2006**

DIFFICULTY: ★ BEGINNER | SERVES: 2 OR 3

At some point, food and video games had become so intertwined that an entire video game genre was born: The cooking simulator. The big mama of cooking simulators, *Cooking Mama*, was first released for Nintendo DS in March 2006. One of the many intriguing dishes you could make in this game was Spaghetti Neapolitan, which has made other notable appearances in the *Castlevania* and *Harvest Moon* series. Neapolitan is a Japanese *yōshoku* (Western-style) dish that combines a ketchup-based sauce with salty smoked meats, onions, peppers, hot pepper sauce, and grated Parmesan cheese. The ingredient list may sound a bit off-putting to some Western palates, but when everything is combined it all just . . . works. So, give it your best effort!

INGREDIENTS

8 ounces (225 g) spaghetti

4 slices thick-cut bacon, chopped

½ cup (70 g) sliced Kurobuta smoked sausages, kielbasa, or all-beef hot dogs

½ small yellow onion, sliced

2 cloves garlic, minced

1 green bell pepper, seeded and sliced

8 button mushrooms, sliced

⅔ cup (165 ml) ketchup

2 tablespoons soy sauce

1 tablespoon unsalted butter

Salt and ground black pepper, to taste

Hot pepper sauce, to taste (optional)

Grated Parmesan cheese, to taste

Flat-leaf parsley, chopped, for garnish (optional)

— MOD —

Not everyone likes the idea of ketchup and pasta together. If that makes this recipe a no-go for you, replace the ketchup with your favorite tomato-based pasta sauce. Or, try the tomato sauce on page 134.

CONTINUE PLAYING ▶

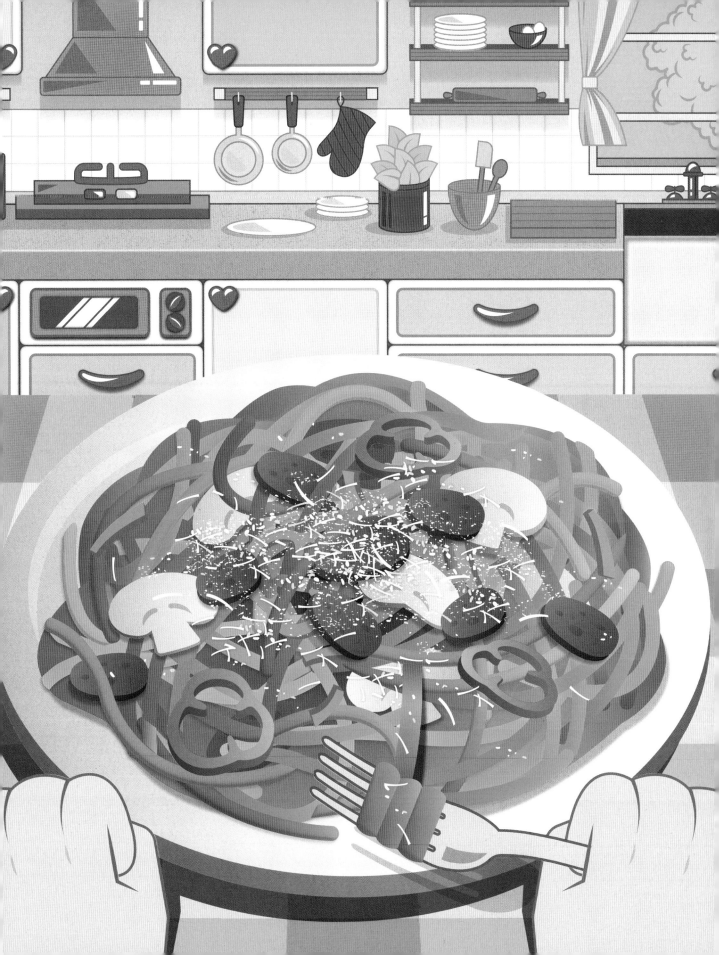

DIRECTIONS

1. Bring a large saucepot of well-salted water to a boil. Cook the pasta according to the package directions until its slightly underdone (see HINT) and reserve about ½ cup (120 ml) of the pasta cooking water.

2. While the pasta cooks, prepare the sauce: Heat a large skillet over medium heat and add the bacon and sausage. Cook until the bacon starts to render out some fat. Add the onion, garlic, green pepper, and mushrooms and sauté until the vegetables start to brown, 2 to 3 minutes.

3. Add the ketchup and soy sauce and give everything a quick stir, then add ¼ cup (60 ml) of the reserved pasta water. Let the sauce cook for 1 minute, then add the butter and sprinkle with salt and black pepper to taste, stirring until butter melts into the sauce.

4. Once the spaghetti is done, use tongs to transfer it directly to the sauce. Stir and cook for another 2 to 3 minutes to let the flavors meld. If the sauce is too thick and the noodles stick together, don't worry—Mama will help! Add a bit more of the pasta water to loosen the sauce.

5. Divide the Spaghetti Neapolitan between the serving dishes. Drizzle with hot pepper sauce (if using) and top with grated Parmesan. Garnish with parsley, if desired.

—— HINT ——

Here's a little tip from Mama: You can tell how done your pasta is by removing a noodle from the boiling water, biting into it (once it cools a little), and examining the cross-section.

For slightly underdone pasta, you should see a thin white ring around darker, uncooked pasta in the center. That's perfect for this recipe, because the pasta is simmered in the sauce for a few minutes after it boils, cooking it to al dente.

For al dente pasta, you should see a solid white dot in the center of your bitten noodle. That means it's soft on the outside but still has some bite, or chew.

SANDVICH

VIDEO GAME: **Team Fortress 2** • YEAR: **2007**

DIFFICULTY: ★ BEGINNER	YIELD: 2 SANDVICHES

It's pretty unusual to see food used as a weapon. The Sandvich, aka the Sandvich Edible Device, is a secondary weapon for the Heavy, one of the nine playable characters in *TF2*. The Sandvich contains lettuce, tomatoes, Swiss cheese, and a few slices each of ham and bologna between two slices of bread, cut diagonally and adorned with a pimento-stuffed olive on a toothpick. Enjoy one for lunch then hype yourself up for the rest of the day by saying "I am full of Sandvich, and I am coming for you!"

INGREDIENTS

1 tablespoon mayonnaise or
 sandwich spread (optional)

4 teaspoons Dijon mustard (optional)

2 slices sandwich bread

4 slices Black Forest ham

3 slices mortadella

3 slices Swiss cheese

4 thin slices beefsteak tomato

2 leaves iceberg lettuce

2 pimento-stuffed olives

DIRECTIONS

1 Spread mayonnaise and mustard (if using) evenly over one side of each slice of bread. On top of one slice, pile the ham slices, folding as needed to prevent too much spillage. Layer on the mortadella slices and Swiss cheese, followed by the tomato slices and lettuce. Top with the other slice of bread, condiment-side down, and align it with the bottom slice.

2 Cut the sandwich in half diagonally. Pierce each sandwich half through the center with a toothpick, then skewer an olive horizontally on each toothpick. Serve the sandwich halves separately to create two Sandviches.

— HINT —

Mortadella is an Italian luncheon meat that originated in Bologna, Italy. The American version derived from it is called bologna. It's fine to use American-style bologna (or even olive loaf) in this recipe. Whichever luncheon meat you choose, it will be the perfect fuel for killing tiny cowards!

THE CAKE

VIDEO GAME: **Portal** ▪ YEAR: **2007**

DIFFICULTY: ★ ★ ★ EXPERT	SERVES: 10 TO 12

Memorable food moments in puzzle platformers are rare indeed, but *Portal* was anything but predictable. This delicious, moist Black Forest cake was the reward that GlaDOS—a diabolical and sadistic AI—dangled in front of its many ~~victims~~ test subjects as they navigated increasingly deadly obstacle courses "for science." No one could have predicted how the phrase "the cake is a lie" would become such a phenomenon that it transcended video game memedom and is now used casually, even by non-gamers, to say that a promised reward is unattainable or fictitious. Don't be intimidated by the length of the recipe; it's not nearly as difficult as destroying your weighted companion cube, you heartless monster! In this cookbook, the cake is the truth.

INGREDIENTS

CAKE

1⅔ cups (205 g) all-purpose flour

1 cup (95 g) cocoa powder

1½ teaspoons baking soda

1 teaspoon kosher salt

½ cup (1 stick/115 g) unsalted butter, at room temperature

1½ cups (300 g) granulated sugar

2 large eggs

1 teaspoon vanilla paste or extract

1½ cups (360 ml) buttermilk

½ cup (120 ml) Kirschwasser, cherry liqueur, or juice

FILLING AND FROSTING

4 cups (960 ml) heavy whipping cream

½ cup (50 g) confectioners' sugar

¼ cup (22 g) cocoa powder

2 cans (29 ounces/850 g) pitted red tart cherries, drained

DECORATION

2 large semisweet chocolate bars (4 ounces/115 g each), frozen

8 maraschino cherries, stems removed

1 white birthday candle

Gloves (to use while decorating)

❄ EASY MODE ❄

Substitute chocolate sprinkles for the chocolate shavings to create a textured effect.
I'm not going to lie (unlike a certain Genetic Lifeform and Disk Operating System we both know):
you'll lose out on some flavor, but it makes decorating a piece of cake!

CONTINUE PLAYING ▶

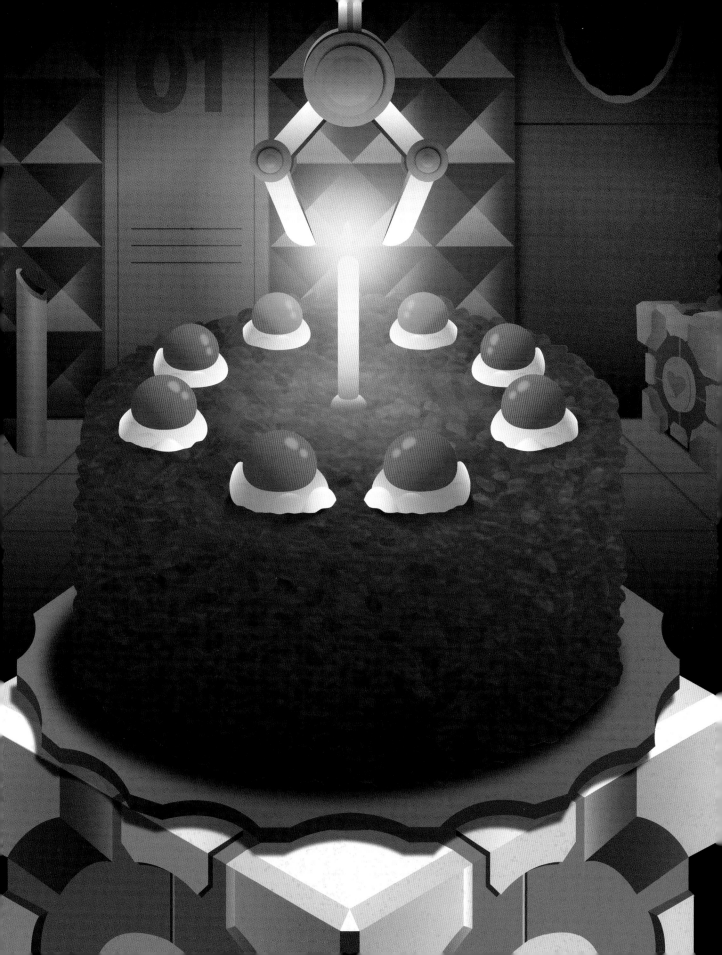

DIRECTIONS

1 **To make the cake:** Preheat the oven to 350°F (180°C; gas mark 4). Grease and flour two 8-inch (20 cm) cake pans and set aside. In a medium bowl, sift together the flour, cocoa, baking soda, and salt. Set aside.

2 In a stand mixer fitted with the paddle attachment or in a large bowl with a handheld electric mixer, cream together the butter and sugar on high speed until light and fluffy. Beat in the eggs and vanilla. Turn the speed to low and alternate adding the flour mixture and buttermilk, ½ cup (120 ml) at a time, until fully incorporated.

3 Pour the batter into the prepared cake pans. Bake until a toothpick inserted in the center of the cakes comes out clean, 35 to 40 minutes. Let the cakes cool in the pans for 10 minutes before turning them out onto plates and placing them in the fridge to cool completely, about 1 hour.

4 Once cooled, remove the cakes from the fridge. Use a serrated bread knife or cake leveler to level the cakes, then cut them in half horizontally, to make four total cake layers. Sprinkle the Kirschwasser evenly over the cut sides of the layers.

5 **To make the filling and frosting:** In a stand mixer fitted with the whisk attachment or in a large bowl with a handheld electric mixer, whip the cream and confectioners' sugar until stiff peaks form. Set aside about one-quarter of this whipped cream for decorating and place in the refrigerator until needed. Mix the cocoa powder into the larger portion of whipped cream until just combined.

6 **To assemble the cake:** Place 1 cake layer on a serving platter or cake stand. Using an icing spatula, spread about one-sixth (about 1 cup/240 ml) of the chocolate whipped cream evenly over the top of the cake layer and scatter with about one-third of the cherries. Top with a second cake layer and spread about one-sixth of the chocolate whipped cream evenly over the top and scatter with one-third of the cherries. Add the third cake layer and spread one-sixth of the whipped cream evenly on top of that and scatter with the remaining cherries. Top with the fourth cake layer. Spread the remaining chocolate whipped cream over the top and sides of the cake.

7 To decorate, use a vegetable peeler or the large side of a grater to grate the frozen chocolate into shavings. Using gloved hands, gently pat the chocolate shavings onto the sides and top of the cake, coating completely.

8 Fill a piping bag fitted with the star attachment with the reserved whipped cream. Pipe eight small dollops around the top rim of the cake and place a maraschino cherry on each. Place a white candle in the center and light. Congratulations, you have made the cake a reality!

CREME-FILLED CAKE

VIDEO GAME: **BioShock** ▪ YEAR: **2007**

DIFFICULTY: ★ ★ NORMAL	YIELD: 10 CAKES

BioShock's treacherous but beautiful underwater city held many secrets, surprises, and snacks! As in post-Apocalyptic series like *The Last of Us* and *Fallout*, players found themselves dumpster diving through dystopia. Or, in this case, a fool's paradise. Just like the characters in *Streets of Rage*, Jack is no stranger to authentic trash can cuisine. Most of the food options in *BioShock* are highly processed snack foods with a long shelf life. So it's no coincidence the creme-filled cakes bear an undeniable resemblance to Twinkies, notorious for their nearly supernatural shelf stability. This recipe is a fresh take on those addictive snack cakes. Thanks, Mom!

INGREDIENTS

EQUIPMENT
Canoe pan (optional, see HINT
on page 101)

CAKES
2 cups (260 g) cake flour

1¼ cups (250 g) granulated sugar

1 tablespoon baking powder

1 teaspoon kosher salt

½ cup (1 stick/115 g) unsalted butter,
softened

1 cup (240 ml) whole milk

1 teaspoon vanilla paste or extract

2 medium eggs

CHOCOLATE CREME FILLING
1 jar (7 ounces/200 g)
marshmallow creme

⅓ cup (35 g) confectioners' sugar

⅓ cup (30 g) cocoa powder

½ cup (1 stick/115 g) unsalted butter
or shortening

1 teaspoon vanilla paste or extract

1 tablespoon sweetened
condensed milk

¼ teaspoon kosher salt

DECORATION
1 tube white decorator icing

CONTINUE PLAYING ▶

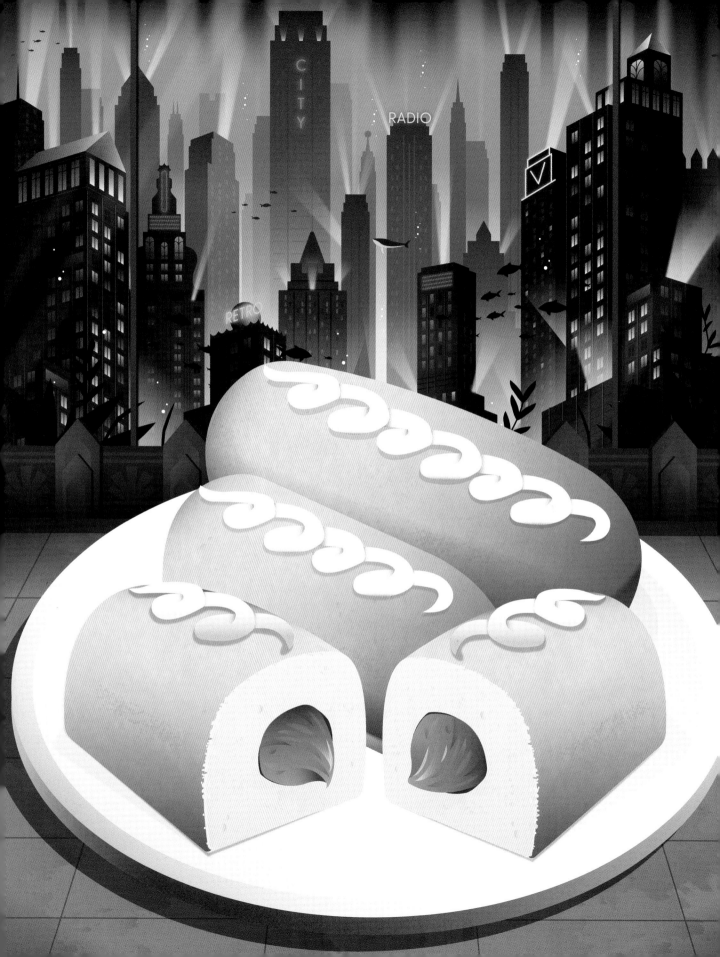

DIRECTIONS

1. **To make the cakes:** Preheat the oven to 350°F (180°C; gas mark 4). In the bowl of a stand mixer or in a large bowl, sift together the flour, sugar, baking powder, and salt. Add the butter, milk, and vanilla. Using the stand mixer or a handheld electric mixer, beat for 3 to 4 minutes, until smooth and somewhat bubbly. Add the eggs, one at a time, and beat for 3 minutes more.

2. Spray a canoe pan or cylinder cake mold with nonstick spray. Divide the batter evenly into the molds, filling them about three-fourths full. Bake the cakes for about 30 minutes, or until a toothpick inserted in the center comes out clean. Let the cakes cool in the molds for 10 minutes, then remove and transfer to a wire rack to cool completely.

3. **To make the chocolate creme filling:** In the bowl of a stand mixer or in a large bowl using a handheld electric mixer, combine all the filling ingredients and beat on high speed for 2 to 3 minutes, until light and fluffy.

4. Transfer the filling to a piping bag with a narrow attachment. Using a chopstick, evenly poke three holes into the bottom of one of the cakes. Sort of swish the chopstick around in the cake to create more room for the filling. Pipe the chocolate filling into each hole. Repeat this process for each cake.

5. When all cakes are filled, attach a narrow frosting piper onto the tube of white decorative frosting. Draw squiggles on the top of each cake. Stuff all the cakes into your mouth immediately.

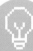

— HINT —

If you don't have a canoe pan, you can make cylinder cake molds with aluminum foil.
Tear out a 12-inch (30 cm) long sheet of aluminum foil. Fold it once lengthwise and then once crosswise.
Place a spice jar in the center and wrap the aluminum foil around it, tucking in the ends to create a
trough-like shape. Make sure the tops are open so you can pour in your batter. Remove the spice jar.
Repeat the process until you have 10 of these.

BLANCMANGE

VIDEO GAME: **Odin Sphere** · YEAR: **2007**

DIFFICULTY: ★ ★ NORMAL	SERVES: 4 TO 6

Vanillaware always takes great care in creating lush, succulent dishes that you want to pull out of the screen and shove in your mouth. It's not all looks, either. In *Odin Sphere*, the quickest and surest way to increase your characters' hit points is cooking and eating food. The cuisine of *Odin Sphere* (including in the acclaimed Leifthrasir remake) has a heavy French influence, and at Rabbit Café players can indulge in sweet confections like blancmange, a luscious and creamy vanilla-flavored dessert typically served with fruit.

INGREDIENTS

BLANCMANGE

4 cups (960 ml) whole milk, divided

½ cup (65 g) cornstarch

½ cup (100 g) granulated sugar, or to taste

2 teaspoons vanilla paste or extract

½ cup (120 ml) heavy cream

COULIS

12 ounces (about 2½ cups/350 g) frozen raspberries, thawed

½ cup (100 g) granulated sugar

¼ cup (60 ml) apple juice

2 tablespoons Chambord (optional)

⅛ teaspoon rose water (optional)

GARNISH

Fresh raspberries

Mint leaves

DIRECTIONS

1 **To make the blancmange:** Place 4 to 6 small individual ceramic, glass, or porcelain ramekins, dessert cups, or similar molds on a tray or baking sheet and set aside. In a small bowl, use a wire whisk to whisk 1 cup (240 ml) of the milk with the cornstarch to form a slurry. Whisk in the sugar and vanilla. Set aside.

2 In a medium saucepan over medium-low heat, heat the cream and the remaining 3 cups (720 ml) milk until steaming. Reduce the heat to low and whisk the cornstarch mixture into the warm milk. Bring to a low simmer. Continue to cook, whisking constantly, until it thickens into a custard-like consistency, 5 to 7 minutes. Divide the custard evenly among the ramekins and let cool to room temperature, about 1 hour, then refrigerate for at least 4 hours, until cold and set.

3 **To make the coulis:** Add all the ingredients to a medium saucepan and bring to a boil on medium-high heat, stirring often. Reduce heat to medium and simmer, stirring frequently, until the sauce reduces by half, 10 to 15 minutes. Remove from the heat and let cool at room temperature for 5 to 10 minutes. Set a mesh strainer over a bowl and strain, scraping and pushing the sauce with a wooden spoon to remove the raspberry seeds. Discard the seeds left in the strainer. Let the sauce cool in the fridge until serving time.

4 Once the blancmange has set, remove them from the molds. To loosen the custard enough to release from the molds, you can dip (but do not submerge) the molds in hot or boiling water for 1 minute to warm the container enough for the blancmange to release. Turn the blancmange out onto the center of the serving plates. Pour the sauce around the base and garnish with fresh raspberries and mint leaves.

CHILI DOG

VIDEO GAME: **Sonic Unleashed** · YEAR: **2008**

| DIFFICULTY: ★ BEGINNER | SERVES: 6 TO 8 |

If you're experiencing a bit of the Mandela effect seeing this one so late in the timeline, you're probably not alone. Our favorite blue hedgehog's love for Chili Dogs was well-established in the comics and the '90s cartoon series long before a single Chili Dog appeared in any of the video games. It wasn't until *Sonic Unleashed* in 2008 that Sonic's Chili Dog obsession was incorporated into the canon of the games.

INGREDIENTS

CHILI SAUCE

1 tablespoon olive oil

1 small yellow onion, finely chopped

1 pound (450 g) 90% lean
 ground beef

1 tablespoon tomato paste

1 tablespoon chili powder

2 teaspoons onion powder

1½ teaspoons garlic powder

½ teaspoon ground cumin

Pinch of cayenne pepper (optional)

1 can (15 ounces/425 g)
 tomato sauce

Salt and ground black pepper,
 to taste

HOT DOGS

8 all-beef jumbo hot dogs

8 hot dog buns, sliced in half

Grated cheddar cheese, for topping
 (optional)

Pickled jalapeños, for topping
 (optional)

Green or red onions, finely chopped,
 for topping (optional)

DIRECTIONS

1. **To make the chili sauce:** In a large skillet, heat the oil over medium-high heat until it shimmers. Add the chopped onion and cook until soft and translucent, 2 to 3 minutes. Add the ground beef and cook until it is browned, breaking up any large pieces, about 8 minutes. Drain the excess fat, if necessary. Stir in the tomato paste; chili, onion, and garlic powders; cumin; and cayenne (if using) until thoroughly combined. Cook for 2 minutes, then stir in the tomato sauce. Reduce the heat to low and simmer for 10 to 12 minutes to let the flavors meld. Taste and adjust seasoning.

2. **Meanwhile, cook the hot dogs:** Heat a grill to medium-high heat. Place the hot dogs on the grates and grill, turning once, until well-marked and heated through, about 2 minutes per side. Turn the heat off and heat the buns on the warm grill until lightly toasted, about 2 minutes.

3. To serve, place the hot dogs in the buns and smother them with the chili sauce. Top with cheddar cheese, pickled jalapeños, and green or red onions, if desired.

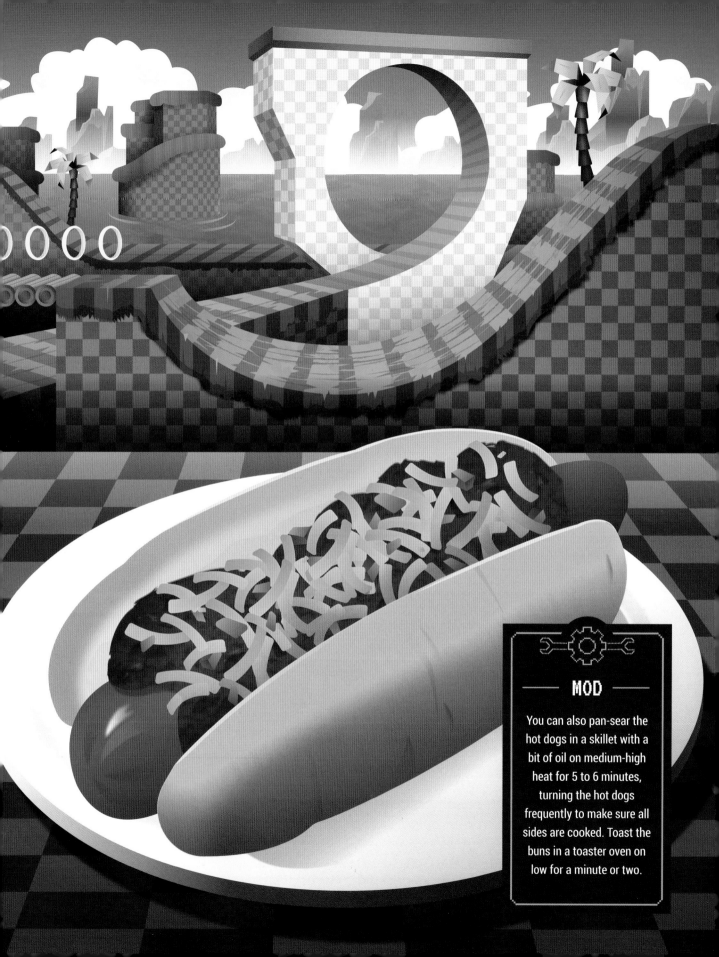

MOD

You can also pan-sear the hot dogs in a skillet with a bit of oil on medium-high heat for 5 to 6 minutes, turning the hot dogs frequently to make sure all sides are cooked. Toast the buns in a toaster oven on low for a minute or two.

MABO CURRY

VIDEO GAME: **Tales of Vesperia** · YEAR: **2008**

DIFFICULTY: ★ BEGINNER	SERVES: 4 TO 6

Cooking has been a major part of the *Tales* series since the very beginning. *Tales of Eternia* (2000) saw the introduction of the Wonder Chef, an eccentric character who disguises himself as inanimate objects and bestows his culinary secrets on whoever happens to find him. Both *Tales of Symphonia* (2003) and *Tales of Vesperia* (2008) made cooking an important part of character development and party dynamics, integrating it into the leveling system itself. Mabo Curry is a dish that reappears frequently throughout the *Tales* series. Seemingly, it's based on mapo tofu, a Szechuan dish that is wonderfully rich and flavorful on its own, but Mabo Curry gets an extra sonic thrust of deliciousness from curry spices. Just don't let your dog do the cooking!

INGREDIENTS

1 cup (240 ml) prepared dashi stock or chicken or vegetable stock

¼ cup (60 ml) doubanjiang (fermented broad bean paste)

¼ cup (60 ml) Shaoxing wine or dry sherry

2 tablespoons oyster sauce

¼ cup (60 ml) chili crisp oil

2 tablespoons mirin or honey

3 tablespoons potato starch or cornstarch

½ teaspoon salt, divided

1 package (12 to 16 ounces/350 to 450 g) firm silken tofu, drained and cut into large bite-size cubes

1 pound (450 g) ground pork or beef

8 green onions, sliced on a bias, greens and whites separated

2 tablespoons peeled and minced fresh ginger

8 cloves garlic, minced

2 tablespoons toasted sesame oil, or to taste

2 tablespoons soy sauce, or to taste (optional)

¼ cup (30 g) curry powder (I prefer S&B brand)

1 tablespoon garam masala (optional)

2 teaspoons ground Szechuan peppercorns, plus more for garnish

Cooked rice or long noodles (such as udon, ramen, or spaghetti), for serving

— HINT —

You can find the less common ingredients in this recipe at most Asian grocery stores or online. Doubanjiang can also be called tobanjiang, fermented chili bean paste, or broad bean chili paste. It has a rich and complex salty-sweet flavor sauce and is the backbone of many beloved Sichuan dishes.

DIRECTIONS

1 In a small bowl, use a metal whisk to whisk together 3 cups (720 ml) water with the prepared dashi stock, doubanjiang, Shaoxing wine, oyster sauce, chili crisp oil, mirin or honey, and potato starch. Set aside.

2 Prepare the tofu. Bring a medium saucepot of water to a boil over high heat and add ¼ teaspoon of the salt. Reduce the heat to low, add the tofu, and simmer for 2 minutes. Remove the pot from the heat and let the tofu soak in the hot water while you prepare the rest of the dish, 10 to 15 minutes.

3 Heat a wok or large skillet over medium-high heat. Add the ground pork or beef and cook until well browned, about 5 minutes, breaking up any large pieces. Add the green onion whites, ginger, garlic, sesame oil and soy sauce (if using). Stir and cook for 1 minute more.

4 Pour in the doubanjiang mixture and bring to a boil until thickened, 8 to 10 minutes. Drain the tofu cubes. Add the curry powder, garam masala, ground Szechuan peppercorns, and prepared tofu. Stir gently to avoid breaking the tofu. Reduce the heat to low and cook until the tofu is heated through and the flavors meld, another 3 to 5 minutes.

5 Serve over cooked rice or noodles. Garnish with the remaining green onions and more ground Szechuan peppercorns.

MOD

To make this recipe vegetarian or vegan, replace the ground meat with finely chopped mushrooms and/or vegan ground meat, use veggie stock instead of dashi, and replace the oyster sauce with vegetarian oyster sauce or soy sauce.

GREASY PROSPECTOR PORK AND BEANS

VIDEO GAME: **Fallout 3** ▪ YEAR: **2008**

| DIFFICULTY: ★ BEGINNER | SERVES: 8 |

In the barren nuclear wasteland of the *Fallout* series, Nuka Cola is king. But it's not the only product in the *Fallout* universe that managed to retain brand-recognition two hundred years post-Apocalypse. In *Fallout 3* and *Fallout: New Vegas*, the player can find cans of Greasy Prospector Pork and Beans. It's deliciously non-radioactive and contains "Hickory Smoked Pig Fat Chunks." *Mmmm*, pig fat chunks. This version utilizes some Nuka Cola to add sweetness and depth of flavor.

INGREDIENTS

8 slices thick-sliced hickory-smoked bacon

1 large yellow onion, diced

2 cloves garlic, minced

1 can (15½ ounces/450 g) white kidney beans (cannellini) with their liquid

2 cans (31 ounces/850 g) great northern beans, rinsed and drained

1 can (15½ ounces/450 g) dark red kidney beans, rinsed and drained

1 can (14½ ounces/410 g) diced tomatoes, drained

¾ cup (180 ml) cola

¼ cup (55 g) packed dark brown sugar

¼ cup (60 ml) molasses

¼ cup (60 ml) ketchup

2 tablespoons Worcestershire sauce

1 tablespoon Dijon or spicy brown mustard

1 bay leaf

1 teaspoon apple cider vinegar

1 teaspoon smoked paprika

½ teaspoon liquid smoke (optional)

Pinch of cayenne (optional)

Salt and ground black pepper, to taste

CONTINUE PLAYING ▶

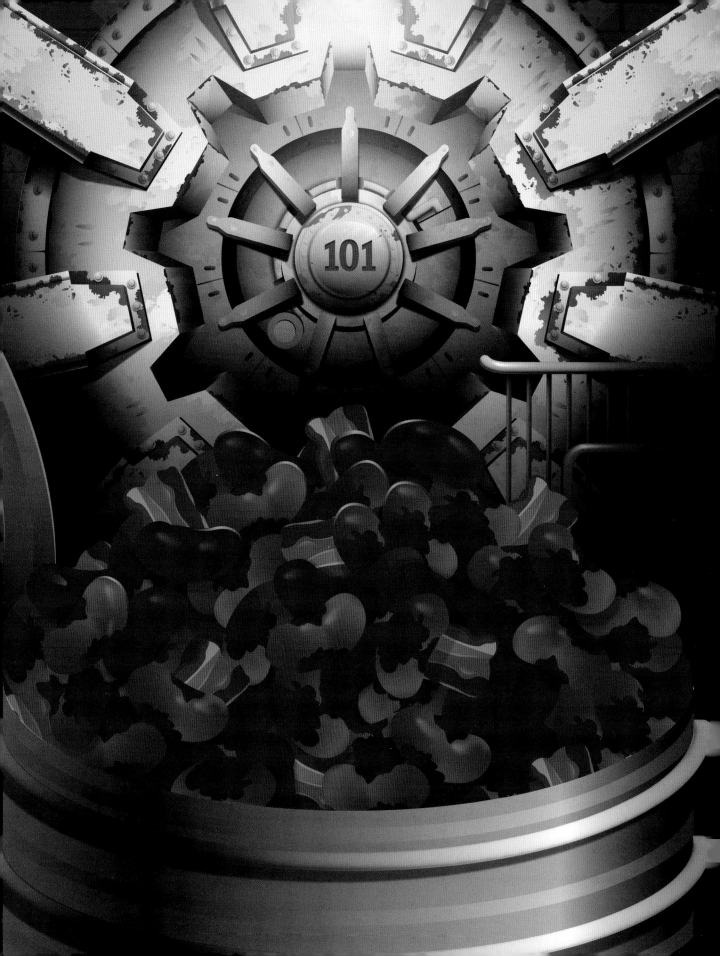

DIRECTIONS

1 Preheat the oven to 375°F (190°C; gas mark 5). In a Dutch oven or a large oven-safe skillet, cook the bacon over medium-high heat until crisp and golden. Remove the bacon and set aside on paper towels to drain. Drain all but 2 tablespoons of bacon fat from the pan and return to the heat. Add the onion and sauté, stirring occasionally, until the onion is lightly browned, 4 to 5 minutes. Add the garlic and cook until fragrant, 1 minute more. Crumble the cooked bacon into the pan and add the rest of the ingredients. Stir to combine.

2 Cover the Dutch oven and transfer to the oven. Bake until the liquid has reduced to a thick sauce that coats the beans, about 1 hour. If there's still too much liquid after 1 hour, remove the lid and bake, uncovered, stirring every 5 to 10 minutes, until reduced. Remove from the oven. Remove and discard the bay leaf. Taste and adjust seasoning. Serve hot in empty, unlabeled cans.

MOD

If you're particularly adventurous, substitute the bacon with a can of hickory smoke–flavored CRAM, or SPAM. Chop it into bite-size pieces and follow the steps for the bacon.

PORO-SNAX

VIDEO GAME: **League of Legends** · YEAR: **2009**

| DIFFICULTY: ★ ★ NORMAL | YIELD: 10 PORO-SNAX |

A quick shout-out to everyone who ever sampled a doggy treat as a child. Sometimes the most intriguing consumables are not meant for the playable characters to eat. Companion animals and other cute creatures, like the adorable, fluffy horned animals known as Poros, must be fed too. In *LoL*, each player starts with a Poro-Snax in their trinket's lot. Poro-Snax look like delicious cinnamon rolls, but because they're like dog treats for Poros, they include meat. When chomping these tasty bacon-cinnamon treats, you may or may not 'splode and multiply—or grow a mustache!

INGREDIENTS

DOUGH

3 cups (375 g) all-purpose flour, plus more for dusting

1 packet (¼ ounce/7 g) instant yeast

½ cup (65 g) Kodiak buttermilk flapjack and waffle mix

¼ cup (50 g) granulated sugar

1 teaspoon kosher salt

6 tablespoons unsalted butter, melted and cooled

1 large egg, at room temperature

1 cup (240 ml) lukewarm milk

1 teaspoon vanilla extract

FILLING

½ cup (50 g) light brown sugar

2 tablespoons ground cinnamon, or to taste

4 tablespoons unsalted butter, melted

½ cup (60 g) chopped pecans (optional)

½ cup (115 g) chopped cooked bacon (optional)

ICING (OPTIONAL)

½ package (4 ounces/115 g) cream cheese, softened

¼ cup (½ stick/55 g) unsalted butter, softened

1 cup (100 g) confectioners' sugar

2 tablespoons heavy whipping cream

Whole milk, as needed

Red decorating gel, for the hearts

CONTINUE PLAYING ▶

DIRECTIONS

1 **To make the dough:** In a large bowl, combine the flour, yeast, Kodiak mix, sugar, and salt. In a separate bowl, using a metal whisk, whisk together the melted butter, egg, milk, and vanilla. Pour the butter mixture into the flour mixture. Stir until a dough forms.

2 Knead the dough until smooth and pliable, 3 to 5 minutes. If the dough is too sticky, add more flour, 1 tablespoon at a time, until the right consistency is reached. If it's too dry, add more milk, 1 tablespoon at a time. Cover the dough with a damp cloth and let rise in a warm spot until it doubles in size, about 1 hour.

3 Preheat the oven to 350°F (180°C; gas mark 4). Grease or line a 10-inch (25 cm) oven-safe skillet or 9-inch (23 cm) baking pan with parchment. Set aside. On a floured work surface, use a floured rolling pin to roll the dough out to a 12 x 12-inch (30 x 30 cm) square.

4 **To make the filling:** In a small bowl, combine the brown sugar and cinnamon. Brush the melted butter evenly over the dough square, then sprinkle on the cinnamon sugar and the nuts and bacon (if using). Roll the dough up into a tight log.

5 Using a sharp knife, cut the log into 10 equal rolls, 4 to 6 inches (10 to 15 cm) each. Place the rolls in the prepared skillet. Bake until lightly browned, 22 to 25 minutes. Let the rolls cool in the pan for 15 to 20 minutes before transferring them to a wire rack to cool completely.

6 **For *Legends of Runeterra*–style Poro-Snax, make the icing:** In a large bowl, use a handheld electric mixer to mix together the cream cheese, butter, confectioners' sugar, and heavy cream. It should be thick but pourable. If it's too thick, add whole milk 1 tablespoon at a time until you're able to pour it. If it's too runny, add more confectioners' sugar until it's the desired consistency.

7 Pour the icing over the rolls and let set, about 10 minutes. Use the red decorating gel to draw little hearts in the center of each. EAT, EAT, AND GROW STRONG!

MOD

If you can't find the Kodiak mix, you can substitute ½ cup whole wheat flour combined with 3 teaspoons of baking powder.

SINNER'S SANDWICH

VIDEO GAME: **Deadly Premonition** ▪ YEAR: **2010**

| DIFFICULTY: ★ BEGINNER | YIELD: 1 SANDWICH |

Similar to *Twin Peaks*—the hit '90s TV show from which this game draws much inspiration—*Deadly Premonition* uses food to enhance Greenvale's mysterious atmosphere and augment its characters' quirkiness. The Sinner's Sandwich is resident Harry Stewart's regular order at the A&G Diner. The combination of turkey, strawberry jam, and cereal initially disgusts York, who surmises that the only reason someone would eat that particular combination is some sort of self-inflicted punishment. However, he quickly changes his mind once he tries the sandwich. Use spicy mayo and pepper Jack cheese for an extra little kick of atonement.

INGREDIENTS

1 tablespoon spicy or regular
mayonnaise (optional)

2 slices white bread

4 slices honey-smoked turkey

Handful of arugula, or to taste

1 or 2 slices pepper Jack or
Muenster cheese

1 tablespoon strawberry jam

¼ cup (8 g) corn Chex cereal

DIRECTIONS

1 Smear the mayonnaise (if using) onto one side of one slice of bread. Top with turkey slices, followed by the arugula, then the cheese.

2 On the other slice of bread, spread the strawberry jam. Press the Chex into the jam.

3 At this point, you can choose whether to eat the sandwich with the cereal and jam on top as it appears in most of the cutscenes, or you can face that piece cereal-down and enjoy the sandwich as it appears when York actually eats it.

4 Atone for your sins.

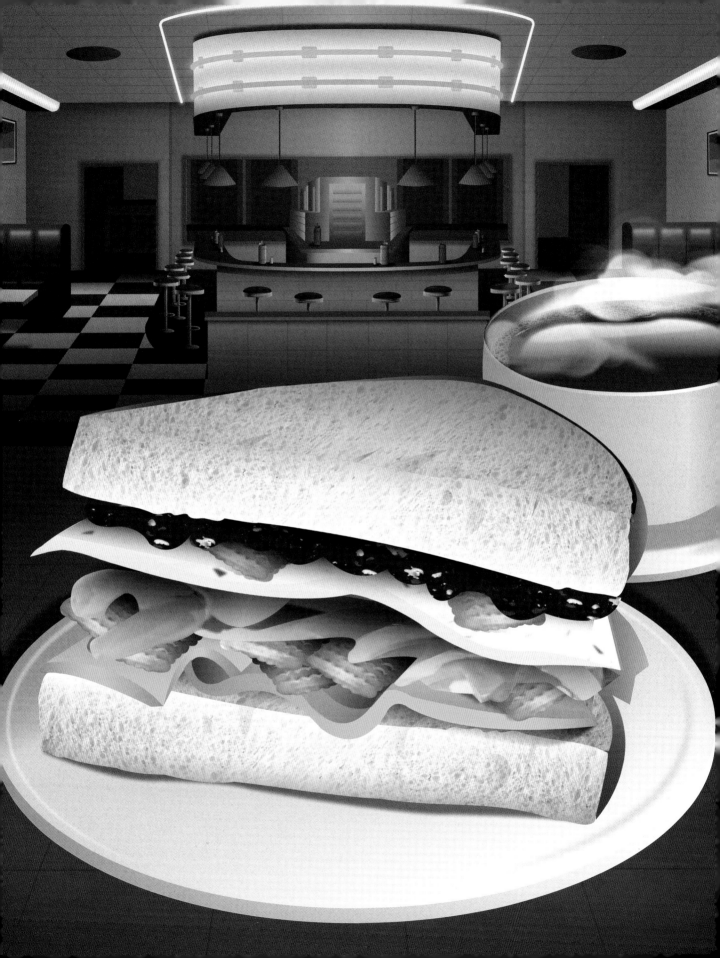

TUMMY-TINGLING TUCHANKA SAUCE

VIDEO GAME: **Mass Effect 2** · YEAR: **2010**

DIFFICULTY: ★ BEGINNER	SERVES: 8 TO 12

In an intricate, story-heavy sci-fi series like *Mass Effect*, cuisine casually mentioned in dialogue can add depth to the world. In the Zakera Café (Commander Shepard's favorite store on the citadel!), players overhear a human character incessantly asking the beleaguered Turian shopkeeper for advice on what food to serve to impress a date. Asked what would be something tasty to put on a steak, the shopkeeper recommends Tummy-Tingling Tuchanka Sauce from the nearby Fishdog Food Factory. With plenty of Szechuan peppercorns, this zesty steak sauce tingles all the way down!

INGREDIENTS

¼ cup (45 g) uncooked glutinous rice

1 to 2 dried Thai or japones chili peppers, to taste

¾ teaspoon whole Szechuan peppercorns, or to taste

¼ cup (50 g) packed light brown sugar

¼ cup (60 ml) fish sauce or coconut aminos

2 tablespoons Worcestershire sauce

1 tablespoon tomato paste

1 tablespoon lime juice

1 clove garlic, minced

1 teaspoon soy sauce

1 green onion, chopped

¼ cup (10 g) chopped fresh cilantro

1 teaspoon sesame paste (optional)

Salt, to taste

DIRECTIONS

1 Heat a wok or a large skillet over medium heat. Once the pan is hot, add the uncooked rice and stir continuously until golden brown, 10 to 15 minutes. Remove the toasted rice from the heat and let cool. In a blender or in a food processor with the knife blade attached, pulse the cooled toasted rice into a coarse powder. Set the powder aside.

2 In the same wok or pan, toast the dried chili peppers and peppercorns over medium heat, stirring constantly, 5 to 7 minutes, until fragrant and slightly smoking. Remove from heat and let cool. In a blender or in a food processor with the knife blade attached, pulse the toasted chili peppers into a coarse powder.

3 Add the toasted rice powder, light brown sugar, fish sauce, Worcestershire sauce, tomato paste, lime juice, garlic, soy sauce, green onion, cilantro, sesame paste (if using), and ½ cup (120 ml) water and puree with the chili powder until smooth. Taste and adjust flavors as desired.

4 Serve with grilled Varren steaks or other meats. Store leftover sauce in a glass bottle or jar with a tight-fitting lid in the fridge for 1 week or in the freezer for up to 3 months.

ELSWEYR FONDUE

VIDEO GAME: **The Elder Scrolls V: Skyrim** · YEAR: **2011**

DIFFICULTY: ★ ★ NORMAL	SERVES: 4 TO 6

In Skyrim, there's no such thing as too much cheese. More powerful than many of the game's mana potions, Elsweyr Fondue is the only food in the game that fills the magic bar instead of the health bar. The in-game ingredients to craft this cheesy delight are Eidar cheese, ale, and Moon Sugar. Eidar cheese looks like a blue cheese, and Moon Sugar, favored by Khajiit, has a crystallized appearance in its raw form. This recipe will make more Moon Sugar than strictly necessary for the fondue, so you can save it for another use. When crushed, Moon Sugar makes a decent rub for meat—and there's always the skooma trade . . .

INGREDIENTS

EQUIPMENT
Fondue pot (optional, see MOD on page 121)

MOON SUGAR
3 catnip tea bags (optional)

⅓ cup (80 ml) blue agave syrup

1 cup (200 g) granulated sugar

3 tablespoons za'atar spice, or to taste

1 tablespoon harissa, or 1 teaspoon cayenne powder, or to taste

1 tablespoon smoked paprika, or to taste

Confectioners' sugar, for coating

FONDUE
1 large clove garlic

2 tablespoons unsalted butter

½ cup (120 ml) Scotch ale

½ cup (120 ml) chicken broth

¼ teaspoon mustard powder

1 tablespoon Worcestershire sauce

8 ounces (225 g) crumbled Danish blue cheese or gorgonzola, plus more for garnish

6 ounces (175 g) cream cheese

Salt and ground black pepper, to taste

Chopped fresh chives, for garnish (optional)

SUGGESTED DIPPERS
Cubed bread (such as a baguette, rye, or pumpernickel)

Sliced cooked steak or chicken

Boiled or fried baby potatoes, halved

Sliced grilled leeks

Celery stalks

Sliced apples

Whole grapes

Pita chips

Kettle-cooked potato chips

Grape tomatoes

Raw carrots, bell peppers, sliced

❄ EASY MODE ❄

If you want to skip making the Moon Sugar, add 1 tablespoon of raw sugar, 1 teaspoon of za'atar spice, and a generous pinch each of harissa powder and smoked paprika directly to the fondue when the instructions say to add the Moon Sugar.

CONTINUE PLAYING ▶

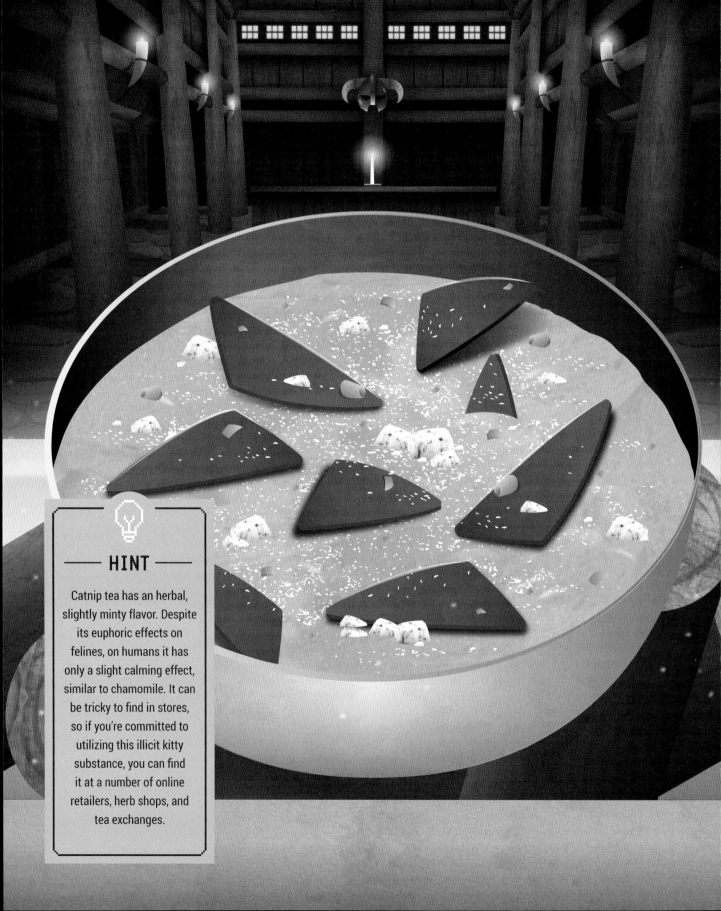

— HINT —

Catnip tea has an herbal, slightly minty flavor. Despite its euphoric effects on felines, on humans it has only a slight calming effect, similar to chamomile. It can be tricky to find in stores, so if you're committed to utilizing this illicit kitty substance, you can find it at a number of online retailers, herb shops, and tea exchanges.

DIRECTIONS

1 **To make the Moon Sugar:** Boil ½ cup (120 ml) water in a small saucepan. Remove from heat and brew the tea bags (if using) for 5 to 7 minutes. Remove the tea bags, squeezing out excess liquid, and discard. Pour the tea into a good-quality metal saucepan with a candy thermometer attached and stir in the agave, granulated sugar, za'atar, harissa, and smoked paprika. Heat the mixture until it reaches 300°F (150°C), stirring constantly. Pour the mixture into a heat-resistant container lined with parchment paper and sprinkle confectioners' sugar over top. Let the Moon Sugar cool and harden.

2 When the mixture is hard, use a butter knife to break it into crystals roughly the size of Jolly Ranchers. Coat with more confectioners' sugar, if desired. The end product should resemble dark sea glass.

3 **To make the fondue:** Cut the garlic clove in half and rub the cut sides around the inside of a fondue pot, then leave the garlic in the pot. Add the butter and turn the heat on the pot to 200°F (110°C). Let the butter melt for a few seconds. Pour in the ale and broth, and add the mustard powder and Worcestershire sauce. Stir with a wire whisk. Bring to a light simmer, 2 to 3 minutes, then turn the heat to low.

4 Add the crumbled blue cheese, stirring with the whisk to incorporate as it melts. When the blue cheese has mostly melted, add the cream cheese and stir until the fondue is smooth. Add 1 to 2 large crystals of Moon Sugar and stir until melted and incorporated, 1 to 2 minutes more. Taste and adjust seasonings.

5 Serve the fondue warm, sprinkled with additional blue cheese crumbles and garnished with chopped chives (if using), alongside your choice of dippers.

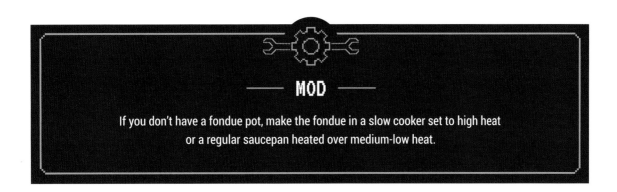

MOD

If you don't have a fondue pot, make the fondue in a slow cooker set to high heat or a regular saucepan heated over medium-low heat.

SUSPICIOUS STEW

VIDEO GAME: **Minecraft** ▪ YEAR: **2011**

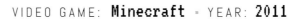

DIFFICULTY: ★ ★ NORMAL | SERVES: 6 TO 8

Occasionally, when players craft food in a game a combination just doesn't work out or has an unexpected result. Suspicious Stew is the predecessor of Dubious Food in *Breath of the Wild* (2017), and the descendant of Bland Meal from the *Paper Mario* series. Crafted with mushrooms and flowers, Suspicious Stew looks light brown with very suspicious purple and green highlights. Give it to someone special!

INGREDIENTS

STEW

1 ounce (25 g) dried wild, porcini, or shiitake mushrooms

1 cup (240 ml) boiling water

2 tablespoons unsalted butter, plus more as needed

1 tablespoon extra-virgin olive oil

1 large yellow onion, diced

6 cloves garlic, minced

1 pound (450 g) cremini mushrooms, trimmed and sliced

6 tablespoons all-purpose flour

½ cup (120 ml) marsala or Madeira wine

4 sprigs thyme

1 bay leaf

3 cups (720 ml) chicken or vegetable stock

1 teaspoon dried sage

½ teaspoon dried marjoram

¼ teaspoon dried lavender flowers

Salt and ground black pepper, to taste

1 tablespoon mushroom soup base or 1 teaspoon umami seasoning

½ cup (120 ml) heavy whipping cream or coconut cream

GREMOLATA

½ cup (120 ml) neutral oil (such as vegetable or grapeseed oil)

3 tablespoons lemon juice

1 cup (35 g) chopped flat-leaf parsley

½ cup (25 g) chopped fresh chives

½ cup (25 g) fresh green herbs (such as cilantro, basil, rosemary, tarragon)

½ teaspoon red pepper flakes (optional)

Salt and ground black pepper, to taste

GARNISH (OPTIONAL)

1 shallot, thinly sliced

Chive blossoms or other purple edible flower

CONTINUE PLAYING ▶

DIRECTIONS

1 **To make the stew:** In a medium heatproof bowl, cover the dried mushrooms with the boiling water. Soak until softened, about 15 minutes. Line a fine-mesh strainer with cheesecloth and set over a measuring cup or bowl. Strain the mushrooms and reserve the soaking liquid. Rinse and coarsely chop the mushrooms. Set aside.

2 Heat the butter and oil in a large pot over medium-high heat until the butter melts. Sauté the onion until translucent, 2 to 3 minutes. Add the garlic and cook until fragrant, about 1 minute. Add in the fresh mushrooms and the soaked mushrooms and cook until the fresh mushrooms have softened and started to sweat, about 5 minutes. Sprinkle the vegetables with the flour, mix well to coat, and cook for 2 minutes.

3 Stir in the wine, reserved mushroom liquid, thyme, and bay leaf and simmer for 3 minutes. Add the stock and stir again. Bring to a boil, and then reduce the heat to low. Stir in sage, marjoram, lavender, salt and pepper, and the mushroom soup base. Cover and simmer, stirring occasionally, until the stew reduces slightly, 20 to 25 minutes.

4 Stir in the cream. Gently simmer over very low heat (do not boil) for another 15 to 20 minutes, until thickened. Taste and adjust seasonings.

5 **To make the gremolata:** In a blender or food processor with the knife blade attached, puree the oil, lemon juice, parsley, chives, herbs, red pepper flakes (if using), and salt and pepper for about 1 minute, scraping the sides of the bowl as needed, to create a bright green sauce.

6 Ladle the soup into serving bowls and dot with the gremolata. Top with sliced shallots and chive blossoms (if using).

MOD

If you're a mushroom connoisseur, try fresh morels, chanterelles, or other wild mushrooms instead of creminis.

PIMENTACO

VIDEO GAME: **Borderlands 2** ▪ YEAR: **2012**

DIFFICULTY: ★ BEGINNER	SERVES: 6 TO 8

Talk about food deserts! Aside from skags and questionable pizza, a hungry vault hunter doesn't have a ton of food choices on Pandora. But in the glovebox of one of Scooter's Catch-a-Ride vehicles, there exists an intriguing complimentary snack: A pimento taco. A *pimentaco*, if you will. But what exactly *is* a pimentaco? Pimento is a word that has different meanings depending on where you are. Allspice berries were once known as pimentos, and still are regionally in Jamaica, so it makes complete sense that the mysterious pimentaco is actually a delicious jerk chicken taco. There's also pimento in the salsa to cover all our pimento bases and make it extra pimento-y. Catch a ride, beeyotch!

INGREDIENTS

MARINADE AND CHICKEN

¼ cup (60 ml) olive oil

⅓ cup (80 ml) lime juice

3 tablespoons jerk seasoning

2 teaspoons ground Jamaican allspice

1 tablespoon soy sauce

Salt and ground black pepper, to taste

1 Scotch bonnet chili pepper, seeded and chopped (optional)

1½ pounds (675 g) boneless chicken thighs

SALSA

2 large or 3 small ripe mangos (about 3 cups/495 g), peeled, pitted, and diced

1 small red onion, finely chopped

1 jalapeño, seeded and diced

½ cup (20 g) chopped fresh cilantro

¼ cup (50 g) diced pimentos (fresh or jarred)

Juice of 1 lime (about 2 tablespoons)

½ teaspoon salt, or to taste

SLAW

2 cups (190 g) shredded cabbage

¼ cup (60 ml) lime juice

½ cup (120 g) mayonnaise

2 green onions, sliced

½ cup (20 g) chopped fresh cilantro

½ tablespoon jerk seasoning

½ teaspoon salt, or to taste

FOR ASSEMBLY

24 corn tortillas (to serve 2 each)

1 tablespoon diced pimentos, for garnish

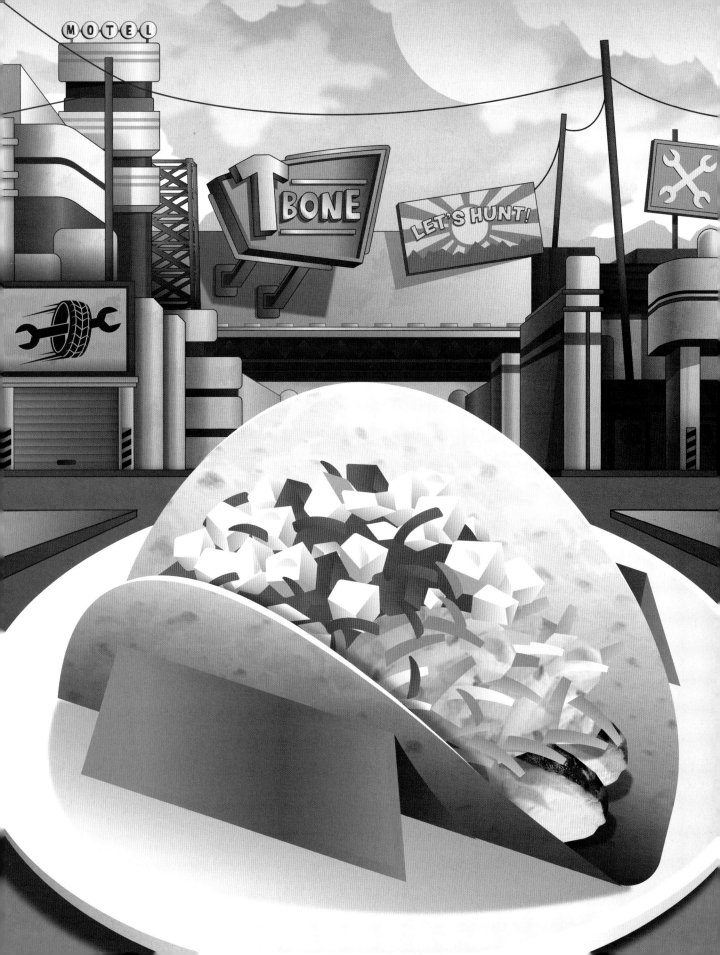

DIRECTIONS

1 **To marinate the chicken:** In a medium bowl, combine the olive oil, lime juice, jerk seasoning, Jamaican allspice, soy sauce, salt and black pepper, and Scotch bonnet (if using) and stir to make the marinade. Put the chicken thighs into a large zip-top plastic bag, then pour in the marinade. Make sure the marinade covers all of the chicken, then seal the bag, squeezing out as much air as possible. Let the chicken marinate for at least 1 hour, up to overnight.

2 **Meanwhile, make the salsa and slaw:** In a medium bowl, toss the mangos with the red onion, jalapeño, cilantro, pimentos, lime juice, and salt. Set aside.

3 In a separate large bowl, toss the shredded cabbage with the lime juice, mayonnaise, green onion, cilantro, jerk seasoning, and salt. Cover both bowls and refrigerate until serving to allow the flavors to meld.

4 Once the chicken is marinated, preheat a grill to medium-high heat. Grill the chicken thighs for 6 to 8 minutes per side, until a meat thermometer inserted in the thickest part of the thigh reaches 165°F (74°C). Let the chicken rest for at least 10 minutes, then slice the thighs into thin pieces.

5 **To assemble the pimentacos:** Warm the tortillas on the grill, stove, or in the microwave. Fill each tortilla (using 1 or 2 tortillas per taco, according to your preference) with the chicken, followed by the slaw, then the salsa. Garnish with additional chopped pimentos, if desired. Serve in the glove box.

MOD

You can cook the chicken thighs in the oven, too. Just preheat the oven to 425°F (220°C; gas mark 7). Bake the thighs in a single layer on a baking sheet lined with parchment paper for 20 minutes, flipping halfway through, until the largest thigh has an internal temperature of 165°F (74°C).

CARROT SOUFFLÉ

VIDEO GAME: **Guild Wars 2** ▪ YEAR: **2012**

| DIFFICULTY: ★ BEGINNER | SERVES: 8 TO 12 |

The foraging and food crafting in *GW2* is both rewarding and fun. It can be just as exciting to find an omnomberry as a piece of quality loot. *GW2*'s recipes are very detailed, some even requiring the player to make separate bases like roux, stocks, and stuffings before adding other ingredients. Carrot Soufflé is made with carrots, baker's wet and dry ingredients, and a walnut topping the player must make separately. The resulting dish is autumnal and fragrant and exists somewhere between dessert world and side dish land. It makes a warm and comforting addition to any Special Treats Week feast.

INGREDIENTS

SOUFFLÉ

2 pounds (900 g) baby carrots

½ cup (1 stick/115 g) unsalted butter, melted

¾ cup (150 g) granulated sugar, or to taste

½ teaspoon kosher salt

4 medium eggs

½ cup (65 g) all-purpose flour

2 teaspoons vanilla paste or extract

2 teaspoons ground cinnamon

½ teaspoon ground nutmeg (optional)

¼ teaspoon ground cloves (optional)

TOPPING

½ cup (65 g) all-purpose flour

1 cup (185 g) packed light brown sugar

⅛ teaspoon ground cinnamon

Pinch of ground nutmeg

1 cup (120 g) chopped walnuts, lightly toasted

6 tablespoons unsalted butter, softened

DIRECTIONS

1. **To make the soufflé:** Preheat the oven to 350°F (180°C; gas mark 4). Grease a 10-inch (25 cm) cake pan and set aside.

2. In a medium or large saucepan, add the carrots and enough water to cover them by 1 to 2 inches (2.5 to 5 cm). Heat until boiling, then reduce the heat to medium. Cover and cook for 20 minutes, or until the carrots are soft. Drain the carrots and let them cool.

3. In a food processor with the knife blade attached, puree the carrots, butter, granulated sugar, salt, eggs, flour, vanilla, cinnamon, and ground nutmeg (if using) and cloves (if using). Spoon the mixture into the prepared cake pan.

4. **To make the topping:** In a medium bowl, stir together the flour, brown sugar, cinnamon, nutmeg, walnuts, and butter to make a crumbly mixture. Sprinkle the topping evenly over the carrot mixture.

5. Bake uncovered for 45 minutes, or until the center of the soufflé has set.

APRICOT TARTLET

VIDEO GAME: **Dishonored** ▪ YEAR: **2012**

| DIFFICULTY: ★ ★ NORMAL | YIELD: 6 TARTLETS |

In *Dishonored*, food is used to explore the social hierarchy of its stylish Victorian-dystopian setting. While the masses eat jellied eels, rat skewers, and canned whale meat, Corvo can score fresh fruit and apricot tartlets by crashing the high-society shindigs.

INGREDIENTS

CRUSTS
1¼ cups (155 g) all-purpose flour, plus more for dusting

½ cup (1 stick/115 g) cold unsalted butter, cubed

2 tablespoons brown sugar

1 egg yolk

1 tablespoon ice-cold water

CUSTARD
½ cup (100 g) superfine sugar

4 egg yolks

2 tablespoons cornstarch

1 cup (240 ml) heavy whipping cream

¾ cup (180 ml) whole milk

2 teaspoons vanilla paste or extract

FOR ASSEMBLY
1 cup (338 g) apricot preserves, divided

8 to 12 (1 pound/450 g) apricots, pitted and sliced

1 tablespoon orange-flavored liqueur, brandy, or rum

—— HINT ——

Fresh fruit can be difficult to come by in the streets of Dunwall. You can use dried apricots if you can't find fresh ones. Soak them in warm water for 30 minutes before using.

CONTINUE PLAYING ▶

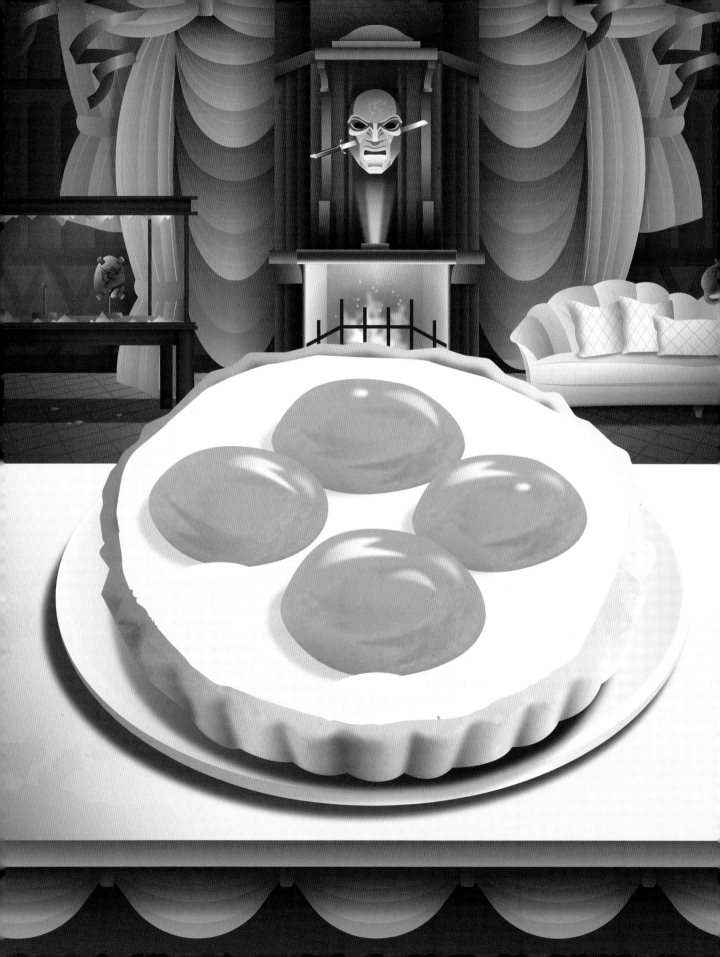

DIRECTIONS

1 To make the crusts: In a food processor with the knife blade attached, add the flour, butter, and sugar and pulse until the mixture resembles fine crumbs. Add the egg yolk and pulse to incorporate. With the food processor running, drizzle in the ice water. Pulse until the mixture comes together, then remove the dough. Form the dough into a ball and wrap it in plastic wrap. Refrigerate for 1 hour.

2 To make the custard: With a wire whisk, whisk together the sugar and egg yolks, then whisk in the cornstarch and vanilla. In a medium saucepan over medium heat, heat the cream and milk together until almost boiling. Reduce the heat to low and add the egg mixture, a little at a time, stirring constantly with the whisk. Allow the custard to thicken, stirring frequently, until it is thick enough to coat the back of a spoon. Transfer the custard to a bowl, wrap with plastic wrap, and place in the fridge to thicken, 2 hours up to overnight.

3 Remove the chilled dough from the fridge and let it rest for 5 to 10 minutes, until it is loose enough to roll out. Lightly flour a clean work surface. Use a rolling pin to roll the dough out until it's about ⅛ inch (3 mm) thick. Line six 4-inch (10 cm) removable-bottom tart tins with the dough and trim away the excess. Refrigerate for 1 hour.

4 Preheat the oven to 350°F (180°C; gas mark 4). Fill the tart crusts with baking weights or beans, loosely cover with aluminum foil, and bake for 15 to 20 minutes. Remove the weights and foil and bake for another 5 to 10 minutes, until the crusts are cooked through and golden. Remove from the oven and cool completely in the tins.

5 To assemble the tartlets: Once the crusts have cooled, divide ½ cup (165 g) of the apricot preserves among the 6 tartlets and use the back of a spoon to spread it evenly around the bottoms. Top the jam with the chilled custard, dividing it evenly among the tartlets and smoothing with the back of a spoon. Set the apricots, cut-side down, into the custard, fitting in as many as you can.

6 In a small heatproof bowl, stir together the remaining ½ cup (165 g) apricot preserves and the orange liqueur and heat in the microwave for 15 seconds. Use a pastry brush dipped in the jam–orange liqueur mixture to glaze the tops of the tartlets. Serve the tartlets at room temperature or chilled.

PIEROGIES

VIDEO GAME: **Don't Starve** ▪ YEAR: **2013**

| DIFFICULTY: ★ ★ ★ EXPERT | SERVES: 10 TO 12 |

The objective of *Don't Starve* is to eat food and not die—and with permadeath and no saving mechanism, the stakes are extra high. To avoid starvation and dangerous drops in sanity, the player must cook and eat food. Initially, that involves foraging for berries and trapping rabbits. Once the player manages to create a "Crock Pot", things get more interesting. One of the most convenient and effective meals cooked in these pots is pierogi, a kind of Polish dumpling. This scrumptious staple has made other notable appearances in *The Witcher* series, in *Cyberpunk 2077* (2020) and *Destiny* (2014).

INGREDIENTS

FILLING

2 tablespoons unsalted butter

1 small yellow onion, finely chopped

4 cloves garlic, minced

2 pounds (900 g) lean ground beef

1 cup (240 ml) beef broth

2 teaspoons garlic powder

1 teaspoon onion powder

2 teaspoons dried marjoram

1 teaspoon kosher salt

½ teaspoon ground black pepper

1 tablespoon bread crumbs
 (optional)

DOUGH

4 cups (500 g) all-purpose flour,
 plus more for dusting

1 large egg

1 teaspoon kosher salt

1 cup (240 ml) lukewarm water

Oil, for cooking

FOR SERVING

1 cup (240 g) sour cream

Chopped fresh chives

— HINT —

After they've been boiled, pierogies can be stored in the freezer for up to 3 months. Reheat by boiling or steaming them from frozen, or thaw them in the fridge first then pan-fry them in butter.

DIRECTIONS

1 **To make the filling:** In a large skillet over medium heat, melt the butter. Add the onions and sauté until translucent, 2 to 3 minutes. Add the garlic and cook until fragrant, about 1 minute more. Add the ground beef. Cook, breaking up big pieces with a wooden spoon, until browned, 6 to 7 minutes. Drain most of the excess fat, leaving about 1 tablespoon in the skillet. Stir in the broth, garlic and onion powders, marjoram, salt, pepper, and bread crumbs (if using). Continue to cook until the meat absorbs the broth, 8 to 10 minutes. Remove from the heat and let cool.

2 Transfer the meat mixture to a food processor with the knife blade attached and pulse until there are no large lumps left and it starts to come together. If the filling seems too moist and doesn't hold together when pressed, stir in 1 tablespoon of bread crumbs. Set aside.

3 **To make the dough:** In a stand mixer with the paddle attachment, combine the flour, egg, salt, and lukewarm water and mix until a tacky dough forms. Turn the dough out onto a lightly floured work surface and knead until the dough is smooth and soft, 5 to 6 minutes. If the dough still sticks to your hands, knead in 1 teaspoon more flour. Wrap the dough in plastic wrap and let rest for 20 minutes.

4 Working in batches, use a rolling pin to roll out some of the dough to about ⅛ inch (3 mm) thick. Keep the unused dough sealed in plastic wrap to prevent it from drying out. Use a 3-inch (8 cm) round cookie cutter or the mouth of a glass to cut out circles. Fill each with about 1 tablespoon of filling, then close each pierogi by folding it in half into a crescent shape and pressing the edges with wet fingers or a fork to seal. Repeat until you've used all the dough and filling.

5 Fill a large saucepot halfway with water, salt it well, and add a splash of oil, to prevent sticking. Bring the water to a low boil.

6 Drop batches of 5 or 6 pierogies at a time into the simmering water then turn the heat down to low. Boil, lightly stirring the bottom of the pot to prevent the pierogies from sticking, for 3 to 4 minutes, until the pierogies float to the top. Remove them with a slotted spoon and set aside on a plate. Repeat until all pierogies are cooked, adjusting heat as needed to keep the water simmering.

7 To serve, plate 3 pierogies in a row, leaning on each other, and spoon a small dollop of sour cream on the tip of each one. Sprinkle on the chopped chives and serve!

MOD

You can also pan-fry the pierogies in a large skillet over medium heat. Melt 2 tablespoons of butter and cook, in batches, until the pierogies are lightly browned on both sides, 5 to 6 minutes.

PRIESTLY OMELETTE

VIDEO GAME: **Final Fantasy XIV** · YEAR: **2013**

DIFFICULTY: ★ ★ ★ EXPERT | YIELD: 1 OMELETTE

The Culinarian role is one of the most challenging and rewarding crafting classes Eorzea has to offer. The in-game recipe for the divine-sounding "Priestly Omelette" lists mushrooms, white truffle, tomato sauce, parsley, and a "fistful" of shredded cheese. The omelets in *FFXIV* seem to be soufflé, a somewhat challenging but worthwhile omelette style. Preparing this fluffy, umami-packed soufflé omelet—and savoring the tasty results—will make you feel like a true master culinarian. An apron and chef's hat might help, too.

INGREDIENTS

TOMATO SAUCE

2 tablespoons extra-virgin olive oil

2 cloves garlic, minced

2 green onions, finely chopped

1 teaspoon red pepper flakes (optional)

1 can (8 ounces/225 g) crushed tomatoes

1 tablespoon soy sauce, or to taste

⅛ teaspoon truffle powder (optional)

Salt and ground black pepper, to taste

MUSHROOMS

1 tablespoon extra-virgin olive oil

½ cup (20 g) fresh shiitake mushrooms, stems removed and finely chopped

1 tablespoon unsalted butter

⅛ teaspoon white truffle oil or truffle powder (optional)

OMELETTE

3 large eggs, separated

¼ teaspoon kosher salt, or to taste

1 tablespoon heavy whipping cream

1 tablespoon unsalted butter

1 fistful (about ½ cup/50 g) shredded Fontina or Gruyère cheese, or a mixture of both

Shaved white truffle or truffle powder, to taste (optional)

Chopped parsley, for garnish

— MOD —

The in-game ingredients for this dish specify white truffle, which is stronger and more pungent than black truffle. However, black truffle tends to be more widely available and affordable. If you don't care about the distinction, it's fine to use black truffle oil, black truffle powder, or whole black truffle for shaving.

1 **To make the tomato sauce:** Heat the oil in a small saucepan over medium heat then add the garlic and green onions and cook until fragrant. Stir in the red pepper flakes (if using) and cook for 30 seconds, stirring frequently to prevent burning. Add the crushed tomatoes, soy sauce, and truffle powder (if using) and stir. Taste and adjust seasonings. Cover and reduce the heat to low and let the sauce simmer on the lowest heat setting while you make the mushrooms.

2 **To make the mushrooms:** Heat the oil in a wok or large skillet over medium heat. Add the mushrooms and butter and cook until the mushrooms have browned and shrunk by half, 4 to 5 minutes. Sprinkle on the truffle oil (if using) and some salt and pepper. Remove from the heat and set aside.

3 **To make the omelette:** In a large bowl, using a wire whisk, handheld electric mixer, or stand mixer with whisk attachment, beat the egg whites until stiff, glossy peaks form. Do not overmix, or they will deflate. In a separate large bowl, beat the egg yolks with salt and heavy whipping cream. Add half of the beaten egg whites to the yolk mixture and gently stir until thoroughly combined. Gently fold in the remaining egg whites until just combined. Again, do not overmix or they will deflate.

4 In a nonstick 10-inch (25 cm) skillet, melt the butter over medium heat until foaming. Use a silicone spatula to scrape the soufflé base from the bowl into the pan. Spread the soufflé base into an even circle in the pan, smoothing the surface with the spatula. Cover and cook until the bottom of the omelette is lightly browned, 3 to 5 minutes. Sprinkle the cheese and reserved mushrooms along the center. Cover and cook for about 1 minute more, until the cheese melts. Sprinkle on the shaved truffle (if using).

5 Carefully slide the omelette out of the pan and onto a serving plate and fold into a half-circle along the cheese–mushroom line. Pour on the tomato sauce so some spills over the side of the omelette. Garnish with chopped parsley and serve immediately.

— HINT —

Crafting as a Culinarian can be challenging. Some of the most common reasons for deflated soufflé are over- or under-beaten eggs and undercooking. But even if you know you did everything right and your omelette still deflated, don't despair! Soufflé is notoriously difficult, and there are a ton of variables—even the ambient temperature and humidity in the kitchen can affect the outcome. The good news is the deflated omelette will still be delicious! So, enjoy your deliciously deflated omelette and try again another time.

SPICY RAMEN

VIDEO GAME: **Destiny** · YEAR: **2014**

| DIFFICULTY: ★ BEGINNER | SERVES: 4 |

Many *Destiny* players had an expired coupon for spicy ramen sitting in their vault for years. It was a largely sentimental item—a memorial for a beloved character—that came with a fun bit of lore. The secret for that rich, flavorful broth that Cayde-6 is so fond of is called the tare. This one, made with red and white miso and shichimi togarashi (Japanese seven-spice), will hit you right in the mouth zone. And don't worry, no chickens named Colonel were harmed in the making of this recipe.

INGREDIENTS

TARE

½ cup (120 g) awase miso or a blend
 of ¼ cup (60 g) red miso and
 ¼ cup (60 g) white miso

2 tablespoons kosher salt

2 tablespoons soy sauce

2 tablespoons mirin or sake

3 tablespoons Japanese or
 Chinese sesame paste or tahini

3 tablespoons doubanjiang,
 gochujang, sriracha, or sambal
 oelek, or to taste

2 tablespoons toasted sesame oil

½ tablespoon rice wine vinegar

½ teaspoon shichimi togarashi

BROTH AND NOODLES

6 (not 7) dried shiitake mushrooms

2 tablespoons neutral oil (such as
 vegetable or sunflower oil)

4 cloves garlic, minced

4 green onions, thinly sliced,
 white parts only

2-inch (5 cm) piece fresh ginger,
 peeled and thinly sliced

1 red chili pepper, or to taste,
 chopped

5 cups (1.2 L) prepared dashi stock
 or mushroom stock, plus more
 if needed

4 servings (about 26 ounces/740 g)
 fresh ramen noodles

SUGGESTED TOPPINGS

Green onions, sliced on a bias

Soft-boiled eggs

Silken tofu

Sliced char siu or barbecue pork

Pickled ginger

Sliced fresh bird's eye chili peppers

Shichimi togarashi

Chili threads

HINT

Tare is the primary seasoning agent in ramen—it's what gives it its signature flavor. But be careful! It's a very salty seasoning. You may or may not end up using all the tare this recipe yields.

CONTINUE PLAYING ▶

DIRECTIONS

1 **To make the tare:** In a small bowl, whisk all the ingredients together with a wire whisk. Set aside.

2 **To make the broth and noodles:** Rinse and slice the dried shiitakes and set aside. In a large saucepot, heat the oil over medium heat. Add the garlic, green onions, ginger, and bird's eye chili peppers. Sauté until fragrant, 1 to 2 minutes. Add the shiitakes and pour in the stock. Bring to a boil, then reduce the heat to medium and simmer for 5 minutes.

3 Reduce the heat to low. Stir in the tare, 1 tablespoon at a time, tasting the broth between each addition until the desired flavor is reached. (If you're serving multiple people, it's best to use a bit less; more tare can be added when serving so folks can customize their bowls. It can also be stored in the fridge for a month or two.) Continue to simmer over low heat for about 10 minutes.

4 Meanwhile, cook the noodles according to the package directions.

5 Ladle the broth into serving bowls. Distribute the cooked noodles evenly between the bowls and arrange your desired toppings over the noodles. Serve with more tare on the side, so guests can add more to the broth as desired.

MOD

We left Colonel out of this recipe out of respect for Clayde-6, but her eggs are fair game! For even more flavor in your mouth zone, a day or so before you want to make Spicy Ramen, you can marinate peeled soft-boiled eggs in a mixture of equal parts soy sauce and mirin overnight (or up to three days). The marinated eggs, also called *ajitsuke tamago* in Japanese, make a perfect topping for ramen and other noodle soups or steamed rice dishes—or can be a delicious snack all on their own.

CRAB RANGOON

VIDEO GAME: **Far Cry 4** ▪ YEAR: **2014**

DIFFICULTY: ★ ★ NORMAL	SERVES: 4 TO 6

Often called the Crab Rangoon Ending, the secret alternative ending of *Far Cry 4* is something else. I don't want to spoil anything, but suffice it to say, Crab Rangoon is featured prominently. Most folks are familiar with these deep-fried delights, which have become an American-Chinese restaurant staple since their invention in 1956. They generally consist of a mixture of cream cheese and crab meat folded inside a wonton wrapper and fried to crispy golden perfection. With a plate of these babies in front of you, you won't want to go anywhere.

INGREDIENTS

FILLING

¾ cup (100 g) crab meat or surimi crab, chopped

½ cup (115 g) cream cheese, softened

1 tablespoon green onion, finely chopped

1 teaspoon soy sauce

1 teaspoon Worcestershire sauce

½ teaspoon garlic powder

½ teaspoon granulated sugar

¼ teaspoon ground white pepper

WONTONS

18 to 20 square wonton wrappers

2 to 6 cups (480 ml to 1.4 L) neutral oil (such as vegetable or sunflower oil), for deep-frying

DIPPING SAUCE

½ cup (120 ml) pineapple juice

¼ cup (45 g) light brown sugar

¼ cup (60 ml) rice vinegar

2 tablespoons ketchup

2 teaspoons light soy sauce

2 teaspoons cornstarch

1 tablespoon room-temperature water

MOD

If you're not a fan of crab, you can replace it with minced mushrooms, hearts of palm, or firm tofu. Or you can just bump up the cream cheese and green onion.

CONTINUE PLAYING ▶

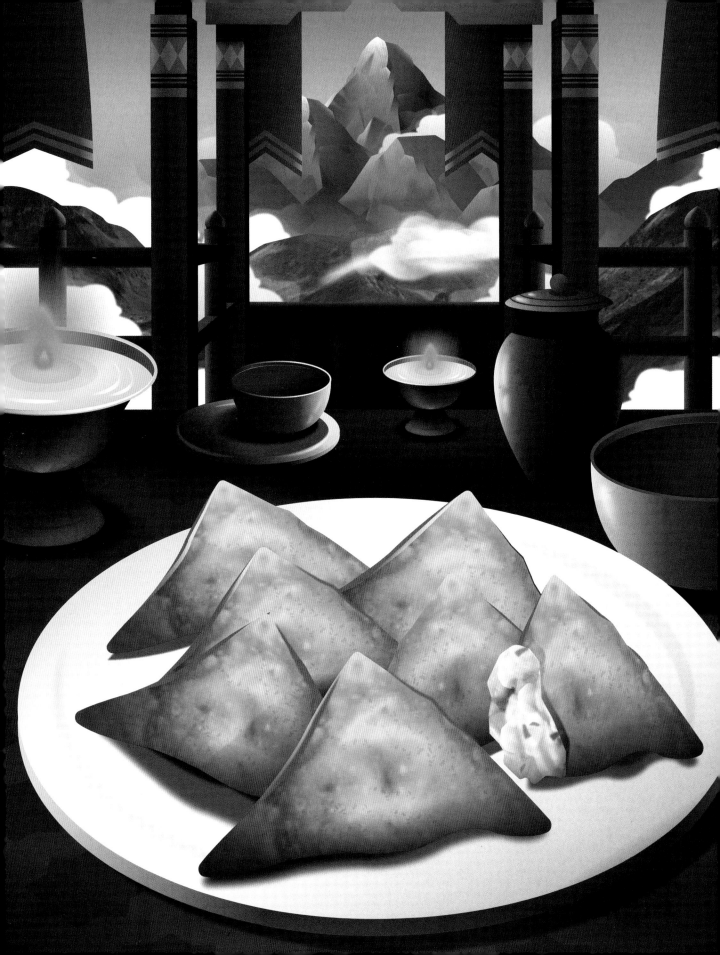

DIRECTIONS

1 **To make the filling:** In a small bowl, combine the crab meat, cream cheese, green onion, soy and Worcestershire sauces, garlic powder, granulated sugar, and white pepper. Taste and adjust seasoning.

2 **To make the wontons:** Working in batches to prevent drying, lay out 2 to 3 wonton wrappers at a time. Place 2 generous teaspoons of filling in the center of each. Dip your finger in water and lightly wet the edge of each wonton wrapper. Fold each wonton wrapper in half diagonally and press to seal into triangles. Pinch the edges together to seal. Repeat with the remaining filling.

3 In a deep fryer or thick-bottomed pot, heat the frying oil to 365°F (190°C), measured by a thermometer. Carefully drop the wontons into the hot oil in batches of 4 to 5 (or smaller, depending on the size of your vessel) to prevent overcrowding. Use a long pair of tongs to rotate the wontons as necessary. Fry for 2 to 3 minutes, until golden brown and crispy. Place the cooked rangoon on a paper-towel-lined plate to cool and dry.

4 **To make the dipping sauce:** In a small saucepan over medium heat, stir the pineapple juice, brown sugar, rice vinegar, ketchup, and soy sauce until it boils. In a small bowl, use a wire whisk to whisk together the cornstarch and water, then stir it into the sauce. Whisk the sauce until the cornstarch is fully incorporated and the sauce has thickened.

5 Transfer the Crab Rangoon to a serving plate and serve with the dipping sauce.

HINT

You can also cook these in an air fryer at 370°F (190°C) for 8 to 10 minutes.

BELGIAN WAFFLES

VIDEO GAME: **Life Is Strange** · YEAR: **2015**

DIFFICULTY: ★ BEGINNER | YIELD: 4 WAFFLES

The toughest choice in any game, ever: Belgian waffles or bacon omelet? *Life Is Strange* is a game with a heavy focus on choices and consequences. Obviously, this is the single most important choice in the game. The correct answer is waffles. Always waffles.

INGREDIENTS

EQUIPMENT
Waffle iron (see HINT)

WAFFLES
2 cups (250 g) all-purpose flour

1½ cups (360 ml) lukewarm
 whole milk

2 large eggs, lightly beaten

6 tablespoons unsalted butter,
 melted and cooled

1 tablespoon brown sugar;
 use 2 tablespoons if omitting
 pearl sugar

1 packet (¼ ounce/7 g) instant yeast

1 teaspoon vanilla paste or extract

½ teaspoon kosher salt

1 teaspoon ground cinnamon
 (optional)

1 cup (200 g) Belgian pearl sugar
 (optional)

TOPPINGS
1 cup (240 ml) heavy
 whipping cream, cold

2 tablespoons confectioners' sugar,
 plus more for dusting

1 teaspoon vanilla paste or extract

16 strawberries or other berries

Maple syrup, to taste (optional)

DIRECTIONS

1. **To make the waffles:** In a large bowl, stir together the flour, milk, eggs, butter, brown sugar, yeast, vanilla, salt, and cinnamon (if using). It's okay if the batter has air bubbles and isn't perfectly smooth. Wrap the bowl with plastic wrap and let the batter rest at room temperature for at least 1 hour, or in the fridge overnight. It will get pretty bubbly. Before cooking, gently fold in the pearl sugar (if using).

2. Preheat the waffle iron. Spray it with nonstick spray and pour the manufacturer's recommended amount of batter (usually ⅔ to ¾ cup/165 to 180 ml) into the center of the iron. Close the lid and cook as the manufacturer directs, or until the waffle is golden brown. Repeat to make 4 waffles (amount may vary depending on your waffle maker) and set onto serving plates.

3. **To make the toppings:** In the bowl of a stand mixer fitted with the whisk attachment or in a medium bowl with a handheld electric mixer, add the cream, confectioners' sugar, and vanilla and beat on high speed until medium-stiff peaks form, 2 to 3 minutes.

4. Place the warm waffles on serving plates. Top each with a dollop of whipped cream and arrange 4 strawberries around the whipped cream. Drizzle with maple syrup (if using) and dust with more confectioners' sugar.

— HINT —
A decent waffle iron doesn't cost much more than a couple waffles at a diner, and it can make paninis, brownies—even bacon omelets.

BUTTERSCOTCH-CINNAMON PIE

VIDEO GAME: **Undertale** ▪ YEAR: **2015**

DIFFICULTY: ★ ★ NORMAL | SERVES: 6 TO 8

Food plays important roles in this fourth-wall-breaking indie title. In *Undertale*, the player controls a small child who finds themselves in a mysterious and occasionally hostile underground region where nothing is what it seems—but where they encounter a lot of food, ranging from magical to grotesque to . . . sentient? But the Butterscotch-Cinnamon Pie that Toriel makes stands out from the rest. This recipe includes vegan substitutions for those who prefer a pacifist run. Dogs love it, and so will you!

INGREDIENTS

CRUST

1¼ cups (155 g) all-purpose flour

¼ teaspoon kosher salt

½ cup (1 stick/115 g) cold unsalted butter or plant butter, diced

¼ cup (60 ml) ice water

FILLING

¼ cup (30 g) cornstarch (½ cup/60 g for pacifist)

1½ cups (360 ml) whole milk or vegan alternative (higher-fat options like soy and oat work best), divided

½ cup (120 ml) heavy whipping cream or full-fat coconut cream

⅔ cup (145 g) packed dark brown sugar

½ teaspoon kosher salt

2 teaspoons ground cinnamon

2 egg yolks, whisked, or ½ cup (130 g) pureed silken tofu

1 tablespoon unsalted butter or plant butter

1 teaspoon vanilla paste or extract

TOPPING

1 cup (240 ml) cold heavy whipping cream or full-fat coconut cream

2 tablespoons confectioners' sugar

1 teaspoon vanilla paste or extract

1 teaspoon ground cinnamon

3 cinnamon sticks, for garnish

❋ EASY MODE ❋

If you thought Sans was the most relatable character in *Undertale*, you may not want to bother making a pie crust from scratch. Go ahead and use a premade one, lazy bones!

CONTINUE PLAYING ▶

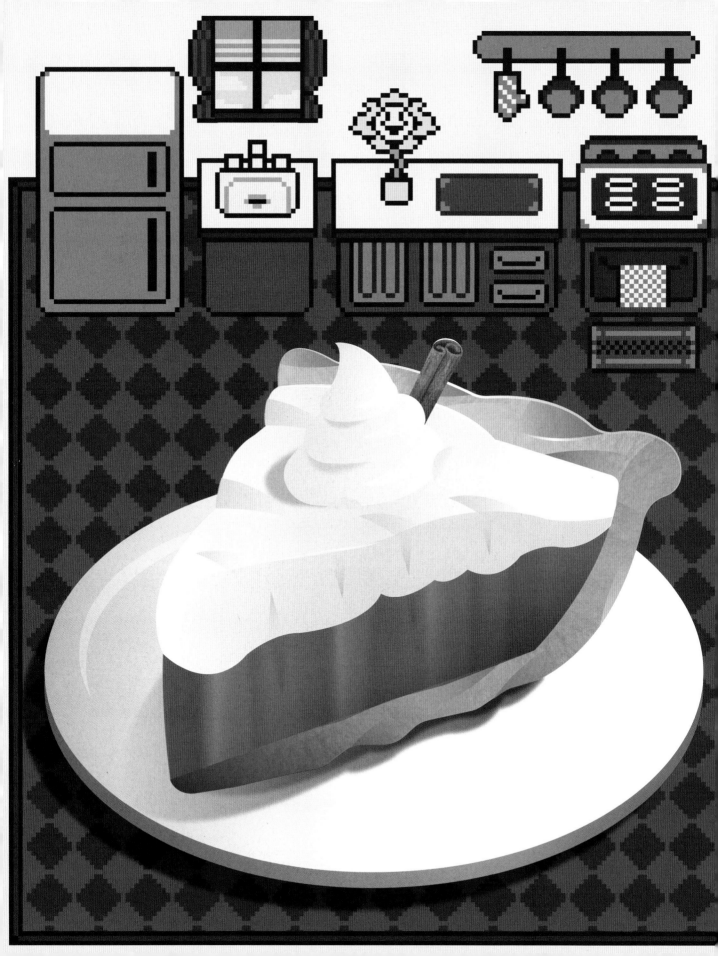

DIRECTIONS

1 **To make the crust:** In a food processor with the knife blade, add the flour and salt, then add the butter, bit by bit, pulsing until it resembles coarse crumbs. Add in the ice water, 1 tablespoon at a time, until the dough comes together. Shape it into a ball, wrap it in plastic, and refrigerate for at least 2 hours, up to overnight.

2 Once the dough has rested, preheat the oven to 375°F (190°C; gas mark 5) and grease a 9-inch (23 cm) pie tin. Use a pastry roller or rolling pin to roll out the dough to fit the tin and press the dough evenly into the bottom and sides. Trim away excess. Fill the pie crust with pie weights or dried beans and bake the crust for 7 to 10 minutes, until golden. Remove it from the oven and cool in the pan until you can safely remove the pie weights. Set aside. (Leave the oven on.)

3 **To make the filling:** Prepare a double boiler by bringing at least 1½ inches (4 cm) water to a boil in a small saucepan. Fit a heatproof bowl over the saucepan, making sure it doesn't touch the water. In a separate small bowl, use a wire whisk to whisk together the cornstarch and ½ cup (120 ml) of the milk until it forms a slurry. Pour the remaining 1 cup (240 ml) milk into the double boiler and whisk in the cream, brown sugar, cornstarch slurry, salt, and cinnamon until the mixture thickens slightly, 8 to 10 minutes. Still over the heat, slowly whisk in the egg yolks or tofu. Continue to whisk constantly until the mixture thickens to a pudding-like consistency, about 5 minutes. Remove from the heat, then add in the butter and vanilla and whisk until both are completely incorporated. Pour the mixture into the pie crust and bake until the custard filling has set and the edges are golden brown, 8 to 10 minutes more. Transfer to a wire rack to cool in the pan for 15 minutes, then transfer the pan to the fridge for an hour for the pie to set. (Don't be tempted to eat it before it cools!)

4 **To make the topping:** In the bowl of a stand mixer with the whisk attachment or in a large mixing bowl using a handheld electric mixer, beat the cream, confectioners' sugar, vanilla, and ground cinnamon until medium-stiff peaks form, about 2 to 3 minutes.

5 Spoon the whipped cream on top of the cooled pie and spread with a rubber spatula. Garnish the pie with the three cinnamon sticks lined up in the center.

WYVERN WINGS

VIDEO GAME: **Dragon Age: Inquisition** · YEAR: **2015**

DIFFICULTY: ★ BEGINNER	SERVES: 3 OR 4

One of the joys of exploring a fantasy world as rich as Thedas is partaking in victuals and refreshments in a local tavern, especially when the game developers create a detailed menu. The Rusted Horn in Crestwood offers Wyvern Wings. Although the tavern apparently serves steak made from real wyvern meat, the menu specifies—emphatically—that the wings are really chicken. Also on the menu is Antivan brandy, which I decided to incorporate into the glaze for the wings. Serve with cold ale, crusty bread, and because this is *Dragon Age*, a selection of fine cheeses, of course.

INGREDIENTS

WINGS

1 tablespoon kosher salt

1 tablespoon baking powder

½ tablespoon ground white pepper

½ tablespoon smoked paprika

3 pounds (1.3 kg) chicken wings

DIPPING SAUCE

⅓ cup (80 g) crème fraiche
 and/or sour cream

⅓ cup (80 ml) buttermilk

⅓ cup (80 g) mayonnaise

2 cloves garlic, finely minced

3 tablespoons chopped fresh dill

3 tablespoons chopped
 fresh tarragon

3 tablespoons chopped fresh chives

2 tablespoons chopped fresh
 flat-leaf parsley

1 tablespoon fresh lemon juice,
 or to taste

1 teaspoon apple cider vinegar

Salt and ground black pepper,
 to taste

GLAZE

½ cup (1 stick/115 g) salted butter

½ cup (120 ml) honey

2 tablespoons brown sugar

¼ cup (60 ml) Worcestershire
 or soy sauce

½ cup (120 ml) brandy

4 cloves garlic, minced

2 tablespoons mustard powder

1 tablespoon garlic powder

1 tablespoon herbs de Provence
 or bouquet garni seasoning

2 teaspoons smoked paprika

DIRECTIONS

1 **To prepare the wings:** In a small bowl, combine the salt, baking powder, white pepper, and smoked paprika. In a large bowl, add the chicken wings and slowly sprinkle in the seasoning mixture while tossing to coat the wings evenly on all sides. Wrap the bowl in plastic wrap and place the chicken in the refrigerator for at least 4 hours or overnight. Remove from the fridge and let it rest for about 1 hour.

2 **To make the dipping sauce:** In a small bowl, stir together all the sauce ingredients. Taste and adjust seasoning. Wrap the bowl tightly in plastic and place in the fridge until serving time, allowing the flavors to meld.

3 **To make the glaze:** In a small saucepan over medium heat, stir together all the glaze ingredients and simmer until the glaze has thickened, 10 to 15 minutes. Set aside.

4 Set an oven rack or broiler pan 6 to 7 inches (15 to 18 cm) from the broiler heating element and heat on high. Cover a baking sheet with aluminum foil. Lay the chicken wings skin-side down (bottom side facing up) on the prepared baking sheet. Broil for 15 minutes, then take the tray out and flip the wings skin-side up. Broil for 15 minutes more, checking occasionally to prevent burning. Remove the wings from the oven and transfer to a large bowl.

5 If the glaze has separated, reheat over low heat until it's warm enough to stir to recombine. Pour the glaze mixture over the wings and toss to coat all sides. Transfer to a large platter or plate and serve with a bowl of dipping sauce on the side.

— HINT —

It may seem weird but baking powder results in much crispier wings. Try it in any wing recipe!

TAKOYAKI

VIDEO GAME: **Yakuza 0** · YEAR: **2015**

DIFFICULTY: ★ ★ NORMAL | SERVES: 5 OR 6

One of the many things that make Kamurochō and other locations in the *Yakuza* series feel so alive are the functioning eateries throughout the map. Takoyaki appears often, including at Gindaco Highball Tavern, based on a real restaurant chain in Japan, and of course at the takoyaki stand, where one particularly heartwarming cutscene takes place. Takoyaki are a savory delight: Balls of rich batter filled with octopus, tempura bits, green onion, and pickled ginger—the ultimate comfort food. To make this dish, you'll need a takoyaki pan or ebelskiver and two takoyaki picks.

INGREDIENTS

EQUIPMENT

Takoyaki pan or ebelskiver pan
 (optional, see HINT on page 150)
2 takoyaki picks or chopsticks

TAKOYAKI SAUCE

3 tablespoons Worcestershire sauce
2 teaspoons mentsuyu or soy sauce
1 teaspoon granulated sugar
1 teaspoon ketchup

TAKOYAKI

1 cup (125 g) all-purpose flour
4 teaspoons cornstarch
1 medium egg, whisked
1 teaspoon soy sauce
2 cups (480 ml) prepared dashi stock
Neutral oil (such as vegetable
 or sunflower oil), for frying
1 cup cooked octopus
 (or substitution of your choice),
 chopped into ½-inch (1 cm) pieces

2 tablespoons bonito flakes, plus
more for serving
4 green onions, sliced fine
2 tablespoons pickled ginger, minced
½ cup (40 g) tenkasu, agedama,
 or panko bread crumbs

FOR SERVING

Japanese-style mayonnaise
 (I prefer Kewpie)
Bonito flakes
Nori flakes or furikake
Green onions, sliced on a bias

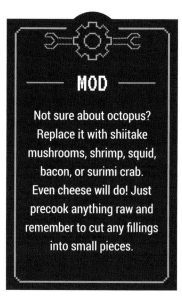

MOD

Not sure about octopus?
Replace it with shiitake
mushrooms, shrimp, squid,
bacon, or surimi crab.
Even cheese will do! Just
precook anything raw and
remember to cut any fillings
into small pieces.

CONTINUE PLAYING ▶

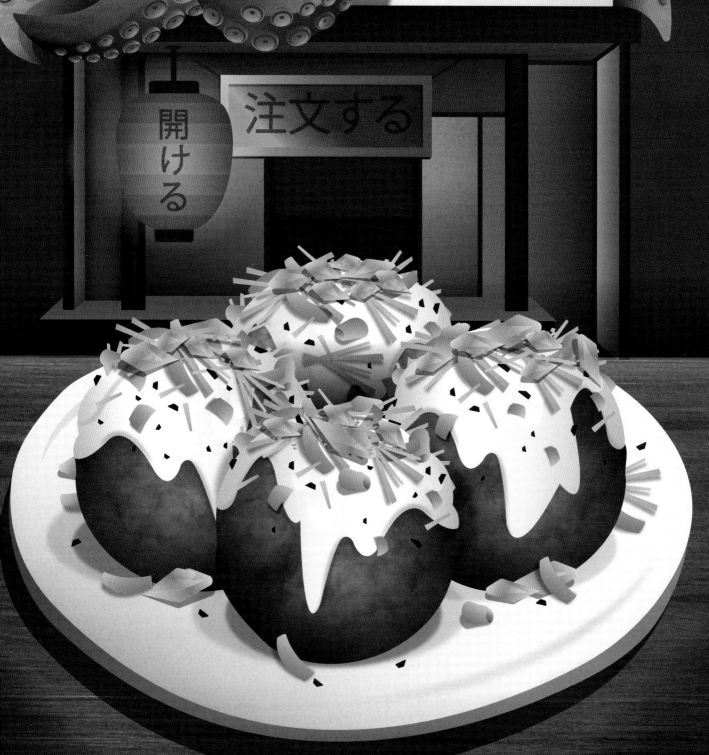

DIRECTIONS

1 **To make the takoyaki sauce:** In a small bowl using a wire whisk, whisk together the Worcestershire sauce, mentsuyu, sugar, and ketchup. Set aside.

2 **To make the takoyaki:** In a medium bowl using a wire whisk, whisk together the flour and cornstarch, then add the egg and soy sauce. Slowly whisk in the dashi to form a thin and runny batter. Transfer the batter to a measuring cup for easy pouring.

3 Bring the takoyaki pan to medium-high heat (400°F/200°C for electric). Brush a neutral oil over the entire cooking surface, making sure to coat inside the wells. Fill each well with batter. (It's okay to slightly overfill them.) Divide the chopped octopus evenly among the wells, putting a few pieces in each cavity, and sprinkle with bonito flakes. Wait about 1 minute, then divide the green onions, ginger, and tenkasu among the wells.

4 Use your takoyaki picks to rotate the takoyaki 90 degrees. If they don't rotate easily, they may need a bit more time to cook on the bottom. Once rotated, cook about 1 minute more, then turn them another 90 degrees. Continue to rotate the takoyaki until all sides are lightly browned and crispy and the balls are easy to rotate, about 10 to 15 minutes. They will become easier to rotate the longer they cook. If the takoyaki become sunken or misshapen, add a bit more batter to fill them out.

5 Transfer the cooked takoyaki to the serving plate(s) and drizzle generously with the takoyaki sauce and Kewpie mayo. Sprinkle liberally with more bonito flakes, nori flakes, and green onions. Serve hot!

— HINT —

If you don't want to buy a takoyaki pan or ebelskiver, pour the batter into ice trays or silicon molds, add the fillings, and freeze solid. Then, deep-fry the frozen batter in neutral oil heated to 350°F to 375°F (180°C to 190°C) for about 4 to 6 minutes. The texture and shape will be different from classic takoyaki but the flavor will be there.

GINGERBREAD

VIDEO GAME: **The Witcher 3: Wild Hunt** ▪ YEAR: **2015**

DIFFICULTY: ★ ★ NORMAL	SERVES: 10 TO 12

The Witcher 3 added a lot of new consumables to the series—and when the *Blood and Wine* expansion was released, things really got interesting. *Blood and Wine* took players to Touissant, the foodie capital of the Continent. There, even the grimiest bandits are likely to drop a bottle of fine wine and some Camembert. Geralt can also learn the highly useful Gourmet ability, which boosts the healing from food by a ton. This recipe is for the Polish-style gingerbread cake Geralt obtains from the Wicked Witch in the Fablesphere, aka the Land of a Thousand Fables, a delightfully twisted fairy tale realm. This gingerbread embodies the spirit of the Witcher, which has always delighted in incorporating—and subverting—traditional European fairy tales and folklore.

INGREDIENTS

GINGERBREAD AND FILLING

½ cup (1 stick/115 g) unsalted butter

⅓ cup (80 ml) rye honey or molasses

½ cup (110 g) dark brown sugar

½ cup (120 ml) cold whole milk

2 cups (250 g) all-purpose
 and/or rye flour, leveled

1 teaspoon baking powder

½ teaspoon baking soda

¼ teaspoon kosher salt

1 teaspoon ground ginger

1 teaspoon ground cinnamon

½ teaspoon ground cloves

¼ teaspoon ground nutmeg

¼ teaspoon ground black pepper

2 teaspoons cocoa powder

2 large eggs

¾ cup (250 g) damson, plum,
 or apricot preserves

CHOCOLATE GANACHE

1 cup (175 g) semi-sweet
 chocolate chips

1 cup (240 ml) heavy
 whipping cream

CONTINUE PLAYING ▶

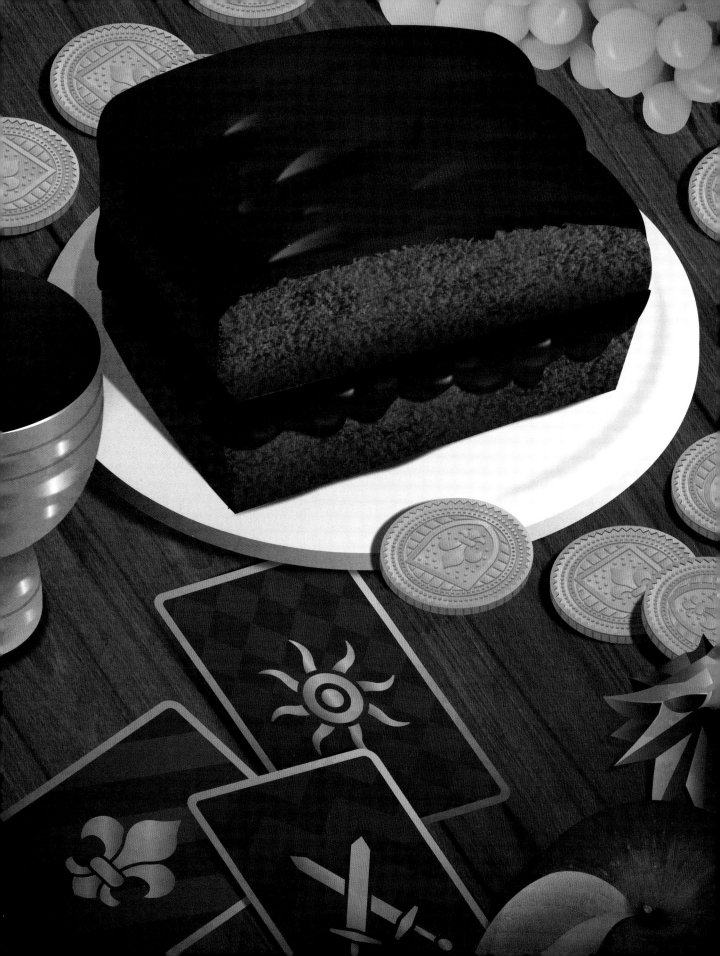

DIRECTIONS

1 **To make the gingerbread and filling:** Preheat the oven to 325°F (170°C; gas mark 3). Grease a 9½-inch (24 cm) nonstick loaf pan and set aside.

2 In a medium saucepan over low heat, heat the butter, honey, sugar, and milk, stirring with a wooden spoon, until the butter starts to melt. (Do not boil.) Remove from the heat and continue stirring until the butter melts completely. Transfer to a large bowl and set aside to cool to room temperature.

3 In a separate medium bowl, sift together the flour, baking powder, baking soda, salt, ginger, cinnamon, cloves, nutmeg, pepper, and cocoa. Once the butter mixture has cooled, use a wire whisk to whisk in the eggs until thoroughly combined. Gradually whisk the flour mixture into the butter mixture just until fully incorporated. Be careful not to overstir. Pour the batter into the prepared loaf pan.

4 Bake on the lower oven rack for approximately 1 hour or until a toothpick inserted into the center comes out clean. If necessary, drape the cake with aluminum foil to prevent the top from burning. Remove the gingerbread from the oven and cool in the pan for 15 minutes before turning it out onto a cooling rack to cool completely.

5 Once cooled, cut the loaf in half to create two squares. Using a serrated knife, carefully cut each square in half horizontally. Spread half of the preserves over the cut part of each bottom layer, then replace the top layer of the cakes.

6 **To make the chocolate ganache:** In a medium heatproof bowl, add the chocolate and cream. Microwave at high power in 20-second intervals until the chocolate is melted and the cream is hot. Stir until smooth and well combined. Let cool, stirring occasionally, until just warm. It should be thick but still pourable.

7 Pour the chocolate ganache over the top of the gingerbread, using the back of a spoon to spread it evenly and allowing some to drip over the sides. Let the ganache set, about 1 to 2 hours, before serving.

— HINT —

Polish-style gingerbread has an intensely spicy and sweet flavor, especially if you use rye flour. Check your local Eastern European grocery store for rye flour, rye honey, and damson jam.

KENNY'S ORIGINAL RECIPE

VIDEO GAME: **Final Fantasy XV** · YEAR: **2016**

| DIFFICULTY: ★ BEGINNER | SERVES: 2 |

The food in *FFXV* has become the stuff of legend—and for good reason! Each of the 109 dishes—which play a major role in the game—is painstakingly rendered in stunning, mouthwatering detail. One of the many culinary delights of *FFXV* is stopping off at a Crow's Nest diner while on the road. The Crow's Nest is a chain of greasy spoons with a lovable mascot called Kenny the Crow. When Noxis and the gang visit the original establishment in Old Lestallum, Ignis (who serves as the party's de facto cook) learns a unique recipe for salmon. With a delightfully rich and zesty smothered salmon steak, Kenny laughs (or caws) at the no-cheese-with-fish stigma.

INGREDIENTS

2 salmon steaks (bones removed)

Salt and ground black pepper,
 to taste

1 tablespoon olive oil

½ yellow onion, finely chopped

6 cloves garlic, minced

¼ cup (60 g) mayonnaise
 (I prefer Kewpie)

2 tablespoons fresh lemon juice

½ tablespoon Dijon mustard

¼ cup (25 g) grated
 Parmesan cheese

½ cup (55 g) shredded
 mozzarella cheese

2 sprigs curly-leaf parsley, for garnish
 (optional)

4 leaves loose leaf lettuce,
 for garnish (optional)

1 tablespoon finely chopped flat-leaf
 parsley, for garnish

DIRECTIONS

1. Preheat the oven to 400°F (200°C; gas mark 6). Line a rimmed baking sheet with aluminum foil. Sprinkle the salmon steaks liberally with salt and pepper and set aside on the prepared baking sheet.

2. Heat the oil in a small skillet over medium heat. Cook the onion until translucent, even a little browned, about 5 minutes. Add the garlic and continue to cook for 2 minutes more, or until both the onions and garlic are softened. Remove from the heat.

3. In a small bowl, combine the mayonnaise, lemon juice, mustard, and cooked onions and garlic.

4. Spread the creamy mayo mixture evenly over the surface of the salmon steaks. (You can leave the two protruding sections uncovered.)

5. Sprinkle the smothered steaks with half of the Parmesan cheese, followed by the mozzarella cheese, then the other half of the Parmesan.

6. Bake the salmon for 15 to 18 minutes. Switch the oven to the broil setting and turn the heat up to high. Broil for 1 to 3 minutes, until the cheese is golden brown and bubbly (like a pizza). Let cool for 10 minutes, or until the cheese has set somewhat.

7. To serve, transfer the salmon steaks to their serving plates and garnish each with a sprig of parsley and 2 slices of lettuce (if using). Sprinkle the chopped parsley over both dishes.

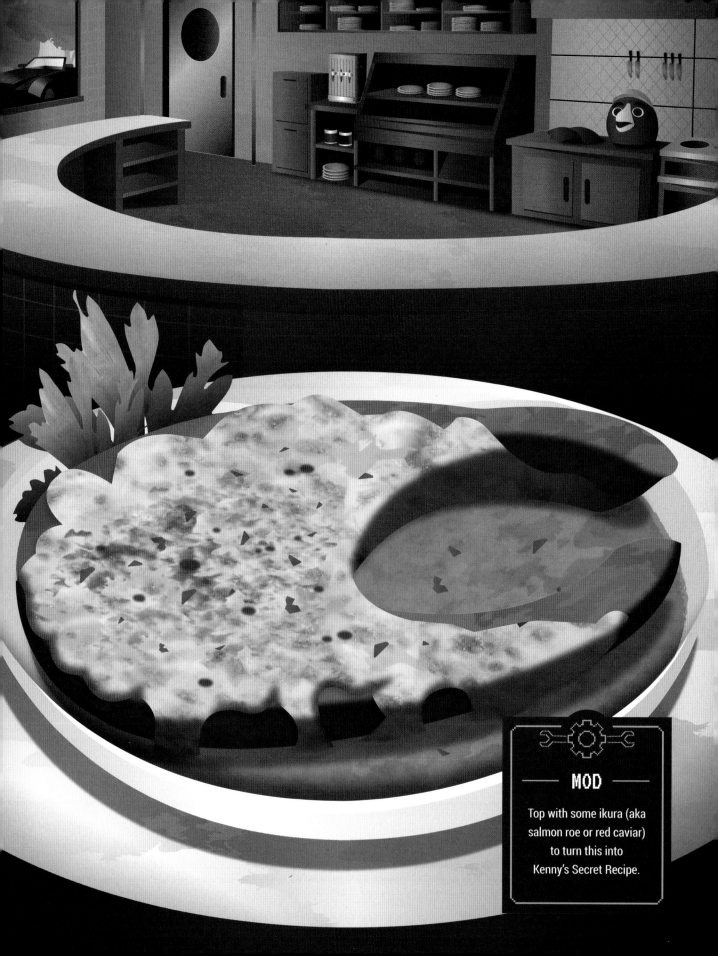

MOD

Top with some ikura (aka salmon roe or red caviar) to turn this into Kenny's Secret Recipe.

ESTUS SOUP

VIDEO GAME: **Dark Souls III** · YEAR: **2016**

DIFFICULTY: ★ BEGINNER	SERVES: 6 TO 8

Estus is the primary healing consumable in the *Dark Souls* series. The contents are never explained, but it appears to be liquid flame in a bottle, perhaps the bottled essence of the lifegiving bonfires. Estus Soup, introduced in *Dark Souls III*, is equally mysterious. With the smoky flavor of bacon to represent the bonfire, a touch of citrus to represent the sun, bone broth for the undead, and, of course, an onion for Siegward of Catarina, this flavorful soup will make you feel as incandescent as the sun. Long may you shine!

INGREDIENTS

6 slices thick-cut smoked bacon, chopped, plus more for topping

1 large yellow onion, diced

4 cloves garlic, minced

8 large carrots, peeled and sliced

1 stalk celery, diced

Salt and ground black pepper, to taste

4 to 5 cups (960 ml to 1.2 L) chicken bone broth

1 tablespoon cream sherry

1 teaspoon smoked paprika

¼ teaspoon ground nutmeg (optional)

¼ teaspoon chipotle powder (optional)

1 tablespoon lemon juice

1 teaspoon fresh orange zest

½ cup (120 ml) whole milk

½ cup (120 ml) heavy whipping cream

2 tablespoons chopped chives, for garnish

DIRECTIONS

1 In a Dutch oven over medium heat, cook the bacon until crisp. Use a slotted spoon to transfer the cooked bacon to a paper-towel-lined plate and set aside. Leave the rendered fat in the pot. Add the onion and cook until translucent, 2 to 3 minutes, then add the garlic and cook until fragrant, 1 minute more. Add carrots and celery, season with salt and pepper, and cook for 6 to 7 minutes, until the veggies have softened somewhat. Add 4 cups (960 ml) of the bone broth, sherry, smoked paprika, nutmeg, chipotle powder (if using), and half of the cooked bacon. Bring the soup to a low boil. Once boiling, immediately reduce the heat to low, cover, and cook for 20 to 25 minutes, until carrots are soft. Remove from the heat and add the lemon juice and orange zest.

2 Carefully transfer the soup to a blender. Cover, with the center part of the blender cover removed to let steam escape, and puree until smooth. (You can also use an immersion blender directly in the pot.) Add a little more broth, about a tablespoon at a time, if the mixture is initially too thick to blend. Return the soup to the pot and continue to cook on low for 3 to 4 minutes until heated through. Remove from the heat, then stir in the milk and cream. Taste and adjust seasonings.

3 Serve hot in bowls or flasks. Garnish with chives and the remaining bacon.

TACO TORNADO

VIDEO GAME: **Overwatch** ▪ YEAR: **2016**

DIFFICULTY: ★ ★ NORMAL	YIELD: 6 TACOS

Each eatery in *Overwatch* has its own unique personality and menu. The Taco Tornado is one of the many delightfully casual dishes to be had at the Panorama Diner on the game's iconic Route 66 map. The interior of this kitschy Americana restaurant contains many Easter eggs and references to Blizzard's other titles, if one cares to look closely. But whatever you do, don't drink the coffee!

INGREDIENTS

"TORNADO" SHELLS

Neutral oil (such as vegetable or canola oil), for deep-frying

6 extra-large (burrito size) flour tortillas

Toothpicks (for securing)

TACO MEAT

1½ pounds (675 g) lean ground beef

1 tablespoon all-purpose flour, plus more if needed

1 tablespoon chili powder

2 teaspoons ground cumin

1 teaspoon garlic salt

1 teaspoon bouillon powder

1 teaspoon dried minced onion

½ teaspoon paprika

½ teaspoon onion powder

½ teaspoon brown sugar

½ teaspoon cocoa powder

1 tablespoon olive oil

1 small yellow onion, finely chopped

4 cloves garlic, minced

TACO FIXINGS

Shredded lettuce

Shredded Mexican blend cheese

Sour cream

Taco sauce or hot sauce

Chopped cilantro

Sliced green onions

Chopped Roma tomatoes or pico de gallo

Jalapeños, seeded and sliced, or pickled

Lime wedges

CONTINUE PLAYING ▶

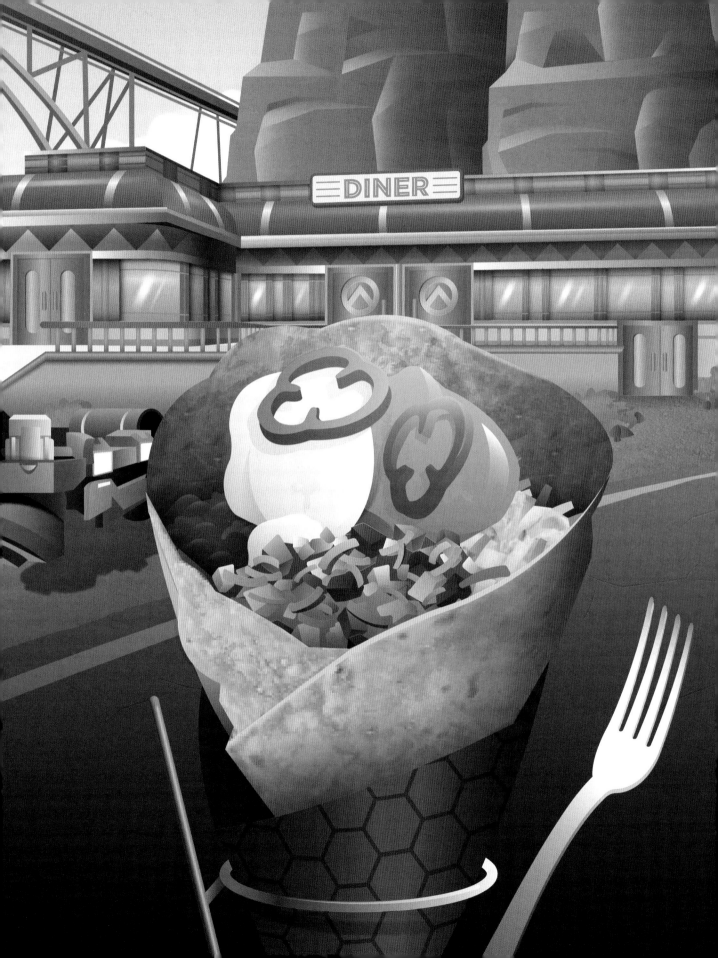

DIRECTIONS

1 **To make the "tornado" shells:** Heat the neutral oil in a deep fryer or thick-bottomed pot to 365°F (185°C), measured by a thermometer. Roll the flour tortillas into a cone and secure the ends with 1 or 2 toothpicks. Once the oil is hot enough, working one or two at a time, use tongs to place the tortilla cone into the oil. Fry, rotating and reshaping the cone as needed, for 1 to 2 minutes, until the tortilla is browned but has not become brittle or burned. Transfer the fried tornado shells to a paper-towel-lined plate to dry. Gently press down any large air bubbles.

2 **To make the taco meat:** In a large bowl, combine the ground beef with the flour, chili powder, cumin, salt, bouillon, dried onion, paprika, onion powder, brown sugar, and cocoa powder.

3 Heat the olive oil over medium-high heat. Add the onion and sauté until translucent, about 2 minutes. Add the garlic and cook until fragrant, about 1 minute more. Add the ground beef mixture, breaking up big pieces with a wooden spoon, and cook until browned, 5 to 6 minutes. Drain excess grease, then add ¼ cup (60 ml) water. Cook for another 5 to 6 minutes until the water is absorbed. Taste and adjust seasoning.

4 **To assemble the taco tornados:** Working horizontally (like you would with a burrito) to ensure a balanced bite, spoon the desired amount of taco meat on the longest side of the shell, then add the lettuce, cheese, sour cream, and taco sauce. Top with the cilantro, green onions, tomatoes, salsa, jalapeños, and lime wedges. Wrap the narrow end of the tornado in parchment paper so you can hold it upright while eating without getting your hands greasy. Serve with a fork.

❄ EASY MODE ❄

Use a store-bought taco seasoning packet to season the beef. You can also skip the frying step and opt for a "soft" taco tornado. Just sprinkle the tortillas with cheese and warm them for 20 seconds in the microwave to make them more pliable, then roll them into the cone shape. Add the taco meat and other toppings as noted.

PANCAKES

VIDEO GAME: **Persona 5** ▪ YEAR: **2016**

| DIFFICULTY: ★ ★ ★ EXPERT | YIELD: 3 PANCAKES |

Did somebody say something about delicious pancakes? In most games with cooking mechanisms, the cooking is the most interactive part of the process. In *Persona 5*, the real action lies in the eating. And there's a lot to eat: extravagant buffets, Japanese favorites like okonomiyaki and shiruko, various curries, burgers that embody the limitless nature of space, and of course, delicious pancakes. These soufflé pancakes look just like the stadium in Dome Town (a version of Tokyo's Dome City) and are so light and fluffy that they might just transport you to another metaverse!

INGREDIENTS

¼ cup (30 g) all-purpose flour

3 tablespoons caster or superfine sugar, divided

½ teaspoon baking powder

2 large eggs, chilled

2 tablespoons whole milk

¼ teaspoon vanilla paste or extract

Pinch of kosher salt

¼ teaspoon cream of tartar

2 teaspoons neutral oil (such as canola or grapeseed oil)

Confectioners' sugar, for serving (optional)

Butter, softened, for serving

Warm maple syrup, for serving

DIRECTIONS

1 In a small bowl, sift together the flour, two tablespoons of the sugar, and the baking powder.

2 Separate the eggs, putting the yolks in one medium mixing bowl and the egg whites into another. (For the meringue we'll whip up in step 4, extremely clean glass or stainless-steel mixing bowls will give you the best results. Plastic bowls can absorb residues that affect how meringue sets.) Set the egg whites in the fridge.

3 To the bowl with the egg yolks, add the milk and vanilla and beat with a wire whisk until frothy. Sift the flour mixture into the egg yolk mixture. Whisk to thoroughly combine, but take care to not overmix. Set aside while you make the meringue.

❋ EASY MODE ❋

Use ring molds to ensure the thickness and shape of your pancakes. Place these directly into the preheated pan, spray the insides of the rings with cooking spray, and fill them about halfway full with batter. Flip the whole thing—ring and batter—when it's time to flip the pancakes.

4 Remove the mixing bowl with the egg whites from the fridge. Add in the salt and the cream of tartar. Using a handheld electric mixer, beat the egg whites on high speed until frothy and pale, about 1 minute. Continuing to beat on high speed, add the remaining sugar, about 1 teaspoon at a time, until stiff glossy peaks form, 1 to 2 minutes more. The meringue should hold a peak but not be too hard or grainy. (If it is, you've overmixed it. Discard it and start over with fresh egg whites.)

5 Preheat a large nonstick pan (with a lid) over very low heat. Lightly brush the pan with oil and rub it around with a paper towel, creating a thin layer of oil. Keep the pan on very low heat while you complete the next step.

6 Add about ⅓ of the meringue to the egg yolk mixture and use a wire whisk to gently combine. Then add half of the remaining meringue to the egg yolk mixture. This time, gently fold the meringue into the yolk mixture while taking great care to not break any air bubbles. Finally, transfer the egg yolk mixture into the bowl with the remaining meringue. Very gently fold the yolk mixture and the remaining meringue together, doing your best to not deflate the meringue as you fold.

7 Using an ice cream scoop or ¼ measuring cup, transfer one scoop of batter into the pan, making a small mound. Then, stack one more scoop of batter onto the first. Don't spread the batter! The mounds should be tall, not wide. Repeat to make 3 pancakes. There will be some batter left over; set this aside.

8 Drizzle 2 to 3 teaspoons of water into the empty spaces in the pan (don't let the water touch the pancakes). If the water sizzles and evaporates right away, turn the heat down and add a little more water. Cover the pan with a lid and let the pancakes cook in the steam for 6 to 8 minutes as they start to set.

9 Uncover the pan and divide the remaining batter evenly in scoops on top of the three pancake mounds. Cover the pan again and cook for 3 to 5 minutes more.

10 Uncover the pan and use an offset spatula to carefully flip the pancakes. If they stick to the pan, give them a couple more minutes to set; the pancakes will break or tear if you force them. Once you've flipped all the pancakes, add another 2 teaspoons of water to the empty space in the pan and cover again. Cook for another 4 to 5 minutes, until nicely browned on both sides.

11 To serve, stack the pancakes on a serving plate. Dust with confectioners' sugar (if using), and top with butter and maple syrup. Serve immediately with a cup of strong black coffee.

MOD

Both cream of tartar and superfine sugar are here to make this intimidating recipe just a tad easier and keep your pancakes light and fluffy. Cream of tartar, which helps stabilize your meringue, is normally found with baking ingredients or in the spice section of the grocery store. If you can't locate it, substitute ½ teaspoon of lemon juice or white vinegar. Superfine sugar dissolves more easily than granulated sugar and makes for a more stable meringue—but it too can be hard to find. In a pinch, you can run granulated sugar through a food processor or blender for about 30 seconds.

BLACKBERRY COBBLER

VIDEO GAME: **Stardew Valley** · YEAR: **2016**

DIFFICULTY: ★ BEGINNER	SERVES: 6 TO 8

In *Stardew Valley*, the epic farm-simulating RPG, the player is given the monumental task of rebuilding the small farm they inherited from their grandfather, all while learning the secrets and idiosyncrasies of nearby Pelican Town. Making food can help the player bond with the townsfolk, boost the player's stats, and earn plenty of money. The most reliable way to learn new recipes in *Stardew Valley* is to tune into the *Queen of Sauce*, a cooking show that airs every Sunday in-game. The Queen of Sauce specifically says that the blackberry cobbler reminds her of Stardew Valley, with its abundance of blackberries to be foraged in the summertime. It's a very profitable recipe during blackberry season and one of Abigail's favorites.

INGREDIENTS

QI SEASONING (OPTIONAL)

½ teaspoon brown sugar

⅛ teaspoon ground ginger

⅛ teaspoon ground allspice

⅛ teaspoon ground nutmeg

Pinch of ground white pepper
 or cayenne (optional)

FILLING

Butter, for greasing

5 cups (700 g) fresh ripe
 blackberries

1 cup (200 g) granulated sugar

½ teaspoon ground cinnamon,
 or more to taste

1 teaspoon vanilla paste or extract

1 teaspoon lemon zest

3 tablespoons cornstarch

¾ cup (180 ml) lukewarm water

TOPPING

1½ cups (155 g) all-purpose flour

2 tablespoons granulated sugar

1½ teaspoons baking powder

½ teaspoon kosher salt

¾ cup (1½ sticks/170 g) cold
 unsalted butter, cut into
 tablespoons

⅓ cup (80 ml) cold buttermilk,
 plus more as needed

3 tablespoons turbinado sugar

Vanilla ice cream, for serving
 (optional)

CONTINUE PLAYING ▶

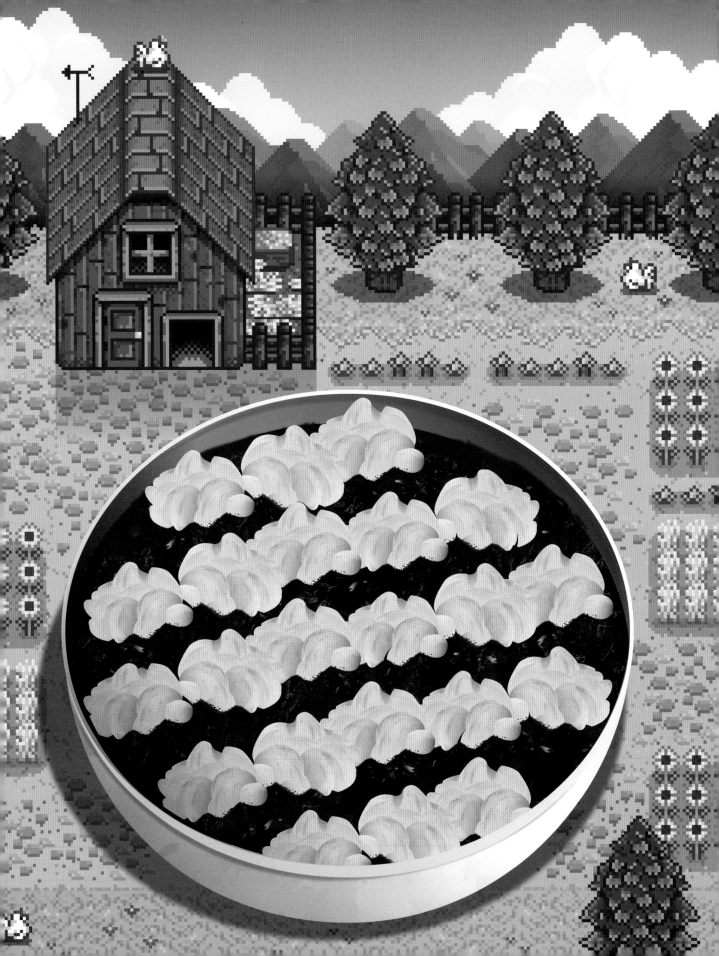

DIRECTIONS

1. **To make the Qi seasoning (if using):** In a small bowl, combine the brown sugar, ground ginger, allspice, nutmeg, and pepper. Set aside.

2. **To make the filling:** Grease a 9-inch (23 cm) round baking dish generously with butter and set aside. Preheat the oven to 350°F (180°C; gas mark 4). In a large saucepan over medium heat, add the blackberries, sugar, cinnamon, vanilla, lemon zest, and Qi seasoning (if using) to taste and stir to combine. Bring to a low boil. Once boiling, reduce the heat to simmer. In a separate small bowl, whisk the cornstarch and water together until smooth. Slowly pour the cornstarch slurry into the blackberry mixture, stirring continuously. Simmer, stirring frequently, for 3 to 4 minutes, until the mixture has thickened. Pour the blackberry mixture into the prepared baking dish. Set aside.

3. **To make the topping:** In a medium bowl, sift together the flour, sugar, baking powder, and salt. Using a pastry cutter or a fork, cut in the butter until the mixture resembles coarse crumbs. With a wooden spoon, stir in the buttermilk until the dough is just moistened. Add more buttermilk as needed for the dough to come together. The dough should be sticky but not too wet to hold together.

4. Drop tablespoons of dough on top of the berry mixture, making a diagonal pattern. Sprinkle the turbinado sugar on top of the dough, along with some more Qi seasoning, if desired.

5. Bake, uncovered, for 30 to 35 minutes, until the filling is bubbly and the topping is golden brown. Let the cobbler cool in the pan for 10 to 15 minutes. Serve warm, with a scoop of vanilla ice cream on top of each serving, if desired.

MOD

The beautiful thing about cobblers is that you can make them with whatever fruits are in season! Swap out blackberries for strawberries and rhubarb in spring, peaches and mango in summer, or apples and cranberries in fall. In winter, use canned or preserved fruits. Baking a cobbler for every season will make you feel like a real citizen of Pelican Town!

POUTINE

VIDEO GAME: **Divinity: Original Sin 2** ▪ YEAR: **2017**

DIFFICULTY: ★ ★ ★ EXPERT	SERVES: 2 OR 3

Food items have been a part of the highly underrated *Divinity* series since *Divine Divinity* (2002), but they've generally been very elemental (bread, water, etc.) until *Original Sin*. The game states that poutine is widely considered to be a variation of the food served in the Hall of Echoes, the ethereal plane where the gods reside and that functions as an afterlife for mortals. It is easily the most useful food in the game—and doesn't have all the guilt of cooked Ishmashell. Poutine, of course, is a beloved Canadian dish that consists of fries, brown gravy, and cheese curds, a combination that is truly ambrosial. See you in the Hall of Echoes!

INGREDIENTS

FRIES

2 large russet potatoes, peeled and
 cut into ¼- to ½-inch (5 mm to
 1 cm) matchsticks

4 cups (960 ml) neutral oil (such
 as vegetable or grapeseed oil),
 for deep-frying

½ teaspoon seasoned salt,
 or to taste

GRAVY

1 tablespoon olive oil

½ yellow onion, finely chopped

4 cloves garlic, minced

½ teaspoon dried thyme

1 teaspoon ground black pepper

6 tablespoons unsalted butter

¼ cup (30 g) all-purpose flour

1 tablespoon Worcestershire sauce

1 cup (240 ml) beef broth, plus more
 as needed

Salt, to taste

FOR SERVING

1 cup (8 ounces/225 g) white
 cheddar cheese curds

1 tablespoon chopped fresh chives,
 for garnish (optional)

❄ EASY MODE ❄

Hear ye! Hear ye! To save time, you can use frozen premade fries and cook as the label directs.

CONTINUE PLAYING ▶

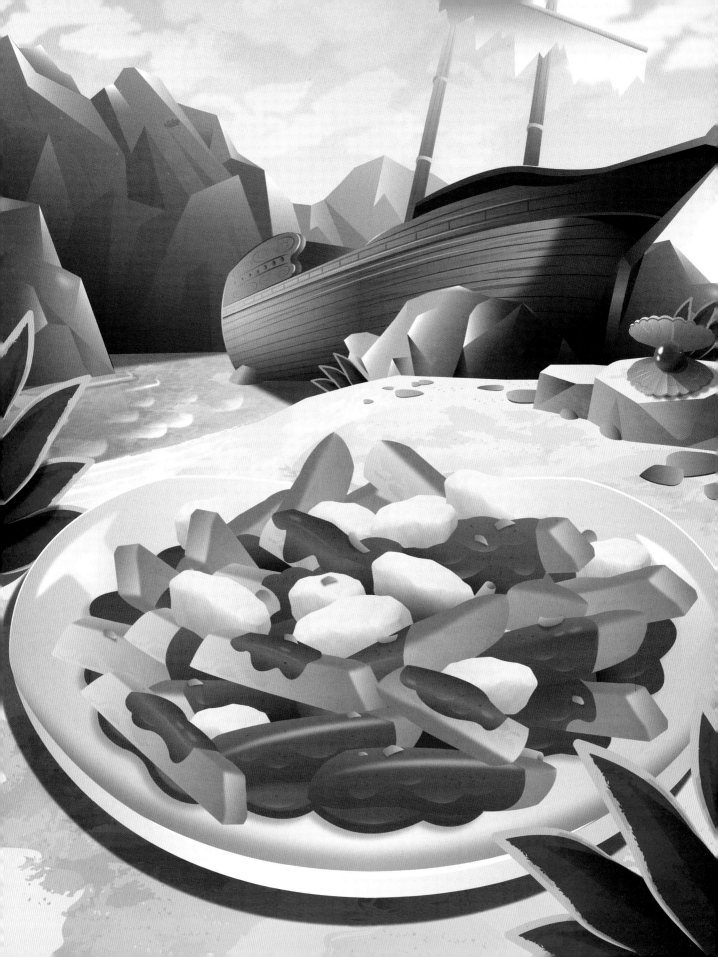

DIRECTIONS

1 In a large bowl filled with cold water, submerge the potatoes and let soak for at least 1 hour, or overnight for extra-crispy fries. Drain well and pat them completely dry.

2 **To make the gravy:** In a medium saucepan over medium heat, heat the olive oil. Add the onion and cook until translucent, 2 to 3 minutes, then add the garlic and cook until fragrant, 1 minute more. Add in the thyme and pepper and cook for 2 more minutes. Add the butter and stir until melted, then add the flour and cook for 5 minutes, stirring constantly. Stir in the Worcestershire sauce and then the beef broth, ¼ cup (60 ml) at a time, stirring after each addition until smooth. If the gravy is too thick, add ¼ cup (60 ml) more broth until the desired consistency is reached. Bring to a boil, then reduce the heat to a simmer and cook for 2 minutes. Taste and adjust the seasoning. Strain the gravy through a mesh strainer into a pouring container, like a Pyrex measuring cup. Wrap with plastic wrap and set aside.

3 **To make the fries:** Line a baking sheet with paper towels and set aside. Pour at least 4 inches (10 cm) of the neutral oil into a thick-bottomed pot or to the fill line of a deep fryer. Heat the oil to 325°F (170°C), measured by a thermometer. Add a small batch of potatoes to the oil and fry for 4 to 6 minutes, until lightly golden, stirring occasionally. Transfer the fries to the prepared baking sheet and repeat until all the fries are cooked.

4 Let the fries cool for 20 minutes, then increase the oil temperature to 400°F (200°C). Working in batches, add the fries back to the pot and fry for a second time until they are crisp and golden brown, about 3 to 4 minutes more. Transfer the fries back to the prepared baking sheet and immediately sprinkle on a generous amount of seasoned salt and toss.

5 Reheat the gravy on the stove if necessary. Transfer the fries to a serving plate, ladle on hot gravy, and toss with tongs to coat. Top with the cheese curds. Ladle on additional gravy to taste. Sprinkle with chopped chives (if using) and serve immediately.

MOD

You can also use an air fryer to make the fries. Spread 2 tablespoons of oil over the fryer basket. Arrange the cut potatoes in a single layer in the basket with space in between each one. Make sure the basket isn't overcrowded so the fries will crisp up. Air-fry at 380°F (190°C) for 12 to 15 minutes, flipping halfway. Take the fries out and set aside when they're crisp and brown around the edges. Repeat until you've cooked all the fries.

CREAMY HEART SOUP

VIDEO GAME: **The Legend of Zelda: Breath of the Wild** ▪ YEAR: **2017**

| DIFFICULTY: ★ BEGINNER | SERVES: 4 TO 6 |

The first open-world Zelda game, *Breath of the Wild* introduced a lot of new ideas to the series. One of the most delightful and satisfying of these was cooking. Throughout Hyrule, ingredients can be foraged and combined to make a staggering 118 stat-boosting dishes—dishes that are necessary for Link to survive the variety of environments in Hyrule. Discovering new dishes usually involves a lot of trial and error, but once Link can enter Gerudo Town, he can attend an evening cooking class and learn how to make Creamy Heart Soup. With fresh milk, voltfruit, hydromelon, and hearty radish, the game calls this a sweet soup and suggests eating it with a partner. In the heat of the Gerudo Desert, this chilled dessert soup would be quite refreshing indeed.

INGREDIENTS

TOPPINGS

3 to 5 large kiwis (about
 ¾ pound/350 g), peeled

Half a mini seedless watermelon

1 to 2 ripe red guavas (about
 1 pound/450 g), or 3 large
 strawberries

SOUP

2 cups (290 g) fresh ripe strawberries

2 cups (300 g) frozen strawberries

⅓ cup (80 ml) honey, plus more
 if needed

½ cup (120 ml) heavy cream

½ cup (120 ml) whole milk

½ cup (120 ml) orange juice

⅓ cup (80 g) sour cream

⅓ cup (80 g) vanilla yogurt

1 teaspoon vanilla paste or extract

DIRECTIONS

1 **To make the toppings:** Use a melon baller or a teaspoon to scoop spheres out of the kiwi and watermelon, making 12 to 18 of each. Create the hearts. If using guava, cut six 1½-inch-thick (4 cm) slices and use a heart-shaped cookie cutter to cut out 6 guava hearts. If using large strawberries, use a paring knife to cut the 3 strawberries in half and carve them into hearts. (You can cut a V into the tops and then narrow the bottoms into sharper points.)

2 **To make the soup:** In a blender or food processor with the knife blade, puree the fresh and frozen strawberries with the honey. (You may need to add a bit of water to loosen them up.) Add in the cream, milk, juice, sour cream, yogurt, and vanilla and blend until just combined. Taste and adjust the sweetness with more honey, if desired.

3 Pour the soup into the serving bowls and arrange the toppings as in the game's depiction: 1 large guava or strawberry heart at the top right quadrant of each bowl, with 5 alternating small spheres of watermelon and kiwi surrounding it. (Use the picture or the game itself for reference!) Serve chilled.

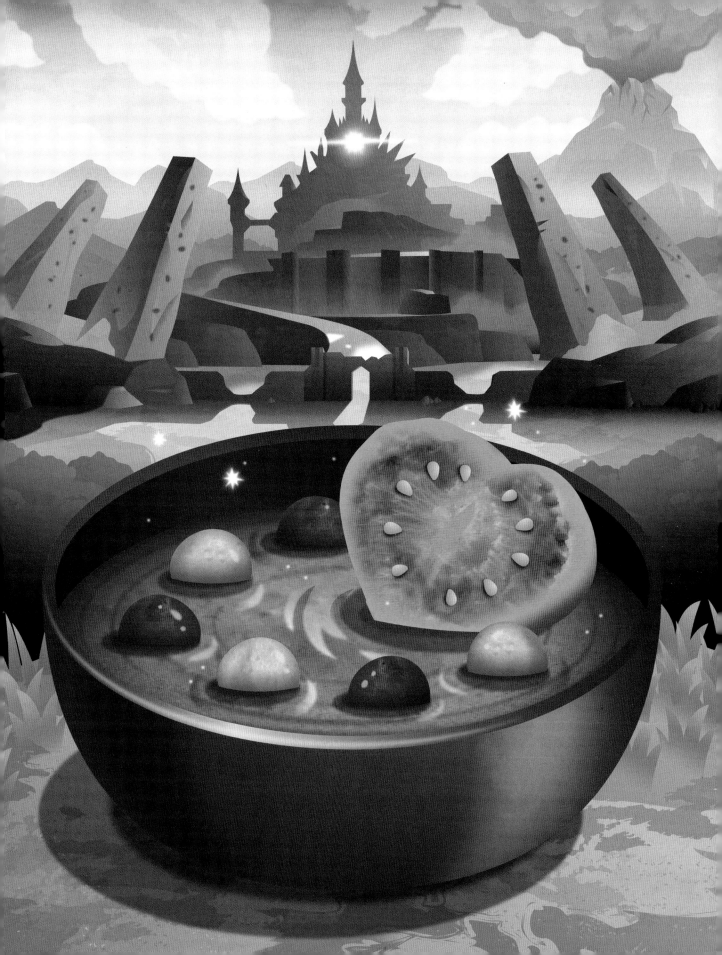

STUPENDOUS STEW

VIDEO GAME: **Super Mario: Odyssey** ▪ YEAR: **2017**

| DIFFICULTY: ★ BEGINNER | SERVES: 4 TO 6 |

The evolution of the food level is brilliantly showcased in *Super Mario: Odyssey*'s eleventh world, Luncheon Kingdom, a spectacle of gigantic foodstuff and psychedelic colors. While traveling to Luncheon Kingdom, Cappy tells Mario that the land is famous for a volcano-created dish called Stupendous Stew. The stew is apparently cream-based, with lots of colorful veggies and some very special meat. This recipe is a take on Japanese cream stew with a few key twists: a speedrun of salty "aged" meat, a variety of colorful veggies that appear in the stew and throughout the level, plus a hint of rock-hard cheese. The flavor is described in-game as "melty deliciousity," and that is apt. Let's a-go!

INGREDIENTS

1½ pounds (675 g) boneless pork loin or chicken thighs

¾ cup (180 ml) heavy whipping cream

5 tablespoons all-purpose flour

¼ cup (30 g) dry milk powder

3 tablespoons unsalted butter

1 white onion, chopped

2 carrots, sliced into rounds

1 medium gold potato, peeled and cut into 1½-inch (4 cm) pieces

2 medium zucchini, sliced into rounds

1 large ear corn, husks and silks removed and cut into 4 small cobs

1 red bell pepper, seeded and chopped

Salt and ground white pepper, to taste

4 cups (960 ml) prepared dashi stock or chicken broth

1 small turnip, peeled and cut into 1-inch (2.5 cm) pieces

2 teaspoons onion powder

½ teaspoon ground ginger

1 teaspoon chicken bouillon powder or all-purpose seasoning

¼ teaspoon ground nutmeg (optional)

½ cup (115 g) cream cheese, softened

1 tablespoon grated Parmesan, or to taste, plus more for serving

DIRECTIONS

1 Pat the meat dry and sprinkle liberally with salt. Set aside for 1 hour.

2 In a medium bowl, combine the cream, flour, and dry milk powder until it forms a smooth paste. Set aside.

3 Heat a heavy-bottomed saucepot over medium-high heat and add the butter, onion, carrots, potato, zucchini, corn, and red pepper. Sprinkle with salt and white pepper. Sauté the vegetables, stirring constantly for 4 to 6 minutes, until the onions are translucent. Do not let them brown, as this will alter the color of the stew.

4 Cut the meat into 1-inch (2.5 cm) pieces.

5 Add the dashi, meat, turnip, onion powder, ginger, bouillon, and nutmeg (if using) to the saucepot with the vegetables and increase the heat to high. Bring the liquid to a boil, skimming away any scum or oil that floats to the top, then reduce the heat to low. Cover the pot with the lid slightly askew, and simmer for 15 minutes, until the meat is cooked through, the veggies are mostly tender, and the liquid is slightly reduced.

6 Add one ladle of the hot broth into the cream mixture and use a wire whisk to whisk until completely smooth and lump-free.

7 Pour the cream mixture into the stew and add the softened cream cheese and Parmesan. Stir to combine. Bring the stew to a low simmer (be careful not to boil) and cook for another 5 to 10 minutes, until the stew thickens. Taste and adjust seasoning. Serve with more Parmesan, if desired.

✳ EASY MODE ✳

This stew is already as easy as stomping goombas, but you can make it even easier by using cream stew roux cubes in place of the cream, flour, and dry milk mixture. Just note that the cubes are preseasoned, so you might want to cut back on the salt, skip the bouillon powder, and replace the dashi with water. The package may or may not call for adding milk.

You can buy cream stew roux cubes online or at your local Asian grocery store.

DURR BURGER

VIDEO GAME: **Fortnite** ▪ YEAR: **2017**

DIFFICULTY: ★ ★ NORMAL | YIELD: 4 BURGERS

One of the most iconic and recognizable video game mascots is an anthropomorphic cheeseburger. With the launch of *Fortnite: Battle Royale*, Durr Burger started out as a landmark in Greasy Grove. Since then, it has had a wild ride throughout the game's many seasons. It broke the fourth wall when the Durr Burger head disappeared from the game only to be found in the middle of the California desert, and completely smashed it when the in-game rivalry between Durr Burger and Pizza Pit spawned a very real player rivalry. *Fortnite* takes place on an island where there exists a SPAM-like product called MEET, and teriyaki SPAM makes a tasty alternative to actual human tongue.

INGREDIENTS

BURGER SAUCE
½ cup (120 g) mayonnaise

¼ cup (60 ml) teriyaki sauce

2 tablespoons honey, runny

Pinch of cayenne (optional)

FIXINGS
8 pearl onions, peeled

8 black olives

4 pimento-stuffed green olives

4 sesame seed buns, lightly toasted if desired

4 thick slices beefsteak tomato

"TONGUES"
4 thin slices (⅛ to ¼ inch/3 to 5 mm) bacon-flavored or regular SPAM

1 tablespoon teriyaki sauce

2 tablespoons dark brown sugar

¼ teaspoon finely ground black pepper

1 tablespoon neutral oil (such as vegetable or grapeseed oil)

BEEF PATTIES
1½ pounds (675 g) 80% lean ground beef

2 teaspoons salt

2 teaspoons smoked paprika

2 teaspoons onion powder

2 teaspoons garlic powder

¾ teaspoon ground black pepper

¼ cup (60 ml) teriyaki sauce

4 slices sharp cheddar cheese

— MOD —

Not a fan of SPAM? Try chunk-style Canadian bacon (aka back bacon or peameal bacon) or a wide slice of turkey bacon. Cooking times may vary.

CONTINUE PLAYING ▶

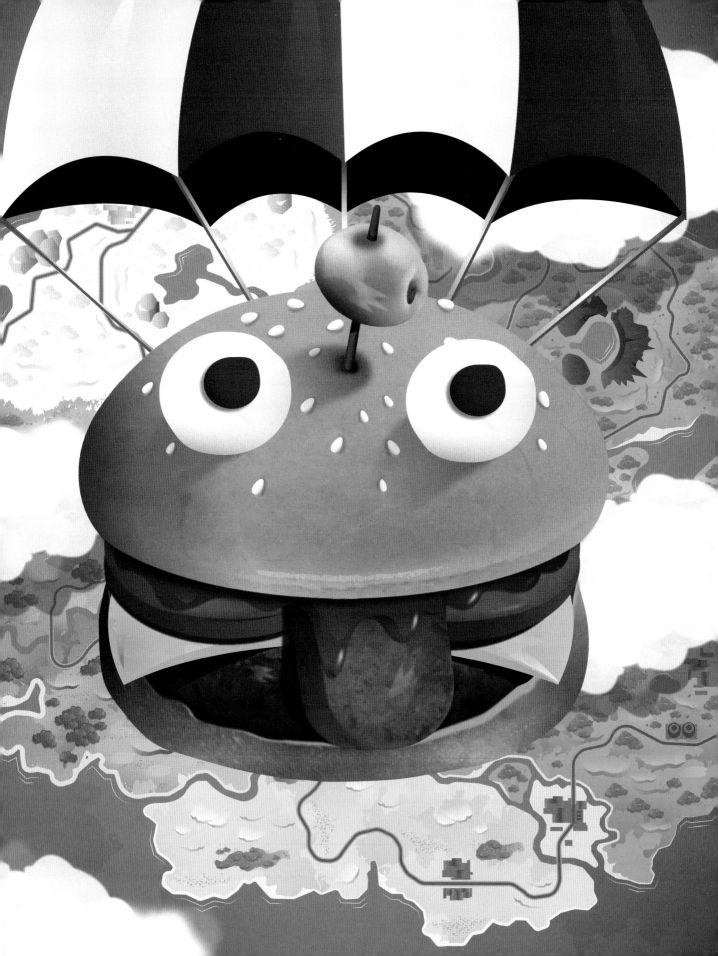

DIRECTIONS

1 **To make the burger sauce:** In a small bowl, combine all the sauce ingredients and set aside.

2 **To prepare the fixings:** Create the eyes by cutting the ends off the pearl onions, then hollow out the insides of each one using a paring knife. Chop the ends off the black olives, then dice the rest. Stuff the diced olive pieces into the hollows of the pearl onions. Stick the ends of the olives on toothpicks and push them into the onion hollows to create the black pupils. Insert 1 toothpick into the bottom of each eye, holding the olives in place with your fingers. You should have 8 complete eyeballs. Set aside. Pierce each of the green olives with toothpicks. Set aside.

3 **To make the "tongues":** With a paring knife, round the edges of the SPAM slices into a tongue-like shape. In a small bowl, stir together the teriyaki, brown sugar, and pepper. Heat the oil in a medium nonstick skillet over medium-low heat. Add the SPAM slices and cook until browned, 2 to 3 minutes per side. Then brush the SPAM slices with the glaze and cook until it thickens and sticks to the SPAM, about 30 seconds per side. Remove the slices from the pan and set aside.

4 **To make the beef patties:** In a medium bowl, mix the ground beef with the salt, paprika, onion and garlic powders, and pepper. Form into 4 equal-size patties.

5 Grill the patties over direct heat or cook in a preheated skillet. For medium doneness, cook for 3 minutes on one side, add a splash of the teriyaki sauce on each, then flip. Place a slice of cheese on each patty and let it melt while the burger cooks through, 3 minutes more.

6 **To assemble the Durr Burgers:** Spread the sauce on the top and bottom buns. Set a burger patty on the bottom bun and top with a slice of tomato. Set a SPAM slice partly on the tomato and partly sticking out from the bun. Cover the burger with the top bun. Insert two eyeball-topped toothpicks deep into the top bun so the toothpick isn't visible and the onions look like two uneven eyeballs. Insert the toothpick with the olive into the top of the bun. Repeat for each burger. Take pictures before sliding the SPAM "tongue" back into the burger and taking a big bite.

✳ **EASY MODE** ✳

Skip making burgers from scratch by using frozen premade patties and cooking according to package directions.

PEARSON'S STEW

VIDEO GAME: **Red Dead Redemption 2** · YEAR: **2018**

| DIFFICULTY: ★ ★ NORMAL | SERVES: 8 TO 10 |

RDR2 introduced campfire cooking with wild game and herbs, as well as a variety of intriguing dishes to be found in the game's nine saloons. Players must eat to remain healthy, and one of the most reliable meals in the game is Pearson's Stew. Living in the Van der Linde camp, Pearson spends his days swigging beer, slicing meat, chopping carrots, and throwing ingredients into a large cooking pot. Arthur can eat a bowl of the stew for free every time Pearson graces the gang with a pot of the stuff. It's likely Pearson pours some of that beer into the stew every now and then. We'll also throw in some of Susan's "secret" herbs—while Pearson's not looking, of course. Restore your core and enjoy this hearty stew with a mug of hot black coffee and some biscuits.

INGREDIENTS

3 pounds (1.3 kg) venison shoulder or boneless beef chuck, cut into 1½-inch (4 cm) pieces

¼ cup (30 g) all-purpose flour

2 tablespoons extra-virgin olive oil, plus more as needed

1 large yellow onion, chopped

6 cloves garlic, minced

1 tablespoon Worcestershire sauce

3 tablespoons tomato paste

1 bottle of beer (porter or dark lager work best)

3 cups (720 ml) beef stock

1 tablespoon fresh thyme leaves

2 leaves fresh mint, chopped

1 teaspoon chopped fresh oregano leaves

1 teaspoon dried marjoram

½ teaspoon dried sage

2 bay leaves

1 pound (450 g) Yukon Gold potatoes, sliced (peeling optional)

4 large carrots, peeled and roughly chopped (about 3 cups/420 g)

2 stalks celery, chopped

Salt and ground black pepper, to taste

Chopped flat-leaf parsley, for garnish

MOD

To make the beef stew you get in Smithfield's Saloon in Valentine, start by crisping 4 or 5 slices of hickory-smoked bacon and set aside. Cook the flour-dredged beef in the bacon fat, then crumble the cooked bacon back into the pan. Replace the ale with a ½ cup (120 ml) of whiskey or bourbon and 1 additional cup (240 ml) of beef broth. Replace the mint with a sprig of rosemary, which should be removed before serving. Wearing a racoon hat while cooking is optional.

CONTINUE PLAYING ▶

DIRECTIONS

1 Preheat the oven to 325°F (170°C; gas mark 3) and set a rack in the lower-middle position.

2 Pat the meat dry and sprinkle liberally with salt and pepper. Dredge the meat in the flour, coating completely. Shake off excess flour.

3 In a large Dutch oven over medium-high heat, heat the oil. Add the meat in batches, and cook until the meat is browned, using a slotted spoon to transfer the meat to a plate as it browns. Add more oil as needed between each batch. Leave the drippings and browned bits in the pot and set the browned meat aside.

4 Add the onion to the pot and sauté in the drippings until translucent, 1 to 2 minutes. Add the garlic and cook until fragrant, 1 minute more, then add the Worcestershire sauce. Cook, stirring with a wooden spoon and scraping the browned bits from the bottom of the pan, for 3 to 4 minutes. Add the tomato paste and cook for 1 minute more.

5 Return the meat and its juices back to the pan and give it a quick stir. Add the beer, beef stock, thyme, mint, oregano, marjoram, sage, and bay leaves. Stir with a wooden spoon to loosen the browned bits from the bottom of the pan. Bring to a boil. Taste and adjust seasoning. Cover the pot with a lid and transfer to the oven. Braise for 2 hours, until the meat has softened and slightly caramelized.

6 Carefully remove the pot from the oven and stir. Add the potatoes, carrots, and celery. Cover and return to the oven. Cook for about 1 hour more, or until the vegetables are soft, the broth is thickened, and the meat is fork-tender. Taste and adjust seasoning.

7 Serve the stew hot with some parsley as a garnish, and wash it down with a mug of beer or a glass of bourbon and a side of almonds.

— HINT —

If you don't have a Dutch oven, braise the meat in a thick-bottomed saucepot over very low heat on the stove for 60 to 90 minutes, until it's fork tender. Stir the stew and check regularly to prevent burning.

CHEESE CURRY

VIDEO GAME: **Pokémon Sword and Shield** ▪ YEAR: **2019**

| DIFFICULTY: ★ ★ NORMAL | SERVES: 8 TO 10 |

Pokémon food has been part of the series since the first generation and, like a Flareon exposed to a Fire Stone, it has evolved. *Pokémon Sword and Shield* introduced the Curry-Dex, which is like the Pokédex but for curry! Just like Pokéblocks and poffins, the overall flavor and effect of the curry depends on several factors. In *SwSh*, the kind of berries used, the main ingredient, and how well the player does the interactive, motion-controlled cooking minigame all affect the resulting curry. Cheese Curry, among the most intriguing of the curries, has rich Moomoo cheese melted over the top.

INGREDIENTS

CURRY

1 tablespoon unsalted butter

1 small yellow onion, finely chopped

4 cloves garlic, chopped

1 pound (450 g) ground beef or pork

3 carrots, finely chopped

1 pound (450 g) cremini mushrooms,
 finely chopped

2 tablespoons curry powder
 (I prefer S&B Brand)

2 tablespoons ketchup

1 tablespoon Worcestershire sauce

1 cup (240 ml) beef broth

Salt and ground black pepper,
 to taste

BÉCHAMEL

¼ cup (½ stick/55 g) salted butter

4 tablespoons all-purpose flour

2 cups (480 ml) whole milk

1 teaspoon chicken bouillon powder

¼ teaspoon ground nutmeg
 (optional)

FOR ASSEMBLY

3 cups (405 g) cooked rice
 (Japanese short grain preferred)

¼ cup (25 g) grated
 Parmesan cheese

1 cup (110 g) shredded
 mozzarella cheese

2 tablespoons panko bread crumbs

1 wheel of mild Brie, sliced into
 wedges, for serving

Chopped flat-leaf parsley, for garnish

CONTINUE PLAYING ▶

DIRECTIONS

1 **To make the curry:** In a large skillet over medium heat, melt the butter and then add the onion. Cook until translucent, 2 to 3 minutes, then add the garlic and cook until fragrant, about 1 minute more. Add the ground beef or pork and carrots and cook for 5 minutes, breaking up the big pieces of meat with a wooden spoon, until the meat is no longer pink. Drain excess fat.

2 Add the mushrooms, curry powder, ketchup, Worcestershire sauce, and beef broth and stir to combine. Continue cooking until the liquid has mostly evaporated and a thick sauce forms. Turn off the heat and sprinkle with salt and pepper. Set aside.

3 **To make the béchamel:** In a separate medium saucepan, heat the butter over medium-low heat until it melts and bubbles. Slowly add the flour and mix well. Slowly pour in the milk, stirring constantly until the sauce thickens, 10 to 15 minutes. Stir in the bouillon and nutmeg (if using). Remove from the heat and set aside.

4 **To assemble:** Preheat the oven to 350°F (180°C; gas mark 4) and grease a large metal or ceramic casserole dish. Spoon the rice into the dish and smooth it over the bottom. Layer on the meat mixture. Pour the béchamel sauce on top and spread with the back of a spoon, then sprinkle on the Parmesan, followed by the mozzarella. Sprinkle the panko over the mozzarella.

5 Bake for 20 to 25 minutes, until the top is golden brown. Or broil for the last 2 to 3 minutes, until browned and bubbly. Let cool for 10 minutes before serving.

6 When plating, emulate the game appearance by scooping some rice from the bottom onto half the serving plate and scooping the curry, béchamel, and cheese onto the other half, nudging the cheese a bit towards the center. Place a wedge of Brie on top and microwave the whole dish for 20 to 30 seconds, until the Brie is soft and slightly runny. Garnish with parsley and serve!

— HINT —

One of the five French "mother sauces" (because it serves as the base for many other delicious sauces), béchamel is a lusciously creamy and versatile sauce that's a must for any chef's Recipédex. Unlike catching a Feebas, it's a relatively easy task to make it—but there are a few things to keep in mind. To avoid breaking the sauce, make sure that the heat stays pretty low, that you are constantly stirring, and that you cook until it's thick enough to coat the back of a spoon.

SAGHERT AND CREAM

VIDEO GAME: **Fire Emblem: Three Houses** · YEAR: **2019**

DIFFICULTY: ★ ★ NORMAL	SERVES: 8 TO 10

Eating is a social affair in *Fire Emblem*. Practically, sharing a meal with students increases their support points and motivation. Narratively, the Dining Hall is a place where players can get to know the game's colorful characters a bit better. One of the most intriguing meals is Saghert and Cream, a dessert the game describes as a baked confection with "peach currant" reduction and "noa fruit" cream. Per game clues, peach currant seems to be the name for regular ol' peaches. Noa fruit is a bit more ambiguous, but given its uses with both sweet and savory dishes (especially fishy ones) citrus makes sense.

INGREDIENTS

PEACH CURRANT REDUCTION

4 medium yellow peaches (about 1 pound/450 g), peeled, pitted, and diced

1 tablespoon lime or lemon juice

1 cup (185 g) packed light brown sugar

½ teaspoon vanilla paste or extract

1 tablespoon cornstarch

SAGHERT

1½ cups (190 g) all-purpose flour

1 teaspoon baking powder

Zest of 2 limes or 1 lemon

1¼ teaspoons ground cinnamon, divided

¼ teaspoon salt

2 tablespoons minced crystallized ginger (optional)

1 cup (2 sticks/225 g) unsalted butter, softened

¾ cup (150 g) granulated sugar

2 large eggs

3 to 4 medium yellow peaches (about 1 pound/450 g), peeled, pitted, and sliced

1 tablespoon packed light brown sugar

NOA FRUIT WHIPPED CREAM

1 cup (240 ml) heavy whipping cream

⅓ cup (35 g) confectioners' sugar

1 teaspoon lime or lemon zest

2 tablespoons lime or lemon juice

GARNISH (OPTIONAL)

Sliced peaches

Fresh mint sprigs

CONTINUE PLAYING ▶

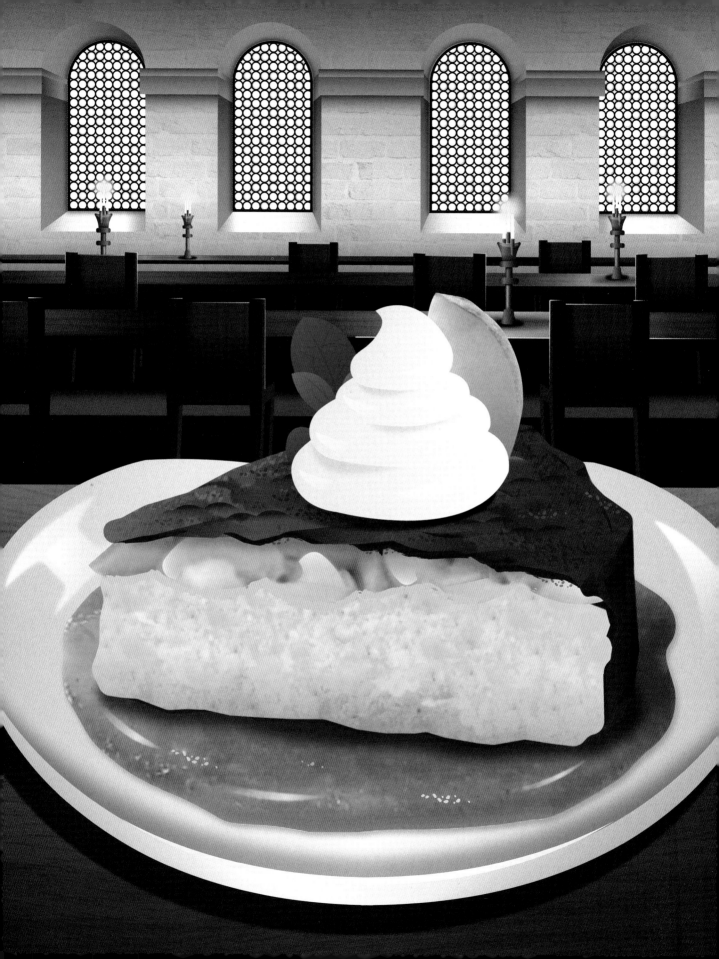

DIRECTIONS

1 **To make the peach currant reduction:** In a medium bowl, add the peaches and lime or lemon juice and stir. Cover the peaches with the brown sugar, wrap the bowl in plastic wrap, and place it in the refrigerator for 1 to 2 hours, until the fruit has softened and released juices.

2 **To make the saghert:** Once the peach reduction mixture is almost ready, preheat the oven to 350°F (180°C; gas mark 4). Line the bottom of a 9-inch (23 cm) springform pan or a cake pan with parchment paper and grease generously with butter. Set aside.

3 In a large bowl, use a wire whisk to whisk together the flour, baking powder, lime or lemon zest, 1 teaspoon of the cinnamon, salt, and ginger (if using). In the bowl of a stand mixer or in a separate large bowl with a handheld electric mixer, beat together the butter and granulated sugar until smooth. Beat in the eggs, one at a time. Add the flour mixture and beat on low speed until smooth. Use a rubber spatula to scrape the batter into the springform pan and distribute evenly. Set the peach slices on top of the batter (create a pattern, if you like).

4 In a small bowl, combine the brown sugar and the remaining ¼ teaspoon cinnamon, then sprinkle it on top of the saghert. Bake the saghert in the middle rack for 50 to 60 minutes, until a toothpick inserted in the center comes out clean and the top is golden brown. If the top starts to brown too quickly, cover the pan loosely with aluminum foil. Remove from the oven and allow to cool for 30 minutes before serving.

5 **Meanwhile, finish the reduction:** In a medium skillet over medium-low heat, add the refrigerated peach mixture and the vanilla and cook, stirring occasionally, until the peaches are tender and the liquid has become syrupy, about 10 minutes. In a small bowl, use a wire whisk to whisk together the cornstarch and 2 tablespoons water to form a slurry. Add the slurry to the peach mixture and stir continuously until it thickens, 1 to 2 minutes. Remove from the heat. Transfer to a blender and puree until smooth. Set the sauce aside until serving time.

6 **To make the noa fruit whipped cream:** In a stand mixer fitted with the whisk attachment or using a handheld electric mixer, whip the cream and confectioners' sugar on medium speed for about 2 minutes, until the mixture begins to thicken. Add the lemon or lime zest and juice, and continue to whip until soft peaks form.

7 To serve, spoon some sauce onto the serving plates before plating the sliced saghert. Top each slice with a dollop of whipped cream. Garnish with fresh peach slices and mint sprigs, if desired.

MIXED-FRUITS SANDWICH

VIDEO GAME: **Animal Crossing: New Horizons** ▪ YEAR: **2020**

DIFFICULTY: ★ BEGINNER | YIELD: 2 SANDWICHES

For the first time in the series, a cooking mechanic was added to *Animal Crossing: New Horizons* with a whopping 141 DIY recipes and brand-new kitchenware. Cooked foods can be sold, gifted, or eaten. When eaten, the player gains enough stamina to relocate trees and break rocks, making rearranging furniture a breeze. Food can also be placed in random spots—just for the aesthetic. Every player starts the game with native fruit trees, so this creamy Japanese fruit sando is the perfect way to utilize all that fresh fruit.

INGREDIENTS

WHIPPED CREAM

1 cup (240 ml) cold heavy whipping cream

2 tablespoons sweetened condensed milk

1 teaspoon vanilla paste or extract

SANDWICHES

2 small mandarins or tangerines, peeled and separated into segments by hand

1 ripe yellow or donut peach, pitted, peeled, and sliced into 1½ x ½-inch (4 x 1 cm) strips

1 ripe Comice or Bartlett pear, cored, peeled, and sliced into 1½ x ½-inch (4 x 1 cm) strips

6 to 8 small strawberries, tops removed

4 slices shokupan (Japanese milk bread), Texas Toast, or any fluffy white bread

DIRECTIONS

1. **To make the whipped cream:** In a cold mixing bowl, add the cream, sweetened condensed milk, and vanilla. Using a handheld electric mixer, whip until soft peaks form. The whipped cream should be stiff enough to hold its shape but spreadable.

2. **To make the sandwiches:** Blot the sliced fruit with a paper towel to remove excess moisture.

3. Lay 2 slices of shokupan flat and spread about ½ inch (1 cm) of the whipped cream onto each. Top the cream on each slice with half the fruit. Arrange the fruit in the same direction you will cut the sandwich (diagonally or horizontally). Fill in the gaps between the fruit with more cream, and then spread an even ½-inch (1 cm) layer of cream on top of the fruit. Top with the remaining two slices of shokupan. Tightly wrap the sandos in plastic wrap and refrigerate for at least 1 hour to set before slicing.

4. Once the sandwiches have chilled, remove the plastic wrap. Using a very sharp knife, cut the crusts off the sandos, then slice them in half either diagonally or horizontally (however you arranged the fruit), making sure to wipe the knife after each slice. Serve immediately!

STICKY HONEY ROAST

VIDEO GAME: **Genshin Impact** · YEAR: **2020**

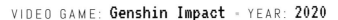

| DIFFICULTY: ★ ★ NORMAL | SERVES: 6 TO 8 |

There was a lot of TLC put into *Genshin Impact*'s food and cooking mechanic. Each of the game's seventy-six dishes is made with a simple but fun cooking minigame and comes with mouthwatering artwork and substantial buffs. Players can obtain this recipe through the endearingly sweet Master's Day Off story quest by helping out a certain overworked Acting Grand Master. The sweet honey gravy is so delicious you might just burst into tears.

INGREDIENTS

1 beef top round, bottom round, or eye round roast (3 pounds/ 1.3 kg), trimmed

Salt and ground black pepper, to taste

¾ cup (180 ml) honey, plus more to taste

¾ cup (180 ml) soy sauce

½ cup (110 g) brown sugar, plus more to taste

½ cup (120 ml) Shaoxing wine or dry sherry

4-inch (10 cm) piece fresh ginger, peeled and sliced into coins

2 lemongrass stalks, tender centers only, cut into batons

2 bay leaves

1 sweet onion, cut into wedges

2 green onions, cut into thirds

8 cloves garlic

6 large carrots, peeled and sliced into 1-inch-thick (2.5 cm) coins

1 daikon, peeled and sliced into 1-inch-thick (2.5 cm) coins

1 tablespoon lemon pepper

½ tablespoon all-purpose seasoning, or to taste

1 tablespoon garlic powder

1 tablespoon onion powder

2 cups (480 ml) beef broth, plus more if needed

2 tablespoons cornstarch or potato starch

Chopped flat-leaf parsley plus 1 sprig, for garnish

CONTINUE PLAYING ▶

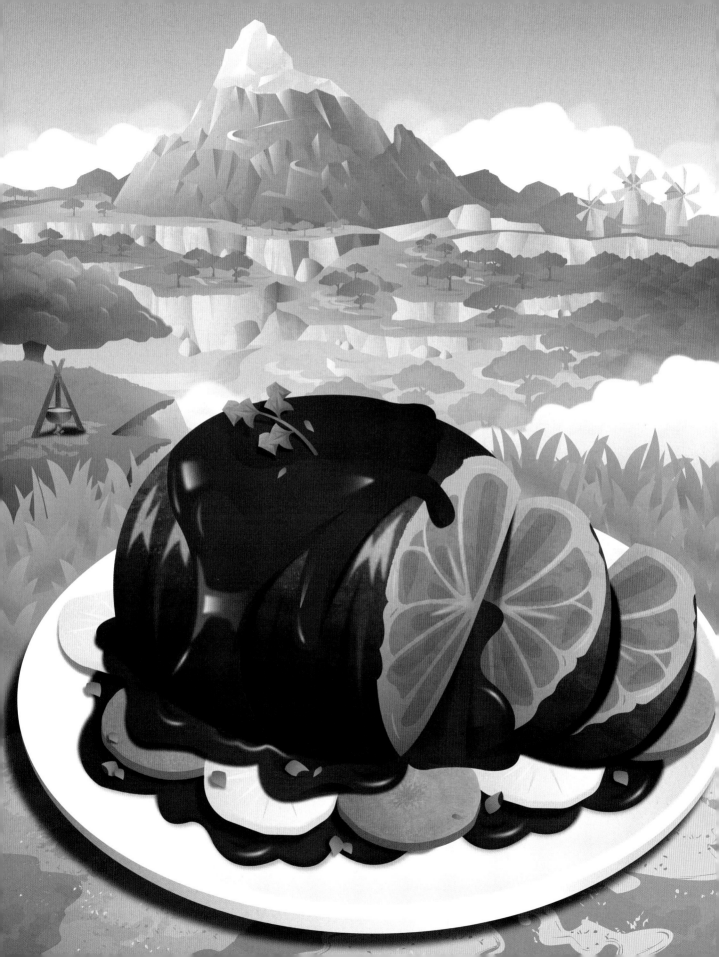

DIRECTIONS

1. Sprinkle the roast liberally with salt and black pepper and set aside at room temperature.

2. Preheat the oven to 350°F (180°C; gas mark 4). In a small bowl, use a wire whisk to whisk together the honey, soy sauce, brown sugar, and Shaoxing wine. Set aside.

3. In a large Dutch oven, sear the beef over high heat until browned on all sides. Then add the ginger, lemongrass, bay leaves, sweet and green onions, garlic, carrots, and daikon. Sprinkle with the lemon pepper, all-purpose seasoning, garlic and onion powders, and salt and black pepper. Arrange the vegetables around the outside of the pot and place the meat in the hole in the center.

4. Pour in the beef broth, then add the soy sauce mixture over the top of the beef. The meat and veggies should be almost but not completely submerged in liquid. If not, add more beef broth as needed.

5. Cook, uncovered, on the bottom rack of the oven for 1 hour. Remove from the oven. Carefully flip the beef so that the top browned part is now facing down and submerged in the broth. Taste the broth and adjust seasoning. Return the pot to the oven and cook for 1 hour more, or until the beef is almost fall-apart tender. (If it needs more time, return the pot to the oven and cook in 20-minute increments until it reaches the desired doneness.)

6. Transfer the cooked beef to a serving platter. Use a slotted spoon to fish out and set aside most of the veggies, but leave behind plenty of onions and garlic and a few carrots or daikon. Remove and discard all the ginger coins, bay leaves, and lemongrass stalks.

7. Pour the broth and lingering veggies into a blender. Cover and, with the center part of the blender removed for steam to escape, puree the broth until smooth. Pour the puree back into the Dutch oven and set it on the stove over medium-high heat. Ladle some of the puree into a bowl. Add the cornstarch to the bowl and use a wire whisk to whisk into a slurry. Add the slurry into the pot and stir to combine with the puree. Taste and add more honey and brown sugar, 1 tablespoon at a time, until the sweetness is to your liking. Cook, stirring frequently, until the mixture thickens into a gravy.

8. Arrange the veggies around the beef and ladle gravy over the top of the roast. Sprinkle the chopped parsley on the veggies and place the parsley sprig on top of the roast before slicing the beef (against the grain) to serve.

MOD

You can also cook the roast in a slow cooker over high heat for 3 to 4 hours or on low for 5 to 6 hours, or until meat is almost fall-apart tender. Check on it periodically and flip about halfway through. Adjust seasoning toward the end of cooking.

JAMBALAYA

VIDEO GAME: **Cyberpunk 2077** • YEAR: **2020**

DIFFICULTY: ★ ★ NORMAL	SERVES: 6 TO 8

Like in many dystopian titles, the food situation in *Cyberpunk 2077* is . . . a little complicated. A variety of the consumable food items (mostly processed synthetic foods of questionable quality) and some of the pizza flavors are truly disturbing. It's not all soy paste and pop-turds, though. Throughout Night City, vendors peddle foods like noodles, "sushi," and various "meat" skewers, and offer players great opportunities to relax and take in the game's fantastic ambience. In one memorable side quest, the player has an opportunity to cook some real(ish) food: a jambalaya with basmati rice and various spices.

INGREDIENTS

1 tablespoon olive oil

3 boneless skinless chicken thighs (about 1 pound/450 g), cut into bite-size pieces

1 pound (450 g) longanisa, Spanish chorizo, andouille, or Portuguese sausage, sliced

2 tablespoons butter (more as needed)

3 bell peppers in a variety of colors, seeded and diced

3 stalks celery, chopped

1 large white onion, chopped

6 cloves garlic, minced

1 can (14 ounces/400 g) crushed tomatoes

3 cups (720 ml) chicken or vegetable broth, plus more if needed

1 tablespoon tomato paste

1 tablespoon soy sauce

1½ cups (270 g) uncooked basmati rice

2 tablespoons creole or Cajun seasoning, or to taste

2 sprigs thyme

1 teaspoon smoked paprika

¼ teaspoon cayenne pepper, or to taste

1 bay leaf

1 pound (450 g) medium shrimp, shelled and deveined

1 cup (155 g) okra, sliced (optional)

1 teaspoon paprika

Salt and ground black pepper, to taste

Green onions, sliced on a bias, for garnish

Chopped flat-leaf parsley, for garnish

DIRECTIONS

1. In a large heavy-bottomed pot or Dutch oven over medium-high heat, heat the oil. Add the chicken and sausage and cook for 5 to 7 minutes, stirring occasionally, until the meat is browned. Use a slotted spoon to transfer the meat to a plate as it browns. Set it aside.

2. In the same pot, melt the butter. Add the bell peppers, celery, onion, and garlic. Sauté the veggies for 5 to 6 minutes, stirring occasionally, until softened. Scrape and stir in any browned bits from the bottom of the pot.

3. Add in the crushed tomatoes, chicken broth, tomato paste, soy sauce, rice, creole or Cajun seasoning, thyme, smoked paprika, cayenne, and bay leaf. Stir to combine. Bring everything to a simmer then reduce the heat to medium-low. Cover and simmer, stirring occasionally to prevent burning (especially toward the end), for about 25 minutes, or until the rice is nearly cooked through. Add more broth if needed if it starts to dry out before the rice has cooked through.

4. Add in the cooked chicken and sausage, along with the shrimp and okra (if using), and stir to combine. Continue to simmer, stirring occasionally, until the shrimp and chicken are cooked through, 2 to 4 minutes. Remove and discard the bay leaf and thyme sprigs.

5. Stir in the regular paprika. Taste and adjust seasoning. Garnish each serving with green onions and parsley. Serve immediately.

MOD

If shellfish is an issue, replace the shrimp with 1 can (15 ounces/425 g) of drained red beans. To make this dish vegan, substitute a flavorful vegan sausage (like meatless chorizo) for the sausage and soy curls or sliced mushrooms for the chicken.

CIORBĂ DE LEGUME

VIDEO GAME: **Resident Evil: Village** · YEAR: **2021**

DIFFICULTY: ★ ★ NORMAL	SERVES: 8 TO 12

Until *RE: Village*, the *Resident Evil* series hadn't really done food before. Well, aside from medicinal herbs, the Jill Sandwich, and whatever was going on at the dinner table in *RE7*. In the Village, a traveling merchant called the Duke can whip up a tasty meal for Ethan if he's got the ingredients. All based on real Romanian dishes, the meals give Ethan *permanent* stat boosts—an extreme rarity for video game foods. However, the most memorable dish is probably Ciorbă de Legume (roughly translated to vegetable soup), which the Winters family is about to enjoy before the mold hits the fan. This brief moment of zen gives the player their first taste of the game's mysterious location.

INGREDIENTS

2 tablespoons olive oil

1 large yellow onion, diced

4 cloves garlic, minced

1 large red bell pepper, seeded and diced

2 large carrots, peeled and diced

2 stalks celery (including leaves), diced

1 kohlrabi, celery root, or parsnip, peeled and diced

Pinch each of salt and ground black pepper

8 cups (2 L) water or vegetable stock

1 tablespoon Vegeta or all-purpose seasoning (optional)

2 bay leaves

1 tablespoon dried lovage

2 sprigs thyme

4 red potatoes, peeled and diced

1 medium zucchini, diced

1 can (28 ounces/800 g) diced tomatoes

1 cup (110 g) fresh green beans, ends trimmed and cut into small pieces

1 cup (145 g) fresh or frozen English peas

½ bunch roughly chopped flat-leaf parsley, plus more for garnish

1 cup (240 ml) sour borș, sauerkraut juice, or lemon juice, or to taste (see HINT)

Sour cream, plain yogurt, or crème fraîche, for topping (optional)

Chopped hot chili peppers (such as bird's eye or habanero, or red pepper flakes), for topping (optional)

Chopped toasted walnuts, for topping (optional)

Chopped green onions, for topping (optional)

Warm crusty bread or baked polenta, for serving (optional)

DIRECTIONS

1. In a large saucepot over medium heat, heat the olive oil. Add the onion and cook over medium heat, stirring, until the onion is soft and translucent, 2 to 3 minutes. Add the garlic, bell pepper, carrots, celery, kohlrabi, and a pinch each of salt and black pepper and continue to cook until the veggies start to soften, another 2 to 3 minutes.

2. Add the water or stock along with the Vegeta seasoning (if using), bay leaves, dried lovage, and thyme. Bring to a boil then reduce the heat to low. Simmer for 2 to 3 minutes, then add the diced potato. Simmer until the potato softens but still has some bite, 3 to 5 minutes.

3. Add the zucchini, diced tomatoes, and green beans. Continue to simmer until the green beans are almost tender, 3 to 5 minutes.

4. Add the peas and parsley, and cook for another 1 to 2 minutes, until the peas are soft but not mushy and still bright green.

5. Stir in the bors, a few tablespoons at a time, tasting in between each addition to see if you want more. Simmer for 1 minute more. Taste and adjust seasoning.

6. Serve hot in bowls and top with sour cream, hot chili peppers, and chopped toasted walnuts, if desired. Garnish with additional chopped parsley and green onions, if desired. Serve with warm crusty bread or baked polenta, if you like.

— HINT —

This soup is traditionally made with a unique Romanian ingredient called borș (pronounced "borsh"), which is a liquid made from fermented wheat bran. It can be very difficult to find outside of Romania, so you can use lemon juice, sauerkraut juice, or even a sour beer instead.

BUNNY DANGO

VIDEO GAME: **Monster Hunter Rise** · YEAR: **2021**

DIFFICULTY: ★ ★ NORMAL	YIELD: 10 DANGO

Skewers are a staple in the *Monster Hunter* series. And if sticks of mouthwatering food isn't fun enough for you, how about the fact that they are served up by sentient bipedal felines? Dango are Japanese dumplings made from rice flour and traditionally served on skewers. They come in a variety of flavors, and in *Rise* they give the player special bonuses based on the flavor combinations that the player chooses.

INGREDIENTS

BUNNY DANGO

10 to 20 small bamboo skewer sticks, soaked

Cooking twine (optional)

1¾ cups (280 g) glutinous rice flour (aka sweet rice flour or Mochiko)

1 cup (160 g) non-glutinous rice flour

1 cup (180 g) confectioners' sugar (or to taste)

1⅓ cups (330 g) silken tofu, drained

2 to 4 tablespoons black sesame paste or black royal icing, for decorating (optional)

1 teaspoon black sesame seeds or chocolate sprinkles, for decorating (optional)

COLORS AND FLAVORINGS (OPTIONAL)

½ teaspoon strawberry, sakura, or dragon fruit powder (for pink)

½ teaspoon ube extract or maqui berry powder (for purple)

½ teaspoon matcha powder or pandan extract (for green)

½ teaspoon blue spirulina or butterfly pea powder (for blue)

1 tablespoon pumpkin puree plus 2 teaspoons rice flour (for orange)

Flavoring extracts of your choice

MOD

You can use gel food coloring to tint the dough, as well.

CONTINUE PLAYING ▶

DIRECTIONS

1 If you'd like to re-create the bunny ear effect, tie two skewers together at one end with a bit of twine. Repeat until you have 10 bunny skewers.

2 In a medium bowl, combine both the rice flours and the sugar and mix with a wooden spoon. Add the silken tofu and continue to stir, then knead until the dough comes together. It should feel like Play-Doh but a little softer and grainier. Add ½ tablespoon more flour if the dough is too wet or sticky, or ½ tablespoon of water if it's too crumbly or stiff.

3 Evenly divide the dough into separate pieces depending on the number of colors and flavors you would like, if using. (I recommend starting with three colors.) For white dango, do not add coloring. Place the dough pieces into separate bowls. Add your chosen color and flavor to each bowl and work them into the dough with your hands. (Make sure to rinse your hands before switching colors!) Shape the dough into 30 round balls of approximately the same size.

4 Fill a large bowl halfway with ice, then cover the ice with water.

5 Bring a large pot of water to a boil. Working in batches, add the lightest color balls to the pot first and boil, stirring occasionally to prevent them from sticking to the bottom, for 3 to 4 minutes, until the balls rise to the surface. Once the balls float, continue boiling for another 2 to 3 minutes, then use a slotted spoon to quickly transfer the dango into the ice water. Repeat for the next batch, working from lighter to darker colors, until all the dango are cooked. You may need to add more ice to the ice water between batches.

6 Drain the cooked dango and skewer them in your preferred order. If you'd like, use black sesame paste or royal icing to create the "hair" and black sesame seeds or chocolate sprinkles to create the eyes and mouth. Serve immediately!

— HINT —

You can change up the ratio of glutinous rice flour to non-glutinous rice flour. This version uses more Mochiko and makes a bouncier dango, a bit closer to mochi in texture. Having an equal amount of both rice flours will give you a firmer, more traditional texture. Having more glutinous rice flour will give you an even softer, squishier texture.

MILDUF'S TREAT

VIDEO GAME: **Horizon: Forbidden West** ▪ YEAR: **2022**

DIFFICULTY: ★ ★ NORMAL	YIELD: 25 TO 35 TREATS

The *Horizon* franchise is set in a post-Apocalyptic world overrun with hostile machines, with the surviving humans scattered in various tribes. This sequel to *Horizon: Zero Dawn* (2017) gave fans a lot of elaboration on the customs of the tribes—particularly their cuisine! Milduf is a cook on the Oseram settlement Chainscrape. Aloy can help Milduf retrieve some ingredients and give him a little confidence boost to unlock his creations. One of Milduf's signature dishes is called Milduf's Treat: fried dough balls dipped in honey, one of them sprinkled with a "spicy powder" for a "fiery surprise." Who doesn't love a little donut roulette?

INGREDIENTS

FRIED DOUGH

2 cups (480 ml) lukewarm whole milk

2 tablespoons granulated sugar

2 packets (½ ounce/14 g) active yeast

3½ cups (440 g) all-purpose flour

Zest of 1 orange (about 1½ tablespoons)

½ teaspoon ground cinnamon

1 teaspoon kosher salt

Pinch of ground nutmeg (optional)

¼ cup (60 ml) extra-virgin olive oil

Neutral oil (such as vegetable or canola oil), for frying

TOPPING

1 cup (240 ml) honey, runny

1 teaspoon ground cinnamon

½ teaspoon chili powder

Pinch of cayenne powder

DIRECTIONS

1 **To make the fried dough:** In a stand mixer fitted with the whisk attachment or in a large bowl with a handheld electric mixer, gently whisk the milk, sugar, and yeast on low until the yeast dissolves completely. Stop whisking and let the yeast bloom for 5 minutes.

2 In a separate large bowl, sift together the flour, orange zest, cinnamon, salt, and nutmeg (if using). Add the flour mixture to the bloomed yeast mixture along with the olive oil. Whisk on low speed for about 2 minutes, until the mixture becomes a smooth batter. Cover the bowl with plastic wrap and let the dough rest in a warm place for at least 1 hour, until it has doubled in size.

3 In a deep fryer or medium skillet, pour enough neutral oil to deep-fry (2 to 3 inches/5 to 8 cm; the amount of oil will depend on the size of your frying vessel). Heat the oil until it reaches 365°F (185°C), measured with a thermometer.

4 Dip an ice cream scoop into the oil to coat, and transfer a few scoops of batter into the hot oil, making sure not to overcrowd the fryer (or the dough will be sad and soggy). You may need to fry the dough in 2 to 4 batches depending on the size of the frying vessel. Fry for about 2 minutes per side, using tongs to rotate the pieces as needed, until they are golden brown and crisp on all sides. Gently fish out the cooked dough with tongs or a slotted spoon, transferring to a cooling rack or paper-towel-lined plate to cool. Repeat until you run out of batter. Let the finished fried dough drain and cool for 30 minutes.

5 **For the topping:** In a small bowl, combine the honey, cinnamon, and chili powder. Dip each piece of cooled fried dough into the honey-cinnamon mixture before placing it on a serving plate, honey side up. On one (or more) of the fried dough pieces, sprinkle the cayenne powder.

BOLUSES

VIDEO GAME: **Elden Ring** · YEAR: **2022**

DIFFICULTY: ★ BEGINNER	YIELD: APPROXIMATELY 24 BOLUSES

A lot of very scary, very powerful creatures are actively trying to kill you in the Lands Between. To counteract that, the player can ingest different types of boluses to heal and cure the many negative status effects in the game, like poison and scarlet rot. Various boluses can be found throughout the map or crafted with the help of an Armorer's Cookbook. These boluses won't cure poison or stop you from bleeding out, but they are delicious and nutritious!

INGREDIENTS

1 cup (125 g) pitted medjool dates

½ cup (60 g) almond flour, plus more as needed

¼ cup (25 g) cocoa powder

1 teaspoon vanilla paste or vanilla extract

2 teaspoons maple syrup or honey

1 teaspoon heavy whipping cream or coconut cream, plus more as needed

¼ teaspoon ground cinnamon, or to taste (optional)

2 tablespoons hibiscus or raspberry powder, plus more for rolling (optional, for staunching)

2 tablespoons matcha or pandan powder, plus more for rolling (optional, for neutralizing)

2 tablespoons butterfly pea powder, plus more for rolling (optional, for stimulating)

DIRECTIONS

1 In a small heatproof bowl, pour enough boiling water over the pitted dates to cover them completely and set aside until softened, about 30 minutes, then drain completely. In a food processor fitted with the knife blade, process the dates until they form a grainy paste. The mixture may stick together and start to form a ball.

2 Add the almond flour, cocoa powder, vanilla, maple syrup, cream, and cinnamon (if using), plus the hibiscus, matcha, and butterfly pea powders (if using). Process for 20 to 30 seconds, until a tacky dough has formed. The mixture should be moist but hold its shape easily. If it's too dry and crumbly, add ½ teaspoon more cream at a time (up to ½ tablespoon) until the dough improves. If too wet, add more almond flour, ½ tablespoon at a time, as needed.

3 Line a surface with parchment paper. Scoop out 1 tablespoon of dough at a time and roll it into a ball. Repeat until you've used all the date mixture (about 24 boluses).

4 Roll the balls in the coloring powder of your choice. Serve slightly chilled or at room temperature.

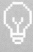

— HINT —

Hibiscus and butterfly pea powders can be purchased online and generally cost between $5 and $10. You can also use other natural food coloring powders or edible cake decorating powders.

MEALS AT A GLANCE

APPETIZERS, SNACKS, AND CONDIMENTS

Crab Rangoon, *Far Cry 4* (2014), page 139

Elsweyr Fondue, *The Elder Scrolls V: Skyrim* (2011), page 119

Green Cheese, *Ultima VII: The Black Gate* (1992), page 30

Mushrooms, *Super Mario Bros.* (1985), page 17

Peanut Cheese Bar, EarthBound (1994), page 36

Poutine, *Divinity: Original Sin 2* (2017), page 167

Smoked Desert Dumplings, *World of Warcraft* (2004), page 79

Starkos, *Beyond Good and Evil* (2003), page 72

Takoyaki, *Yakuza 0* (2015), page 148

Tummy-Tingling Tuchanka Sauce, *Mass Effect 2* (2010), page 118

Wyvern Wings, *Dragon Age: Inquisition* (2015), page 146

MAINS

✳ Breakfast ✳

Belgian Waffles, *Life Is Strange* (2015), page 142

Pancakes, *Persona 5* (2016), page 162

Priestly Omelette, *Final Fantasy XIV* (2013), page 134

✳ Lunch & Dinner ✳

Cheese Curry, *Pokémon Sword and Shield* (2019), page 180

Chili Dog, *Sonic Unleashed* (2008), page 104

Ciorbă de Legume, *Resident Evil: Village* (2021), page 192

Coq Au Vin, *Deus Ex* (2000), page 64

Corn Pasta, *Harvest Moon 64* (1999), page 60

Durr Burger, *Fortnite* (2017), page 174

Elixir Soup, *The Legend of Zelda: The Wind Waker* (2002), page 69

Estus Soup, *Dark Souls III* (2016), page 158

The Fowl Wrap, *Grand Theft Auto: Liberty City Stories* (2005), page 84

Greasy Prospector Pork and Beans, *Fallout 3* (2008), page 108

Grilled Cheese, *The Sims 2* (2004), page 74

Jambalaya, *Cyberpunk 2077* (2020), page 190

Jurassic Pork Soup, *Chrono Trigger* (1995), page 43

Kenny's Original Recipe, *Final Fantasy XV* (2016), page 156

Koopasta, *Paper Mario: The Thousand-Year Door* (2004), page 76

"Level Ate" Flamin' Yawn 'n' Eggs, *Earthworm Jim 2* (1995), page 40

Mabo Curry, *Tales of Vesperia* (2008), page 106

Paramite Pies, *Oddworld: Abe's Oddysee* (1997), page 50

Pearson's Stew, *Red Dead Redemption 2* (2018), page 177

Pierogies, *Don't Starve* (2013), page 132

Pimentaco, *Borderlands 2* (2012), page 125

Pizza, *Devil May Cry 3* (2005), page 82

Ration, *Metal Gear Solid* (1998), page 56

Sandvich, *Team Fortress 2* (2007), page 95

Sinner's Sandwich, *Deadly Premonition* (2010), page 116

Spaghetti Neapolitan, *Cooking Mama* (2006), page 92

Spicy Food (aka Superspicy Curry), *Kirby's Dream Land* (1992), page 24

Spicy Ramen, *Destiny* (2014), page 136

Sticky Honey Roast, *Genshin Impact* (2020), page 187

Stupendous Stew, *Super Mario: Odyssey* (2017), page 172

Superb Soup, *The Legend of Zelda: Twilight Princess* (2006), page 90

Suspicious Stew, *Minecraft* (2011), page 122

Taco Tornado, *Overwatch* (2016), page 159

Today's Special, *Final Fantasy VII* (1997), page 53

Trash Can Chicken, *Streets of Rage 2* (1992), page 33

Wall Meat, *Castlevania* (1986), page 21

POTIONS

Grog, *The Secret of Monkey Island* (1990), page 22

Red Potion, *The Legend of Zelda* (1986), page 20

Mana Potion, *Diablo* (1996), page 48

SWEETS AND TREATS

Apricot Tartlet, *Dishonored* (2012), page 129

Batwing Crunchies, *EverQuest* (1999), page 59

Blackberry Cobbler, *Stardew Valley* (2016), page 164

Blancmange, *Odin Sphere* (2007), page 102

Boluses, *Elden Ring* (2022), page 198

Bunny Dango, *Monster Hunter Rise* (2021), page 194

Butter Cake, *Silent Hill 2* (2001), page 66

Butterscotch-Cinnamon Pie, *Undertale* (2015), page 143

The Cake, *Portal* (2007), page 96

Carrot Soufflé, *Guild Wars 2* (2012), page 128

Creamy Heart Soup, *The Legend of Zelda: Breath of the Wild* (2017), page 170

Creme-filled Cake, *BioShock* (2007), page 99

Gingerbread, *The Witcher 3: Wild Hunt* (2015), page 151

Jill Sandwich, *Resident Evil* (1996), page 46

Milduf's Treat, Horizon: *Forbidden West* (2022), page 197

Mixed-Fruits Sandwich, *Animal Crossing: New Horizons* (2020), page 186

Pokéblocks, *Pokémon Ruby and Sapphire* (2002), page 70

Poro-Snax, *League of Legends* (2009), page 111

Power Pellets, *Pac-Man* (1980), page 16

Saghert and Cream, *Fire Emblem: Three Houses* (2019), page 183

Sea Salt Ice Cream, *Kingdom Hearts II* (2005), page 87

Sweet Roll, *The Elder Scrolls: Arena* (1994), page 37

Yoshi's Cookies, *Yoshi's Cookie* (1992), page 26

LEVELING UP

★ **BEGINNER**

Batwing Crunchies, *EverQuest* (1999), page 59

Belgian Waffles, *Life Is Strange* (2015), page 142

Blackberry Cobbler, *Stardew Valley* (2016), page 164

Boluses, *Elden Ring* (2022), page 198

Carrot Soufflé, *Guild Wars 2* (2012), page 128

Chili Dog, *Sonic Unleashed* (2008), page 104

Corn Pasta, *Harvest Moon 64* (1999), page 60

Creamy Heart Soup, *The Legend of Zelda: Breath of the Wild* (2017), page 170

Elixir Soup, *The Legend of Zelda: The Wind Waker* (2002), page 69

Estus Soup, *Dark Souls III* (2016), page 158

Greasy Prospector Pork and Beans, *Fallout 3* (2008), page 108

Green Cheese, *Ultima VII: The Black Gate* (1992), page 30

Grilled Cheese, *The Sims 2* (2004), page 74

Grog, *The Secret of Monkey Island* (1990), page 22

Jill Sandwich, *Resident Evil* (1996), page 46

Kenny's Original Recipe, *Final Fantasy XV* (2016), page 156

Koopasta, *Paper Mario: The Thousand-Year Door* (2004), page 76

"Level Ate" Flamin' Yawn 'n' Eggs, *Earthworm Jim 2* (1995), page 40

Mabo Curry, *Tales of Vesperia* (2008), page 106

Mana Potion, *Diablo* (1996), page 48

Mixed-Fruits Sandwich, *Animal Crossing: New Horizons* (2020), page 186

Peanut Cheese Bar, *EarthBound* (1994), page 36

Pimentaco, *Borderlands 2* (2012), page 125

Pokéblocks, *Pokémon Ruby and Sapphire* (2002), page 70

Power Pellets, *Pac-Man* (1980), page 16

Ration, *Metal Gear Solid* (1998), page 56

Red Potion, *The Legend of Zelda* (1986), page 20

Sandvich, *Team Fortress 2* (2007), page 95

Sinner's Sandwich, *Deadly Premonition* (2010), page 116

Spaghetti Neapolitan, *Cooking Mama* (2006), page 92

Spicy Ramen, *Destiny* (2014), page 136

Stupendous Stew, *Super Mario: Odyssey* (2017), page 172

Sweet Roll, *The Elder Scrolls: Arena* (1994), page 37

Tummy-Tingling Tuchanka Sauce, *Mass Effect 2* (2010), page 118

Wall Meat, *Castlevania* (1986), page 21

Wyvern Wings, *Dragon Age: Inquisition* (2015), page 146

★★ NORMAL

Apricot Tartlet, *Dishonored* (2012), page 129

Blancmange, *Odin Sphere* (2007), page 102

Bunny Dango, *Monster Hunter Rise* (2021), page 194

Butter Cake, *Silent Hill 2* (2001), page 66

Butterscotch-Cinnamon Pie, *Undertale* (2015), page 143

Cheese Curry, *Pokémon Sword and Shield* (2019), page 180

Ciorbă de Legume, *Resident Evil: Village* (2021), page 192

Coq Au Vin, *Deus Ex* (2000), page 64

Crab Rangoon, *Far Cry 4* (2014), page 139

Creme-filled Cake, *BioShock* (2007), page 99

Durr Burger, *Fortnite* (2017), page 174

Elsweyr Fondue, *The Elder Scrolls V: Skyrim* (2011), page 119

The Fowl Wrap, *Grand Theft Auto: Liberty City Stories* (2005), page 84

Gingerbread, *The Witcher 3: Wild Hunt* (2015), page 151

Jambalaya, *Cyberpunk 2077* (2020), page 190

Jurassic Pork Soup, *Chrono Trigger* (1995), page 43

Milduf's Treat, *Horizon: Forbidden West* (2022), page 197

Paramite Pies, *Oddworld: Abe's Oddysee* (1997), page 50

Pearson's Stew, *Red Dead Redemption 2* (2018), page 177

Pizza, *Devil May Cry 3* (2005), page 82

Poro-Snax, *League of Legends* (2009), page 111

Saghert and Cream, *Fire Emblem: Three Houses* (2019), page 183

Sea Salt Ice Cream, *Kingdom Hearts II* (2005), page 87

Spicy Food (aka Superspicy Curry), *Kirby's Dream Land* (1992), page 24

Sticky Honey Roast, *Genshin Impact* (2020), page 187

Superb Soup, *The Legend of Zelda: Twilight Princess* (2006), page 90

Suspicious Stew, *Minecraft* (2011), page 122

Taco Tornado, *Overwatch* (2016), page 159

Takoyaki, *Yakuza 0* (2015), page 148

Trash Can Chicken, *Streets of Rage 2* (1992), page 33

★★★ EXPERT

The Cake, *Portal* (2007), page 96

Mushrooms, *Super Mario Bros.* (1985), page 17

Pancakes, *Persona 5* (2016), page 162

Pierogies, *Don't Starve* (2013), page 132

Poutine, *Divinity: Original Sin 2* (2017), page 167

Priestly Omelette, *Final Fantasy XIV* (2013), page 134

Smoked Desert Dumplings, *World of Warcraft* (2004), page 79

Starkos, *Beyond Good and Evil* (2003), page 72

Today's Special, *Final Fantasy VII* (1997), page 53

Yoshi's Cookies, *Yoshi's Cookie* (1992), page 26

❌ INDEX ❌

A

apples
Blancmange, 102
Green Cheese, 30–32
Spicy Food (aka Superspicy
Curry), 24–25
Trash Can Chicken, 33–35
apricots
Apricot Tartlet, 129–131
Gingerbread, 151–153
Yoshi's Cookies, 26–29
arugula: Sinner's Sandwich, 116
avocados: Starkos, 72–73

B

bacon
Coq au Vin, 64–65
Durr Burger, 174–176
Estus Soup, 158
Greasy Prospector Pork and
Beans, 108–110
Green Cheese, 30–32
"Level Ate" Flamin' Yawn 'n'
Eggs, 40–42
Pearson's Stew, 177–179
Poro-Snax, 111–113
Smoked Desert Dumplings,
79–81
Spaghetti Neapolitan, 92–94
Takoyaki, 148
bananas: Jurassic Pork Soup,
43–45
beans
Ciorbă de Legume, 192–193
The Fowl Wrap, 84–86
Greasy Prospector Pork and
Beans, 108–110
Ration 56–58
beef
Cheese Curry, 180–182
Chili Dog, 104
Durr Burger, 174–176
Elsweyr Fondue, 119–121
"Level Ate" Flamin' Yawn 'n'
Eggs, 40–42
Mabo Curry, 106–107
Paramite Pies, 50–52
Pearson's Stew, 177–179

Pierogies, 132–133
Ration, 56–58
Spaghetti Neapolitan, 92–94
Starkos, 72–73
Sticky Honey Roast, 187–189
Taco Tornado, 159–161
Today's Special, 53–55
bell peppers
Ciorbă de Legume, 192–193
Jambalaya, 190–191
Ration, 56–58
Spaghetti Neapolitan, 92–94
Stupendous Stew, 172–173
blackberries: Blackberry Cobbler,
164–166
broad bean paste: Mabo Curry
106–107
buttermilk
Blackberry Cobbler, 164–166
The Cake, 96–98
Poro-Snax, 111–113
Wyvern Wings, 146–147

C

cabbage: Pimentaco, 125–127
carrots
Carrot Soufflé, 128
Cheese Curry, 180–182
Ciorbă de Legume, 192–193
Elixir Soup, 69
Estus Soup, 158
Pearson's Stew, 177–179
Spicy Food (aka Superspicy
Curry), 24–25
Starkos, 72–73
Sticky Honey Roast, 187–189
Stupendous Stew, 172–173
Superb Soup, 90–91
Today's Special, 53–55
cauliflower: Elixir Soup, 69
celery
Ciorbă de Legume, 192–193
Coq au Vin, 64–65
Estus Soup, 158
Jambalaya, 190–191
Jurassic Pork Soup, 43–45
Pearson's Stew, 177–179
cherries: The Cake, 96–98

chicken
Corn Pasta, 60
Coq au Vin, 64–65
Elsweyr Fondue, 119–121
The Fowl Wrap, 84–86
Jambalaya, 190–191
Pimentaco, 125–127
Spicy Food (aka Superspicy
Curry), 24–25
Stupendous Stew, 172–173
Trash Can Chicken, 33–35
Wyvern Wings, 146–147
chocolate
Batwing Crunchies, 59
Bunny Dango, 194–196
The Cake, 96–98
Creme-Filled Cake, 99–101
Gingerbread, 151–153
Peanut Cheese Bar, 36
Power Pellets, 16
Yoshi's Cookies, 26–29
cocoa powder
Boluses, 198
The Cake, 96–98
Creme-Filled Cake, 99–101
Gingerbread, 151–153
Ration, 56–58
Taco Tornado 159–161
Yoshi's Cookies, 26–29
corn
Corn Pasta, 60
Stupendous Stew, 172–173
crab
Crab Rangoon, 139–141
Takoyaki, 148
cream cheese
Butter Cake, 66–68
Crab Rangoon, 139–141
Elsweyr Fondue, 119–121
Green Cheese, 30–32
Pokéblocks, 70
Poro-Snax, 111–113
Stupendous Stew, 172–173
Sweet Roll, 37–39

D

daikon: Sticky Honey Roast,
187–189

damson preserves: Gingerbread, 151–153
danmuji: Today's Special, 53–55
dates: Boluses, 198
Dijon mustard
 Greasy Prospector Pork and Beans, 108–110
 Green Cheese, 30–32
 Kenny's Original Recipe, 156
 Sandvich, 95

F

fish
 Kenny's Original Recipe, 156
 Superb Soup, 90–91

H

ham: Sandvich, 95

I

ice cream
 Blackberry Cobbler, 164–166
 Jill Sandwich, 46
 Sea Salt Ice Cream, 87–89

J

jalapeño peppers
 Chili Dog, 104
 The Fowl Wrap, 84–86
 Koopasta, 76–78
 Pimentaco, 125–127
 Pizza, 82–83
 Taco Tornado, 159–161

K

kielbasa: Spaghetti Neapolitan, 92–94
kiwis: Creamy Heart Soup, 170
kohlrabi: Ciorbă de Legume, 192–193

L

leeks: Coq au Vin, 64–65

M

macadamia nuts: Power Pellets, 16
macaroni: Ration, 56–58
mandarins: Mixed-Fruits Sandwich, 186
mangos
 Pimentaco, 125–127
 Starkos, 72–73
marshmallow creme: Creme-Filled Cake, 99–101
miso: Spicy Ramen, 136–138
molasses
 Gingerbread, 151–153
 Greasy Prospector Pork and Beans, 108–110
mortadella: Sandvich, 95
mushrooms
 Cheese Curry, 180–182
 Coq au Vin, 64–65
 Mushrooms, 17–19
 Priestly Omelette, 134–135
 Spaghetti Neapolitan, 92–94
 Spicy Ramen, 136–138
 Suspicious Stew, 122–124
 Takoyaki, 148–150

O

octopus: Takoyaki, 148–150
okra: Jambalaya, 190–191
olives
 Durr Burger, 174–176
 Jurassic Pork Soup, 43–45
 Sandvich, 95
 Starkos, 72–73

P

panko bread crumbs
 Cheese Curry, 180–182
 Takoyaki, 148–150
pasta
 Corn Pasta, 60
 Koopasta, 76–78
 Mabo Curry, 106–107
 Ration, 56–58
 Spaghetti Neapolitan, 92–94
 Spicy Ramen, 136–138
peaches
 Mixed-Fruits Sandwich, 186

Saghert and Cream, 183–185
Yoshi's Cookies, 26–29
peanut butter
 Batwing Crunchies, 59
 Ration, 56–58
peanuts: Peanut Cheese Bar, 36
pears
 Mixed-Fruits Sandwich, 186
 Today's Special, 53–55
peas: Ciorbă de Legume, 192–193
pecans
 Poro-Snax, 111–113
 Power Pellets, 16
pepperoni
 Mushrooms, 17–19
 Pizza, 82–83
 Ration, 56–58
pimentos
 Durr Burger, 174–176
 Pimentaco, 125–127
 Sandvich, 95
pineapple juice
 Crab Rangoon, 139–141
 Grog, 22
plantains: Jurassic Pork Soup, 43–45
pork
 Cheese Curry, 180–182
 Greasy Prospector Pork and Beans, 108–110
 Jambalaya, 190–191
 Jurassic Pork Soup, 43–45
 Mabo Curry, 106–107
 Paramite Pies, 50–52
 Ration, 56–58
 Sandvich, 95
 Smoked Desert Dumplings, 79–81
 Spaghetti Neapolitan, 92–94
 Spicy Ramen, 136–138
 Stupendous Stew, 172–173
 Wall Meat, 21
potatoes
 Ciorbă de Legume, 192–193
 Elsweyr Fondue, 119–121
 Pearson's Stew, 177–179
 Poutine, 167–169
 Spicy Food (aka Superspicy Curry), 24–25
 Stupendous Stew, 172–173
pretzels: Batwing Crunchies, 59

pumpkin
 Bunny Dango, 194–196
 Superb Soup, 90–91

R

ramen noodles
 Mabo Curry, 106–107
 Spicy Ramen, 136–138
raspberries
 Blancmange, 102
 Jill Sandwich, 46
 Yoshi's Cookies, 26–29
rice
 Cheese Curry, 180–182
 Jambalaya, 190–191
 Jurassic Pork Soup, 43–45
 Mabo Curry, 106–107
 Spicy Food (aka Superspicy
 Curry), 24–25
 Today's Special, 53–55
 Tummy-Tingling Tuchanka
 Sauce, 118
rum
 Apricot Tartlet, 129–131
 Grog, 22
 Mana Potion, 48
 Red Potion, 20

S

sausage
 Jambalaya, 190–191
 Spaghetti Neapolitan, 92–94
seaweed: Today's Special,
 53–55
sherbet: Grog, 22
sherry
 Estus Soup, 158
 Mabo Curry 106–107
 Smoked Desert Dumplings,
 79–81
 Sticky Honey Roast, 187–189
shrimp
 Jambalaya, 190–191
 Takoyaki, 148–150
SPAM
 Durr Burger, 174–176
 Greasy Prospector Pork and
 Beans, 108–110
spinach
 Koopasta, 76–78

Today's Special, 53–55
squash
 Elixir Soup, 69
 Superb Soup, 90–91
strawberries
 Belgian Waffles, 142
 Bunny Dango, 194–196
 Creamy Heart Soup, 170
 Jill Sandwich, 46
 Mixed-Fruits Sandwich, 186
 Sinner's Sandwich, 116
 Yoshi's Cookies, 26–29

T

tangerines: Mixed-Fruits
 Sandwich, 186
tea
 Elsweyr Fondue, 119–121
 Red Potion, 20
 Smoked Desert Dumplings,
 79–81
teriyaki sauce: Durr Burger,
 174–176
toffee: Batwing Crunchies, 59
tofu
 Bunny Dango, 194–196
 Butterscotch-Cinnamon Pie,
 143–145
 Crab Rangoon, 139–141
 Mabo Curry, 106–107
tomatoes
 Chili Dog, 104
 Ciorbă de Legume, 192–193
 Durr Burger, 174–176
 The Fowl Wrap, 84–86
 Greasy Prospector Pork and
 Beans, 108–110
 Jambalaya, 190–191
 Jurassic Pork Soup, 43–45
 Paramite Pies, 50–52
 Pearson's Stew, 177–179
 Pizza, 82–83
 Priestly Omelette, 134–135
 Ration, 56–58
 Sandvich, 95
 Spaghetti Neapolitan, 92–94
 Spicy Food (aka Superspicy
 Curry), 24–25
 Taco Tornado, 159–161
 Tummy-Tingling Tuchanka
 Sauce, 118

tortillas
 The Fowl Wrap, 84–86
 Pimentaco, 125–127
 Taco Tornado, 159–161
turkey: Sinner's Sandwich, 116

V

venison: Pearson's Stew, 177–179

W

walnuts
 Carrot Soufflé, 128
 Ciorbă de Legume, 192–193
 Sweet Roll, 37–39
watermelon: Creamy Heart Soup,
 170
whiskey
 Pearson's Stew, 177–179
 Red Potion, 20
wine
 Coq au Vin, 64–65
 Mabo Curry, 106–107
 Smoked Desert Dumplings,
 79–81
 Sticky Honey Roast, 187–189
 Suspicious Stew, 122–124
wonton wrappers
 Crab Rangoon, 139–141
 Smoked Desert Dumplings,
 79–81

Y

yogurt
 Ciorbă de Legume, 192–193
 Creamy Heart Soup, 170

Z

zucchini
 Ciorbă de Legume, 192–193
 Stupendous Stew, 175–176

✖ ACKNOWLEDGMENTS ✖

Thanks to the sweetest, kindest mother, Rolanda Conversino, for taking on so many recipes. I'm so happy you got to do something from *The Witcher.* And thank you to Joe Conversino for tolerating all the weird food.

Thanks to Jeffrey Diza for helping me choose what to include in this tome, especially for not letting me accidentally snub the JRPG fans. Also, thanks for helping build the JILL sando, and for explaining the grammatical intricacies of "50 DKP minus." See you in our special place.

Nicholas Reeder, thanks for always helping me troubleshoot and for making 100% sure the trash can chicken came out juicy and flavorful. I'm going to miss having my favorite mentor/sous-chef close at hand.

Jessica and Wes Garcia, I cannot thank you both enough for everything, especially your commitment to making sure the butter cake was fit for human (not monster) consumption. I hope there were minimal folding-the-cheese incidents. I cannot wait to see you again!

Amanda and Brian Backur, thank you for being my cooking minions once again, and doing it with such enthusiasm and panache!

Jay Perez, thanks for reminding me that there was, in fact, food in Chrono Trigger. *Collin noises*

Erin Canning, thank you so much for making this one happen. Best editor ever!

Thanks to the folks at Quarto for continuing to support me as an author, it's been a fun eight years!

My babies, thanks for dealing with a very distracted mommy.

✖ ABOUT THE AUTHOR ✖

Cassandra Reeder launched her blog, *The Geeky Chef*, in 2008, making fictional food and drinks from a vast array of fandoms a reality with simple and fun recipes. Since then, she's published a series of cookbooks based on the trailblazing blog, including *The Geeky Chef Cookbook* and *The Geeky Bartender Drinks*. In 2023, she released *The Unofficial Princess Bride Cookbook*, a delicious celebration based on the cult classic film. When not conjuring up recipes for fictional food, Cassandra can be found having adventures and perusing the food carts in Portland, Oregon, with her husband and two little geeks.